RAILROAD EMPIRE ACROSS THE HEARTLAND

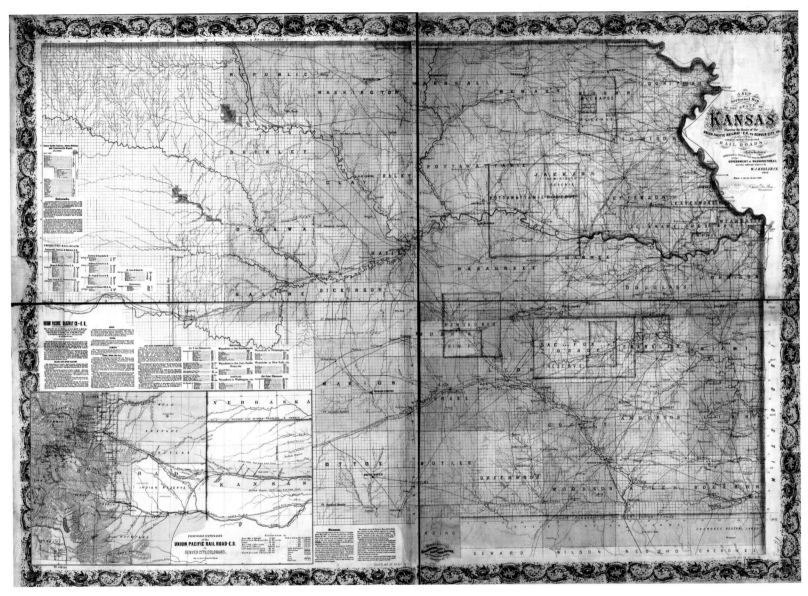

Keeler 1867 Map of Kansas

RAILROAD EMPIRE ACROSS THE HEARTLAND

Rephotographing Alexander Gardner's Westward Journey

James E. Sherow

Photographs by John R. Charlton

UNIVERSITY OF NEW MEXICO PRESS | ALBUQUERQUE

Published 2014

Printed in China

19 18 17 16 15 14 1 2 3 4 5 6

Library of Congress Cataloging-in-Publication Data

Sherow, James Earl.

 Railroad empire across the heartland : rephotographing Alexander Gardner's westward journey / James E. Sherow ; [photographs by] John R. Charlton.

 pages cm

 Includes bibliographical references and index.

 ISBN 978-0-8263-5509-6 (paperback : alkaline paper) — ISBN 978-0-8263-5510-2 (electronic)

 1. West (U.S.)—History—1860–1890—Pictorial works. 2. Gardner, Alexander, 1821–1882—Travel—West (U.S.) 3. Frontier and pioneer life—West (U.S.)—Pictorial works. 4. Railroads—West (U.S.) —History—19th century—Pictorial works. 5. United States—Territorial expansion—Pictorial works. 6. West (U.S.)—Pictorial works. 7. Repeat photography—West (U.S.) 8. Landscape photography—West (U.S.) I. Charlton, John R. II. Title.

 F594.S55 2014

 978'.02—dc23

 2013049089

Cover photographs: Detail of "Indian Farm on the Delaware Reservation, Kansas (1867)," by Alexander Gardner, courtesy J. Paul Getty Museum; and "Indian Farm on the Delaware Reservation, Kansas (1993)," courtesy John R. Charlton.

Designed by Lisa Tremaine

Composed in New Baskerville and Futura

CONTENTS

ILLUSTRATIONS

FROM ALEXANDER GARDNER TO JOHN R. CHARLTON

In 1934, Robert Taft, a chemistry professor at the University of Kansas and the president of the Kansas State Historical Society, delivered an address titled "A Photographic History of Early Kansas." On that occasion, Taft celebrated the enormous accomplishments of famous Civil War and western photographer Alexander Gardner's work in depicting "towns, scenes and institutions" of Kansas in 1867, which constituted "the most valuable, historically, of all the fifteen thousand photographs possessed" by the historical society. Taft also noted how Gardner's photographs could serve as a baseline for depicting landscape changes. Taft himself possessed a series of photographs of Lawrence, Kansas, taken over a sixty-five-year time span, many from nearly the same vantage points as Gardner's 1867 photographs. Beginning with Gardner's photographs, Taft observed that each succeeding photograph of the same location revealed a "remarkable" spread of trees covering the city. He believed that "if there were available photographs of such Kansas localities as the Gardner series taken at more or less regular intervals," then such rephotography would graphically reveal "not only the structural and social development of the town and of the state, but also depict in unmistakable manner the growth of physical features."[1] Beginning in 1993, John R. Charlton took up Taft's charge to rephotograph Gardner's work.

John Perry, the president of the Union Pacific Railway Company, Eastern Division (UPED), had hired Gardner to photograph the accomplishments of his company in 1867. Gardner's work represents an incredible, arduous undertaking. He took "imperial" photographs, so called because each glass plate measured 16 × 20 inches. He used the wet collodion process to create glass negatives. Collodion was a highly flammable, sticky, clear gel that Gardner used to coat glass plates that he then dipped into an emulsion. While still wet, Gardner placed the plate into his camera and exposed the coated glass to light for several seconds to render a negative image. Exposure times varied depending on a variety of factors, such light, ambient temperatures, and relative humidity, which together

Figure 1. Portrait of Alexander Gardner in his Washington, D.C., studio. Courtesy Indiana State Museum and Historic Sites, Corporation, Fort Wayne, Indiana.

determined how the wet plate emulsions interacted with the surrounding air. Gardner used the camera lens cap as his shutter. Immediately upon taking the glass plate out of the camera, Gardner rinsed it with water and "fixed" the image by dipping the glass plate into a solvent of silver iodide. Afterward, he again rinsed the plate in clear water, dried the plate, and finally coated the plate with varnish. Then he stored the plates in such a way as to protect the glass from breaking or being overly exposed to light in his field wagon, which also served as his darkroom. In short, given the difficulties of photographing the route, Gardner took extraordinary pains to frame his shots to illustrate the growth and spread of agriculture and town building in the state, all of which he did to highlight UPED railroad construction.

Charlton's techniques and equipment differ considerably from those Gardner employed. In order to rephotograph Gardner's imperial photographs, Charlton used a large-format camera. Beginning in the early 1990s, Charlton used silver film and darkroom techniques to develop his prints. About this same time, digital photography came of age and quickly made film development obsolete. By the end of Charlton's undertaking, he was using a digital camera and processing his prints in a Photoshop digital darkroom. In effect, Charlton began photographing with the technology that had replaced Gardner's techniques only to end by employing a digital format that replaced his earlier use of silver halide photography.

Gardner also operated a stereographic camera. Gardner employed essentially the same photographic development process to make stereo photographs as was used to develop imperial photographs. The difference was that his stereo camera contained two lenses on the front of the box that produced two separate images on the glass plate. Each image was formed from a slightly different angle, much in the same manner that human eyes capture images and relate the information to the brain. From the glass plates the images were transferred onto a stereoview card that could be placed in a handheld viewer. When these cards were placed in the viewer they produced a three-dimensional effect. In order to rephotograph Gardner's stereo series, Charlton used an old Stereo Realist camera that used 35mm film.

Charlton began his own photographic trek across the state with the goal of replicating the same scenes that Gardner had photographed, and this effort required exceptionally careful and exacting effort on Charlton's part. He collected high-quality reproductions of Gardner's prints from various collections around the country. The unusable mounted photographs on UPED boards ended up in the hands of individuals like Dr. William A. Bell, Gardner's fired predecessor and the future business partner of UPED treasurer William J. Palmer. Director Perry had demanded that Palmer fire Bell because of Bell's photograph of a mutilated soldier's body at Fort Wallace. Such photographs were bad for fostering the sale of railroad lands in the state. While Palmer replaced Bell with Gardner, in time Palmer and Bell became friends, and Palmer made Bell the physician for the 32nd parallel route expedition to the Pacific Ocean. Consequently, Bell gained access to Gardner's UPED mounted photographs and used them to illustrate his book about the UPED surveys that he published in England without any attribution to Gardner.[2] Later his estate auctioned them at Sotheby's, and they were then scattered across Europe and America.

Gardner was much more comprehensive with his stereo series, usually replacing the imperial camera with the stereo camera on the same tripod and repeating the large format with a stereo version, and then turning to another direction or changing spots for related views. His technique created near panoramic combinations, the views often triangulating one another, which provided clues to what was taken where. These differing stereoscopic views also helped Charlton to establish the large-format locations.

In 1934, when Taft acquired Gardner's stereo photograph, the Kansas State Historical Society became the largest collection of Gardner's stereographic series. Taft wrote the earliest

articles about the historical significance of Gardner's series, including his book *Photography and the American Scene*.[3] Taft, even then, proposed that the series be the basis of a rephotographic survey: "Such photographs show not only structural and social development of the towns of the state, but depict in unmistakable manner the growth of physical features."[4] Taft even made his own version of some of Gardner's Lawrence views for his book *Across the Years on Mount Oread*.[5]

Taft researched historical maps, reports, journals, letters, and news stories all related to Gardner's photographic series in order to place names, dates, and persons in the prints. From this historic evidence, Charlton worked to calculate the date, daylight times, and exact location of each of Gardner's prints. Charlton could track Gardner's sequence by observing the daylight angles and shadows in Gardner's prints. In Gardner's prints of Lawrence, for instance, morning light and shadows appear across the Kaw River in his views of north Lawrence (see photograph 22A), and shifting midday shadows are evident in the photographs taken overlooking the city from the top of Mount Oread (see photograph 21A). Later afternoon shadows appear in Gardner's views overlooking the Wakarusa Valley in the photographs that he took from the south end of Mount Oread (see photograph 24A). Charlton's understanding of the visual clues in Gardner's prints allowed him to sequence his photographs with Gardner's and to know the approximate times of day, or days, when Gardner took his photographs, so that he could take his at the same time.

Moreover, chromolithographic bird's-eye maps of the cities were being drafted when Gardner began his work across Kansas. Chromolithography is a tedious printing technique for reproducing color prints. An image, in this case the bird's-eye maps, was drawn on a limestone or a zinc plate; next the plate was treated with an acid, and then the plate was inked and placed in a printing press, so that the image on the plate was transferred to paper. Color prints required that each color be transferred by an individual stone or metal plate, so a color print required as many passes through the printing press as there were colors in the image. These bird's-eye maps provided amazingly accurate details of the buildings and streets that exactly matched Gardner's views. These cities included Kansas City, Wyandotte, Leavenworth, Lawrence, and Topeka. Maps were later made of some of the cities farther west, but these did not match what was there when Gardner traveled through them. St. Louis has had many chromolithographic maps of it made over the years. For Charlton, the map that proved the most useful showed Eads Bridge crossing over the Mississippi River. Eads Bridge was not yet built when Gardner took his photograph, but it still stands and appears in Charlton's rephotograph (see photograph 1B).

The 1869 city maps and the 1867 photographs made by Gardner show long treeless landscapes in the cities and beyond. Townspeople had harvested what little riparian growth had existed long before Gardner arrived on the scene. This presented Charlton with a major obstacle in repeating Gardner's views. It would only be possible to gain the proper distances in Gardner's views by raising the repeat views over the treetops. In Lawrence, Charlton could do this only from the rooftops of several university buildings on Mount Oread. Charlton gained access to them by dropping Chancellor Gene Budig's name to his staff around campus, a privilege he acquired while making one view over the city from the chancellor's backyard. The chancellor saw Charlton and, intrigued by Charlton's enterprise, told him who to contact for access to the rooftops of university buildings. Charlton took several photographs over treetops to the north and east atop the KU Alumni Center (see photographs 21B and 22B) and other photographs to the south from atop Blake Hall (see photograph 24B).

Most of Kansas, and nearly all of the locations in Gardner's series, are now on private property. This includes private/public properties along rivers, levees created by the U.S. Army Corps of Engineers, and roads owned by cities, counties, or the state. There are also, of course, the railroads and

bridges now owned by the Union Pacific Railroad Company. For Charlton to gain access to the Gardner locations he had to contact property owners and be reasonably discreet and careful about not drowning or getting run down by vehicles, including trains. Charlton took a few views on public lands, for example Kanopolis Lake State Park, where ironically no public access existed when Gardner had taken his photographs. However, by virtue of Charlton's employment at the time with the Kansas Geological Survey, the park rangers provided him with a state boat to reach the site and allowed him to land the boat in order to take the closeup photographs of the remains at Indian Hill (see photographs 49B and 50B). Because of windy lake conditions, Charlton had to spend two days working to rephotograph Gardner's views there.

Especially in the western series, Charlton had to make several attempts before he was satisfied that he had captured Gardner's views. Landmarks became more difficult to discover as the distances between settlements in Gardner's series grew. Even though there are railroad mileage markers on the line today, some sections of the line have been relocated, and the mileage markers no longer represent their 1867 locations. This became challenging for Charlton as the western realm of Kansas was open shortgrass prairie without place names, and Gardner's photographic mounts were simply labeled by a railroad mile "On the Great Plains of Kansas" (see photographs 59A, 61A, and 63A). In total, Charlton assembled more than 250 pairings of his and Gardner's photographs that together reveal Kansas from east to west. In essence, Charlton's photographs chronicle the aftereffects of railroad "empire" building in Kansas. Altogether, it took Charlton several years of careful preparation and effort to rephotograph Gardner's work.

As Charlton put it, "I often feel while I'm rephotographing Gardner's images that I'm sort of taking a workshop . . . [a] field workshop in photography from Gardner, cause I'm learning about his sense of composition and balance . . . as well as the subjects."[6] Charlton's photographs indeed captured the vast changes to the region predicted by Taft. As the company's promoters claimed in 1867, the railroad created an American empire in the region, and Charlton's rephotography captures that transformation in intimate detail.

In Gardner's time, the Union Pacific Railway Company, Eastern Division, served as the "new agent" for spreading American civilization. In the company's wake followed powerful urban, cultural, and economic forces that spread across and transformed the grasslands. The railroad prepared the ground for planting a new ecosystem on the High Plains. The completion of the UPED road led to the near total transformation of the grasslands and ended by harnessing them to powerful urban social and economic forces. More specifically, Charlton's photographs document the emergence of an American-managed landscape of domesticated grasses characterized by brome, wheat, corn, and domesticated animals such as cattle with little, if any, trace of an American Indian–managed landscape of buffalo grass and bison. The 1867 photographs by Gardner, and Charlton's rephotographs taken in the 1990s and 2000s, provide stark testimony to the transformation from an American Indian cultural landscape to a Euro-American urban and industrial farming landscape.

I was introduced to Charlton and his work more than ten years ago, and my fascination with ecological change in the grasslands dovetailed nicely Charlton's unbounded enthusiasm for rephotographing Gardner's work. I immediately became excited about the potential to blend my knowledge of historical grassland ecology with Charlton's photographic expertise and knowledge of Gardner. Much to my delight, Charlton encouraged me to work with him in an effort to have Gardner's work—beyond his Civil War photography—reach a broader audience.

In short, through rephotography and interpretative historical analysis, Charlton and I hope to illustrate the dramatic transformation of the Kansas grasslands wrought by the technological power of railroad building. The ninety-one

pairings of Gardner's and Charlton's photographs presented here reveal a mutable rather than an enduring grassland ecosystem. Gardner's grasslands of 1867 will never reemerge, and Charlton's grasslands of the late 1990s and early 2000s continue to change in response to ongoing technological, economic, cultural, and climatic changes. Taft thought that rephotography of a site every ten years would provide a valuable, visual historical record of economic, ecological, and cultural change. Not that Charlton and I will be ready to repeat the effort represented in this book in another ten years, but undoubtedly in another 130 years another set of photographs would reveal vast changes to these grasslands set into motion by events and forces of today. Ultimately, Charlton and I hope to reveal a clearer picture of the ongoing human role in ecological change.

Charlton expresses his thanks and appreciation to the many curators and personnel at the institutions where various Gardner collections are housed. These professionals include Nancy Sherbert at the Kansas State Historical Society and Virgil Dean and Ramon Powers formerly of the same institution. Others are Jacklyn Burns, Weston Naef, and Judith Keller at the Getty Museum in Los Angeles, California. At the DeGoyler Library on the Southern Methodist University campus, Dallas, Texas, are Kay Bost, David Farmer, and Anne Peterson. At the University of Kansas, Lawrence campus, are Sheryl Williams at the Kansas Collection and Steve Goddard, Kate Meyer, and Luke Jordan at the Spencer Museum. Charlton received great assistance from Duane Sneddeker, Kirsten Hammerstrom, and Dave Schultz at the Missouri Historical Society in St. Louis and from Charles E. Brown at the St. Louis Mercantile Library. Charlton also received considerable assistance from James McCauley, formerly of the Kansas Geological Survey, with maps and locations early in the project. Special thanks go to Dan Merriam, editor of *Transactions of the Kansas Academy of Science,* for publishing my articles on Gardner. Also, thanks go to Donald Worster at Kansas University for introducing me to Sherow. Lastly, Charlton gives particular thanks to Mark Klett at Arizona State University, his mentor in rephotographic techniques.

I want to express my thanks and appreciation especially to Mark Feige, whose expertise in environmental history is unquestioned, and to Derek Hoff, a valued colleague and friend. Both read drafts and made invaluable insights that certainly strengthened and clarified the narrative. In conference settings I have benefited from many others who have read, heard, or seen earlier versions of this work, and in this regard I would like to give special thanks to Don Pisani, Richard Orsi, and Sterling Evans, whose criticisms I always value. In my department's "brown bags," feedback from colleagues and graduate students sharpened my thinking. I certainly am grateful for the support, patience, and encouragement of Clark Whitehorn, the editor-in-chief of the University of New Mexico Press. It should never be forgotten that this work is a collaborative effort and that I have enjoyed and valued working with Charlton. Also, I want to thank my dean, Professor Peter Dorhout, and the chair of my department, Professor Louise Breen, for providing the subvention for the publishing of Charlton's and my work. Without fail, my sharpest and most trusted critic is Bonnie Lynn-Sherow, whose support and love is the foundation of my work. Charlton does not make photographic errors, so any errors found in this work bear my handprints.

"THE NEW PIONEER OF POPULATION AND SETTLEMENT"

The Making of an American Imperial Landscape

If you want to see what the railroad is, and how civilization and progress date from it—how it is the conqueror of crude nature, which it turns to man's use, both on small scales and on the largest—come hither to inland America.

—WALT WHITMAN, "Upon Our Own Land"

Around nine o'clock during a warm mid-June evening in 1867, diners had just finished a sumptuous and elegant banquet in the Southern Hotel, one of the finest in all of St. Louis, Missouri. Sen. Richard Yates of Illinois, speaking for the indisposed president pro tempore of the United States Senate, Benjamin Wade, stood and addressed an audience of other U.S. senators, local politicians, and reporters from the *Philadelphia Inquirer, Cincinnati Gazette, New York Times, New York Tribune,* and the *Chicago Republic.* The president of the Union Pacific Railway Company, Eastern Division (UPED),[1] John D. Perry, had assembled and sponsored this distinguished entourage, which had just finished touring his accomplishments in Kansas. Addressing an enthusiastic audience, Senator Yates declared the Union Pacific Railway Company, Eastern Division, the "new agent of civilization." By this statement he plainly conveyed railroad building across the grasslands of Kansas as the essential technology, preceding and preparing the ground for an American empire, one that would take root and flourish in the land itself.[2]

Five years prior to this feast, many avid supporters and investors had already anticipated similar outcomes of railroad building after President Abraham Lincoln had signed into law the Pacific Railway Act of July 1, 1862. For instance, Horace Greeley, never at a loss to promote transcontinental railroad building, caught the tenor of the times in his *New York Daily Tribune*—well, at least he caught the Republicans' enthusiasm for using iron rails to bind the nation. At the height of the Civil War, while President Lincoln worried whether or not a nation "conceived in liberty" could "long endure" and remain united and governed "by the people," Greeley's *Tribune* heralded the prospects of an *empire* created through railroad building. Such an empire would assure that fast-growing centers of capital, commerce, and manufacturing, such as Chicago and New York, would complete their national dominance over Southern interests. So proclaimed the *Tribune,* "Of the magnitude of the [building of the UPED railroad], or of its value to

Figure 2. Title page of William A. Bell's New Tracks in North America *(London: Chapman and Hall, 1869), with a lithographic reproduction of Alexander Gardner's photograph, "Westward the Course of Empire Takes Its Way."*

the country, nothing need be said. The completion of the road would stimulate emigration and develop the 'inexhaustible resources of our new mineral and pastoral States and Territories in the West—an influence in itself equal to the acquisition of an empire.'"[3] At the same time, George T. Pierce, writing for the *American Railroad Journal,* noted how the Union Pacific Railway Company, Eastern Division, upon completion would have "absolute control of all the vast New Mexican trade."[4] Any Eastern company, Pierce predicted, would race to connect with the Union Pacific Railway Company, Eastern Division, in order to command the trade coursing over its rails. While Lincoln may have embraced a government of the people, by the people, and for the people, his signing into law the Pacific Railway Act of July 1, 1862, gave birth to an empire shaped and controlled by railroad companies, their technologies, and the cultural values of their promoters.[5]

Railroad entrepreneurs and supporters understood that locomotives towed more than freight and passenger cars. Railroads, the "new agent," led the way for an American empire, one designed to replace a perceived wilderness with an idealized civilization and landscape. Railroads possessed the power to clear the way of American Indian peoples to make room for capitalists, promoters, farmers, and town builders who would plant an American civilization—complete with its institutions, economy, and social structure—into the land in such a way as to deliver its fruits into an urban-driven national and international economy.[6] In addition, the Union Pacific Railway Company, Eastern Division, hauled into Kansas the Northern ideal of a "free labor" society devoid of slavery and a planter class. On June 8, 1867, when the entourage had reached Fort Harker, Kansas, Benjamin Brewster, the attorney general of Pennsylvania, put it this way: "Iron ways . . . invited intercourse; gave facilities for commercial, social and political community of feeling and thought, and that made the East, the North, the Middle, and the West, as one people to subdue a rebellious and stiff-necked generation, who had with

fierce impiety raised their bloody hands against the life of our common country."[7] During the ground breaking ceremony in September 1863, foreman H. H. Sawyer of the Union Pacific Railway Company, Eastern Division, demonstrated as much when he drove into the ground a post marking the westward start of construction on the state line of Missouri and Kansas. After he pounded the stake into the ground, he marked it with red chalk: on the Missouri side of the post he wrote "slavery," and on the Kansas side he wrote "liberty."[8]

This "liberty," however, would be entirely constrained by imperial aspirations and the attendant demands made upon people and the land by the technology of railroads. This understanding of railroad building and its ramifications diverges completely from a mythic Turnerian or agrarian explanation for the development of Euro-American settlements and republican institutions. Frederick Jackson Turner's 1893 essay, "The Significance of the Frontier in American History," focused on how people's comingling with the frontier served as a constant source of republican rejuvenation. American railroad builders, on the other hand, viewed the iron horse as the means to destroy the frontier, thereby clearing a space for an American empire with all of its institutions ready to take root. Regardless of what Lincoln might have meant by the phrase "a new birth of freedom," railroaders hardly envisioned republican institutions constantly revitalized by contact with a receding frontier. If anything, they assumed that the creation of American liberty and free labor had virtue so long as it contributed to the rise of great cities tethered to railroads. Railroad developers understood how great industrial urban centers were creating the demand for expanded agricultural production in order to feed the rapidly swelling cities of the United States and Europe. Theoretically, their roads would lay the basis for republican institutions, but those institutions would always operate at the behest of their creators, the investor class of railroaders.

Turner's "frontier thesis" also pays homage to the advance of

agriculture, which made possible the growth of cities. Something different, however, occurred in Kansas with the building of the Union Pacific Railway Company, Eastern Division. By the middle of the nineteenth century, the rapid population growth of Eastern, Midwestern, and European cities and the attendant amassing of capital in these centers had created a demand for agricultural production where none had existed before. In June 1867, Sen. John A. J. Creswell of Maryland pressed this point upon the audience gathered in St. Louis to celebrate the accomplishments of the Union Pacific Railway Company, Eastern Division: "Gentlemen of the West!" he began, "you are a great people, to be sure, but you are not all the people in the universe." He warned, "Remember that there is still an East, and that without that East—or rather, without it and the rest of the Union—you cannot complete your great railroad system, nor construct your other extensive works of internal improvements. . . . You cannot rejoice more in your prosperity than we do; because it is as much our work as yours."[9]

When UPED president John D. Perry resumed building across Kansas after the Civil War, hardly any farms at all existed west of Junction City until near the city of Denver, Colorado. Railroads extended the demands of urban centers such as St. Louis and Chicago for the expansion of agriculture. In this way they were able to extract resources out of the new states and territories and deliver these into the hands of powerful mangers of capital and trade, who transformed these goods into marketable commodities useful for an industrial economy and at the same time amassed nearly immeasurable wealth and power for themselves. Moreover, the Union Pacific Railway Company, Eastern Division, created its own smaller urban network across Kansas, and the towns in this network prospered so long as they served the demands of railroading and urban markets to the east. Strange as it might sound, by 1900 railroad building through the grasslands had created a thoroughly urban-shaped ecosystem.

Railroad promoters rode a wave of changing global demographics that profoundly altered the grasslands of America (and countless other regions around the globe). Prior to 1800, a mere 2.5 percent of the world's population lived in cities, but by 1900 over 10 percent did, and over two-thirds of this overall urban population resided in Europe and North America. New York, for example, was one of ten cities in the United States to have a population over 20,000 in 1830. But between 1830 and 1860, the urban population of the United States doubled every decade, and as this trend continued, more than fifty American cities surged to over 100,000. By 1850, New York's population topped 700,000, and it reached nearly 3.5 million by 1900.[10]

In his sweeping survey of western expansion from 1783 to 1939, James Belich identifies two forces making this phenomenal growth possible—"the synergy between ideological . . . and technological shifts."[11] In other words, market culture values coupled with railroad technology shaped the Euro-American occupation of the grasslands. When considering this expansion across the grasslands during the post–Civil War years, all of this, as Belich asserts, was fueled by a "rail-led boom." By 1890 an amazing network of transcontinental railroad lines led directly to Chicago, and from Chicago rails conducted freight trains toward New York City and East Coast ports. Chicagoans not only engaged in a profitable exporting economy, but they also became importers of the raw materials extracted out of the grasslands in order to meet their own rising consumer economy. As immigrants poured into the windy city, Chicago worked as "its own best customer," as Belich suggests. The captains of industry and their control of attendant technologies fueled the large growth of an expansive urban matrix, and by 1900, for the first time in human history, the global urban industrial economy outpaced the global agricultural economy.[12]

During this time of great demographic and economic upheaval, many pundits regarded the growth of cities, and not farms, as the highest form of American "progress." For instance, while on his journey to Kansas, William Bell, an

Englishman who later became a business partner with William Jackson Palmer, the treasurer of the UPED, offered the following assessment of 1867 Saint Louis:

[The eastern bank of the Mississippi River] is marred considerably by the total absence either of large timber or good houses . . . but the opposite side, marked by the broad bustling quay, and a string of many-storied river boats, two miles in length—the dense piles of warehouses and the rest of the city built on a higher level, forming the background—is perfect as a picture of American progress.[13]

As historian Carl Abbott correctly asserts, cities such as St. Louis "were the spearheads of trans-Mississippi settlement."[14] Abbott catches the thinking of the time by quoting James Bryce, who wrote: "To have an immense production of exchangeable commodities, to force from nature the most she can be made to yield . . . making one's city a centre of trade . . . is preached by western newspapers as a kind of religion."[15] Bryce knew of what he wrote. Historian Michael Adas describes this impulse as "America's divinely appointed civilizing mission" shaped by technological imperatives and, above all, by railroads.[16]

Alexander Gardner also celebrated the economic hustle and bustle of St. Louis. Unlike Bell and Bryce, who used words, Alexander Gardner witnessed the economic power of cities through the camera lens. Gardner had a distinguished reputation built upon his photographs of American Indian delegations visiting Washington, D.C., his famous views of Civil War battlefields, and his portraits of luminaries such as Walt Whitman. Gardner photographed one other well-known public figure who avidly promoted transcontinental railroad building: he made several portraits of President Abraham Lincoln, perhaps the most renowned being the last known photograph of the president.

In 1867, Alexander Gardner became an employee of the Union Pacific Railway Company, Eastern Division. Gardner's brother, James, and William Pywell, Gardner's assistant, accompanied him. The company directors had located their main office in St. Louis, where Gardner met them and received his instructions for photographing the work of the company in Kansas and beyond. Before heading west Gardner took a little time to provide an image of the perfect picture of American progress—St. Louis commerce on the Mississippi River (see photograph 1A).

Photographing the Route

From his office in St. Louis, John D. Perry, the president of the Union Pacific Railway Company, Eastern Division, decided to hire Gardner as part of an effort to avert a serious problem with Congress. The Transcontinental Railway Act promised support for his undertaking by providing treasury bonds and public lands for each mile constructed according to federal guidelines. He faced financial disaster given the very real possibility that federal capital and political support might be delayed, or even pulled, for his bold ambition to span the North American continent by rail from Kansas City, Kansas, to the West Coast port cities of San Diego and San Francisco. He badly needed to reassure Congress that subsidizing his railway line with bonds and land grants still made sense.

Perry's problem arose after President Andrew Johnson received reports indicating that the building of the UPED line from Kansas City to Lawrence had been poorly constructed and therefore failed to merit federal support. In 1866, the president authorized a special commission to investigate the situation and make a formal investigation into the quality of the construction. The commissioners' report pointed out several deficiencies in the line, such as a poor location of the route, cuts and embankments far too narrow, grades too steep in several locales, too few crossties per mile under the rails, not enough ballasting to sustain the weight of trains,

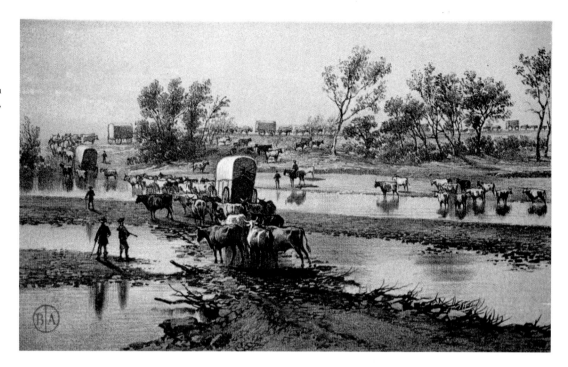

Figure 3. This is a chromolithographic reproduction of Gardner's photograph of a Santa Fe–bound train crossing the Smoky Hill River to the south of present-day Ellsworth, Kansas. Taken from William A. Bell's New Tracks in North America *(London: Chapman and Hall, 1869), 28, this rendering of Gardner's photograph illustrates one way in which Perry met his objective of reaching a wider-reading public. See photograph SS145.*

underbuilt culverts and bridges, and too few support buildings such as depots. The report raised serious alarms among the investors given the prospects that the Johnson administration might not release federal bonds and public lands to the company.[17]

Perry responded quickly on several fronts. To demonstrate just how well done the construction and operation of the line was, he gave tours of the route to important congressmen, their wives, and newspaper reporters. Perry also sought to impress important politicians not in attendance by having Gardner photograph the route and then having the prints published in albums for Congressional consumption. Perry anticipated an additional benefit of reaching a wider audience through lithographic reproductions of Gardner's prints or through books that chronicled and illustrated the expeditions along the route. He also wrote a formal refutation of the

commission's findings to the secretary of the interior.[18] Perry's pursuit to bolster the construction of the UPED line is how Alexander Gardner entered the picture.

In 1867, William Bell, an English-educated doctor, arrived in St. Louis. He heard about an expedition charged with detailing one of the railway routes to the West Coast. Intrigued, he found the company office and inquired about joining. All of the positions were filled except for that of the photographer. Despite lacking any real skills, Bell volunteered to fill the post. Former Civil War generals W. W. Wright and William Jackson Palmer commanded this mission for Perry's UPED line, and almost immediately they recognized that Bell was nearly inept at photography. Knowing that an amateurish product would fail to meet his needs, Perry immediately went looking for a replacement. Nonetheless, Perry kept Bell within his circle, and the latter proved his worth as an

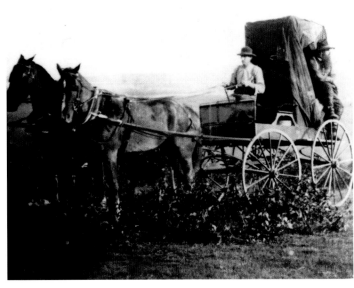

Figure 4. Gardner's Traveling Photographic Laboratory on the Grasslands of Kansas, 1867. Courtesy of the Kansas State Historical Society.

investor and publicist. Bell's account of his adventures across Kansas, *New Tracks in North America* (1869), is one of the best renderings of the expedition. Still, Perry lacked a competent photographer, so he wisely turned to Alexander Gardner.

Perry recognized in Gardner an artistic genius that Walt Whitman and Abraham Lincoln also highly esteemed. Gardner was nothing less than a master of his art. As Whitman observed, "Gardner was a real artist—had the feel of his work—the inner feel, if I may say it so . . . he was also beyond his craft—saw farther than his camera—saw more: his pictures are an evidence of his endowment."[19]

Gardner's personal history offers a fascinating story by itself. Inspired by American utopian reform movements, he

immigrated to the United States from his native Scotland in 1850. He and his brother, James, soon were in the thick of the abolitionist movement, but nonetheless he became enthralled by photography and quickly perfected his craft. For a while during the Civil War he worked as a photographer for Mathew Brady, a famous photographer best known for his Civil War photographs. But Gardner clashed with Brady, and so he began his own firm and subsequently took many famous photographs of battlefields and Union Army life.[20] Still, Gardner was more than a war photographer: he photographed Indian delegations and portraits of the rich and famous as well as young soldiers off to war. Some writers justifiably consider Gardner the first photojournalist. His shots of the hanging of the Lincoln conspirators and of Jacob Wirtz, the notorious commander of the Confederate prison at Andersonville, are just two examples of his remarkable journalistic work. By 1867, Gardner's fame as a photographer had spread far and wide, which is why Perry employed him.[21]

The owners of the Union Pacific Railway Company, Eastern Division, knew that Gardner could meet their expectations to show the progress and accomplishments of their company. They assumed that photographs of the landscapes, inhabitants, prominent geological formations, and general botany along the route would dramatically illustrate the potential riches derived from building this railroad. In the end, his photographs contributed an unambiguous visual justification for federal support. Beginning in September 1867, Gardner traveled with entourages of would-be investors, politicians, reporters, and company officials. President Perry planned trips and surveys from the eastern border of Kansas to San Francisco. Some parties only traveled as far as Salina, Kansas, where train travel ended. Some continued by horse and wagon along the line of future construction and returned after reaching various points along the way to Colorado. Gardner continued photographing through what would become the states of New Mexico and Arizona, all the way to the Pacific Coast. He ended

a journey of over two thousand miles with shots taken of Seal Rock near San Francisco in 1868.

Alexander Gardner produced more than just high quality visual advertising for the UPED line. His photographs richly detail the economic, social, and ecological consequences of railroad building. Above all, his prints show one form of cultural grassland management yielding to another that depicts the remnants of a receding landscape once manipulated by American Indian peoples and the emergence of a landscape primarily shaped by African and Euro-Americans. No one had yet rendered the startling path of "American Civilization" the way Gardner did through the lens of his cameras in 1867 and 1868. American painters and illustrators such as John Gast and Fanny Frances Palmer provided an allegorical rendering of the march of progress, but Gardner offered framed views tracing the *actual* unfolding of the American empire. And these views revealed a tragic reality: American Indian peoples with their horse-borne hunting cultures, open-range ranchers, American farmers, city dwellers, and industrialists could not all occupy the grasslands simultaneously because of the different ways in which their respective cultures employed plant, mineral, energy, and water resources. For American Indian peoples, Americans consistently and inevitably held the balance of power because of their ability to draw on remote, abundant sources of fuel, fiber, and food to power their occupation of the region. This capacity overwhelmed American Indians, and, later, open-range cattlemen, who could not disengage from an increasingly weakened grassland ecosystem and the trade networks that had once sustained them.[22]

As Gardner documented an emerging railroad empire in 1867, Americans debated not only Reconstruction but indeed the very core issues of their democracy. Should women have the right to vote? Should freedmen have the right to vote? In Kansas, male voters rejected these foundational rights for both women and African Americans in the fall of 1867.[23] At the same time, American Indians in the state fared even less

well as they tried to occupy the western portions of the state. Gen. Winfield Scott Hancock's campaign against the Southern Cheyenne Dog Soldiers and Oglala Sioux in the spring of 1867 created a violent uproar throughout the High Plains. Eventually, Congress and the Bureau of Indian Affairs attempted to pacify American Indian peoples through the Medicine Lodge Treaty negotiations, which took place in October 1867 and effectively removed American Indians from their former bison-hunting grounds in the state, clearing the way for unhindered railroad construction.[24]

American promoters envisioned more than using railroads to demolish a wilderness in Kansas to make way for the advance of civilization. These pundits considered the Union Pacific Railway Company, Eastern Division, a force greater than an army or navy for acquiring an American global empire. Joseph Copley, a nationally well-known correspondent for the *Pittsburgh Gazette*, echoed this theme directly. Northern readers knew Copley for his reformist zeal and his abiding interest in religious issues. Perhaps Copley's devout Presbyterian faith and the loss of two of his sons in the Civil War shaped his understanding of an American empire.[25] Whatever the source of his inspiration, Copley regarded the railroad as the "great agent and pioneer of civilization." His experience chronicling the Union Pacific Railway Company, Eastern Division, in the grasslands led him to relate how "every institution of an advanced social condition" followed in the wake of railroad construction. Cities, industries, and American institutions created the "music of busy life" in the prairies where before only the "cry of the savage or the wolf" had prevailed. This "mighty tide of civilization" defined the "March of Empire." More than this, Copley envisioned the railroad as the harbinger of a "Christian civilization," the course of which was ever westward.[26]

Several historians have examined how railroad technology became more than a tool in human hands; it shaped an empire around itself. In his *Dominance by Design*, Michael Adas

maintains that "America's emergence as a global power has been consistently driven by a sense of can-do confidence, a faith in scientific and technical solutions, and missionary certitude that the United States was destined to serve as a model for the rest of humanity." More succinctly, Adas illustrates how "technological imperatives have shaped . . . the ideology of America's civilizing mission, and the policies and programs actually pursued."[27] Historians Daniel Howe and William Thomas have shown how this "March of Empire" was already in common currency prior to 1867. Howe's work details how Americans' faith in Protestantism coupled with technological advances in telegraphy and railroads foretold a future of "domination and exploitation of the American continent." Excluded from this promise of an American future were Mormons, Catholics, and any other religious group that deviated from mainstream Protestantism. American Indian peoples had to stand aside and assimilate into this new order or else be destroyed by the march of empire led by the railroad. The Civil War, according to Thomas, hardened this notion of a Christian empire predicated upon railroad development. In all of his reporting to his Eastern readers, Copley's views exemplify exactly the points being driven home by Adas, Howe, and Thomas.[28]

Like many Americans of the time, the promoters of the Union Pacific Railway Company, Eastern Division defined empire in both commercial and cultural terms. Many Americans fixated not only on capturing Chinese and Japanese trade but also on converting the peoples of those nations to Christianity. And American technology would pave the way. In June 1867, Senator Yates of Illinois predicted that merchants from China and England would ride the rails to meet in St. Louis to do business. William Bell similarly dreamed of how the "trans-continental highway" of the Union Pacific Railway Company, Eastern Division, would create an epicenter of trade based in St. Louis. He foresaw how the silks and teas of China along with the "choicest products" of Europe would meet in the middle of the continent. And as icing on the cake, St. Louis would command the Mississippi River trade from New Orleans to Minneapolis–St. Paul, Minnesota.[29] Copley added to these predictions a more celestial vision, as he saw the building of the railroad as a divinely guided endeavor, one to serve more "as a channel of Christian civilization than as an avenue of commerce." The railroad would open "a channel through which new light, new life, a better civilization, and the Gospel of Peace, shall flow to hundreds of millions of human beings." The effects would "revolutionize" China and Japan, create a "new and better life" for Russians, "restore Mexico to order and civilization," and influence "all Western Europe."[30]

Humorist Charles Godfrey Leland, who also rode along on the UPED line, even prophesied that the railroad would "destroy the realm of Mormon without the aid of legislation, by letting in light upon its ignorant fanatics."[31] One of Leland's traveling companions, Congressman Godlove S. Orth of Indiana, added bluntly that the UPED line meant the solution to the "Utah problem" where its "one hundred thousand deluded human beings—with its mis-named religion, a shame and a blot upon our fair name—will be pierced and crossed by the Pacific Railroad . . . and thus the cause of Mormonism . . . will disappear, to be remembered only as among the disagreeable and disgusting things of the past." Copley believed that this "Christian" transformation would result from the "effect of this new avenue of commerce, this new highway over which Empire is to march."[32] In this heady environment, Gardner's photographs captured the economic, cultural, and ecological clout of railroads to transform the grasslands along the lines of Copley's imperial prophecies.

The Technology of Railroads as an Ecological Force
Gardner's work illustrates what emerged in Kansas as a result of this "March of Empire" propelled by the railroad, the "new agent of civilization." Any technology initially begins as a human-produced tool, but it becomes more than

human-crafted aid as it reshapes the culture that created it and transforms ecosystems. In our case, the Union Pacific Railway Company, Eastern Division, reshaped American social, economic, and ecological relationships wherever it built. Hence theorist Kevin Kelly refers to the "essential self-propelling momentum" of technology.[33]

More specifically, railroads worked as an ecological force reordering the grassland ecosystems of Kansas. Alexander Gardner's photography of the UPED route through Kansas in 1867 displays this transformation. In fact, Gardner's contemporaries expected that the Union Pacific Railway Company, Eastern Division, would make over the prairies, and Gardner's photographs caught the realities of this ecological transformation. The humorist Charles Leland summed up the views of many when he proclaimed that the "prairies were made by Providence for railroads." He viewed the land grants held by the company as giving title to "the richest lands in America," which were capable of producing an "infinitely prosperous" population—assuming that railroad connections to eastern markets converted these lands from wilderness into Euro-American settlements.[34]

This notion that railroads possessed the technological prowess to render a "wilderness" into "civilization" was a nearly universally accepted axiom in western thinking. Kate Brown illustrates this nicely in her comparative study of railroad building in Karaganda, Kazakhstan, by Soviet planners in the 1930s, and in Billings, Montana, by the Northern Pacific Railroad Company in the 1880s. Both were created, as Brown writes, "for commerce and the quick extraction of resources at railheads and responded not to ecological limits but to the surveyor's rational grid." Similarly, if UPED president Perry understood anything in building the UPED rail across a trackless, cityless, farm-less landscape, he realized that the landscape and its extractable resources had to be rationalized in order to be quickly loaded into his boxcars, because empty boxcars would produce only economic woe for him

and the investors. Building railroads also meant, as in the cases of Karaganda and Billings, eliminating the presence of the people who occupied the land prior to the arrival of the railroad. The Kazakhs in Kazakhstan, the Sioux and Crows in Montana, the emigrant tribes in eastern Kansas, and the Southern Cheyennes and Arapahos in western Kansas would be removed by state force. Their respective uses and management of the resources of the grasslands in Kazakhstan, Montana, and Kansas all conflicted with the *needs* of railroads to have those resources employed and shaped in an entirely different manner.[35]

Cultural and state power drove railroad building. Consequently, a set of American cultural values streamed into the grasslands in the wake of advancing railroad lines. And both the UPED line and the cultural values that propelled it acted as ecological forces: technology and culture became new elements added to the mix of physical and biotic entities shaping the grasslands and thereby forcibly creating a *domesticated* grassland. This transformation, as ecologist Robert O'Neil has written, shows that human beings must be seen as a "keystone species," one that has a "disproportionate effect on the persistence of other species to the extent that their removal may lead indirectly to the loss of such other species in the community."[36] Human beings act as more than an external force "deriving goods and services" from any particular biome. Rather, humans and their various cultures and technologies participate directly in shaping ecosystems, and when one culture and its technologies displace others in a landscape, a different set of ecological relationships emerge.

In O'Neil's ecological terms, the UPED line created an "invasion pathway" for "populations that would not otherwise occur."[37] Railroad builders like Perry, who sought to tap the resources of the grasslands, converted them into capital and fixed the pathways that transported those resources to meet the demands created by urban markets. These pathways allowed cattle to replace bison, wheat to replace little

bluestem, and gridded cities and farmscapes to replace the open grasslands surrounding American Indian villages. With this transformation, Copley's American empire became literally fixed in the soil, and it created its own set of demands and constraints upon the very culture that spawned it.

Emphasizing the place of humans in a living ecosystem demands that we consider the technology of railroads as something more than machinery and steel tracks. As Kevin Kelly would argue, the railroad was a force possessing its own power to shape an ecosystem just as thoroughly as the humans who built the locomotives. The effects of this force rolling across and transforming the grasslands become apparent in Alexander Gardner's photographs of railroad building across Kansas.[38] Railroad building followed its own logic as it molded workers' lives, displaced American Indian peoples, established the placement and design of towns and farms, harnessed the national economy, and created new industries and markets. All of this occurred beyond the free choices of American Indians, town developers, organized laborers, and capitalists. Railroads were more than a tool for transportation; they embodied cultural, social, economic, and ecological forces sweeping through the grasslands and altered everything in and around their paths.

Three important characteristics shaped railroad building in the grasslands. First, there was the *inevitability* of railroad technologies; that is, the physics of steam locomotion, steel manufacturing, and construction techniques led inevitably to the forms and structures of railroad systems, no matter where on earth they were built. Second, the development of railroad lines was *contingent* on what happened in the past. An example that writer Kevin Kelly gives in his book *What Technology Wants* is that ancient Roman war chariots accommodated two large war horses, and the ruts left by the chariot wheels had an average width of 4' 8½". Carriages through the ages were built to fit these ruts, and when English engineers first built tramways they kept the rails spaced 4' 8½" apart for horse-drawn carriages. The rail distance was kept intact once steam-powered locomotives replaced horses.[39] The third characteristic is *human free will*, which flourishes within the confines of inevitability and contingency. Americans freely employed the railroad to usher onto the prairies of Kansas new cultural and economic forces, which in turn altered the ecology of the grasslands. Again, railroads carried more than freight and passengers. They transported people's views about religion, gender, and education into the region. The UPED line provided the means by which market forces from the large urban areas of the Midwest and Eastern seaboard cities reached out into the grasslands and marked the landscape with urban outposts: the rails were followed by cattle drives, farms, and industries all centered on the economics of railroad transportation.

As railroads channeled the economic and cultural power of cities by tapping and reshaping the natural resources of the grasslands, they transformed American Indian–managed landscapes into ones dominated by Euro-American cultural and economic values—the values of American empire as touted by Copley and Bell. Perry and his fellow railroad financiers and supporters at the time heralded this empire as ordained, as right and proper. As one of the main chroniclers of the 1867 UPED-sponsored tour, the journalist Copley heralded how railroad building across the grasslands created a new order of Euro-American settlement. "The old process must be inverted," he wrote. "The locomotive must precede the plough, and the town the farm. Even Kansas, with all its fertility . . . could not be occupied in any other way."[40] In June 1867, the UPED entourage held a great banquet at Fort Harker, and there Senator Yates proclaimed "the *new* fashion" of railroad building: to push railroads far into the "wilderness" well in advance of populating the land. "The locomotive is the new agent of civilization," Yates exclaimed. "The railroad," he assured his companions, "is carrying our institutions far into the centre of the West. We need nobody to fight the Indians, when the whistle of the locomotive shall frighten the wolf and the antelope before it."[41]

Those American Indians who were pushed aside included the emigrant nations remaining in Kansas, such as the Delawares, who lived near Fort Leavenworth (see photograph 15A). Gardner's photograph of a Delaware farmstead in Leavenworth County reveals how Senator Yates's notions of savagery even included American Indians adaptation to Euro-American styles of farming. No matter how thoroughly American Indians may have adopted Euro-American ways, they did not, could not, fit into the senator's notions of civilization and the advance of an American Empire carried by railroads. Given this line of thinking, Euro-Americans considered the UPED line powerful enough in and of itself to erase all American Indian people's marks on the land in order to clear the way for "civilization."

Like Senator Yates, Copley informed his eastern readers that the land was well suited for "the habitation of civilized people." He also asserted that "population will *follow*" the UPED line. Copley was certain that Euro-Americans could not precede the railroad, because the "log-cabin can never be an institution" on the plains, and "the ranch is no place for women and children."[42] The Englishman William Bell chimed in with the same refrain: "In the great West, where continuous settlement is impossible, where . . . spots of great fertility and the richest prizes of the mineral kingdom tempt men onward into those vast regions . . . the locomotive has to lead instead of follow the tide of population."[43] The correct means for advancing the American Empire had been found.

Gardner's Photographs and the Advance of Empire

Small cities and fledgling urban outposts were necessary appendages to the railroad. Each one, whether built and growing, or in some stage of early development, had to make itself conform to the needs of the railroad. City promoters had to help fill the capital needs of the railroad by providing fuel and water to power the locomotives, and these small towns had to serve as collector points for the marketable commodities of the grasslands. Gardner's photographs of Lawrence, Kansas, reveal a small city well suited to fill these functions. By 1864, the citizens of Lawrence had already given themselves over to the Union Pacific Railway Company, Eastern Division, by providing extensive economic subsidies for its construction.[44] These investments in the railroad seemed to bear fruit as shown in Gardner's photograph of the main street of Lawrence, which showed no signs of its utter destruction by Quantrill's raiders merely four years before (see photograph 19A).

The surrounding countryside of the Wakarusa River Valley also showed the outline of an advancing empire. Taken from atop Mount Oread,[45] where the University of Kansas was under construction, Gardner's photographs reveal a landscape undergoing rapid transformation from open grasslands to farmlands neatly arranged in a grid system (see photograph 24A). The railroad connections to eastern urban markets made possible the budding commercial agriculture and landscape rearrangements in Gardner's photographs. He intended this view of the valley to advertise just how well Euro-American economic and cultural institutions had taken root in the grasslands. Copley expressed this same view, writing, "As the Union Pacific Railway, Eastern Division, is pushed forward, section after section, up the Kansas—now 250 miles beyond the Missouri—settlers in thousands follow it, and even precede it, so that already numerous towns have grown up where, two years ago, Indians and buffaloes were roaming, each surrounded with well-tilled and productive farms."[46] As Gardner's photograph shows, Euro-American values were taking root in the valley.

Copley recognized how necessary educational institutions were to reproducing the cultural values giving rise to this new American empire. In Manhattan, Kansas, he saw one of the very first examples of a new form of higher education created exclusively for that purpose: Kansas State Agricultural College (KSAC). The charter of this college, one of the first endowed by the Morrill Land Grant College Act of 1862, promised to

educate agrarian and laboring classes in republican virtues and in the science of industry and agriculture. But dominance over nature also infused the college's cultural DNA as highlighted in the school motto, "Rule by Obeying the Laws of Nature." Gardner's photograph of the Bluemont building on the KSAC campus exemplifies the value placed on the transformative power of those institutions (see photograph 37A).

Meanwhile, Bell's take of Kansas State Agricultural College accorded nicely with his observations of the transformative forces that were literally taking root in the grasslands. Because it provided new opportunities for women's education, Bell called this budding institution "The Paradise of Petticoats." He noted how women were receiving the same education in the same setting as men and how, new for the times, the faculty supposedly made no gendered distinctions in their teaching methods. He went on to note, "All the advanced forms of thought upon education and woman's rights have been imported direct from the New England States, and *have quickly developed in this virgin soil to an extent hitherto unprecedented.*"[47] Bell's language—"advanced form of thought," "imported from the New England States," and "developed in virgin soil"—equates Euro-American cultural values to a living force, a seed taking root with the capacity for reproduction through education.

Bell, however, overestimated the case for equal educational opportunities for women when he said, "bold, indeed, would be the man . . . who dared to oppose openly this phalanx of political Amazons." In October of 1867, less intimidated Kansas male voters defeated the first proposal in the nation to make women's suffrage part of a state constitution. Moreover, although women did enroll at Kansas State Agricultural College, the curriculum for them revolved around improving the domestic economy of the home. Even if Bell had engaged in hyperbole, he had recognized how Euro-American cultural values were taking root and replacing the vacated cultural niches left by retreating American Indian peoples and traders. Other values, such as the creation of money markets for

extracted resources and manufactured commodities, along with the distinctive technological infrastructure of railroad transportation, made it all possible. Echoing a common Euro-American view, Bell and Copley saw this as the "right plan of human progress."[48]

The growing presence of trees in the grasslands also indicated how railroads propelled the advance of the American empire. Euro-Americans valued trees in the grasslands as a sign of the march of civilization. Copley believed that the only impediment to tree growth was the presence of American Indian peoples. And here he was absolutely correct. The photograph of Manhattan and the Blue River with Bluemont Hill in the background shows a landscape nearly devoid of trees except for a thin line huddled along the riverbank. In 1994, John R. Charlton photographed the city in nearly the same location as Gardner had. By 1935, the river had shifted course over a mile to the east, and by 2000, red cedars and hardwoods completely blanketed Bluemont Hill (see photographs 36A and 36B). As Copley predicted, "when the country is settled" trees would become more numerous.[49]

In 1870, Brevet Major and Assistant Surgeon George Miller Sternberg stood at the end of a four-century ecological drama.[50] George W. Martin, the editor of *The Union*, a Junction City, Kansas, newspaper, published a letter from Sternberg with insights about what it would take to transform the wild grasslands into a region dominated by Euro-American farming practices. Prior to writing his letter, Sternberg had ridden widely with the Seventh Cavalry through the mixed-grass and shortgrass biomes and had developed a keen interest in the natural history of these ecosystems. Consumed with curiosity about the land, he studied its fossil remains scientifically, and in time he would become a nationally renowned paleontologist. In February 1870, however, his letter to the editor covered the subject of prairie fires. This army officer had taken careful note of the ecological effects of American Indian burning practices, yet at the same time he thought of American

Indians as uncivilized inhabitants of a wilderness and as lacking a conscious, purposeful management of the grasslands. Obviously, Sternberg was blind to the inconsistency in his logic that deemed American Indians as wild but recognized their grassland management practices—practices that had domesticated and shaped the grassland ecosystem in keeping with their own cultural values.

Around Junction City trees became scarce, and Sternberg understood why. He astutely labeled American Indian peoples' grassland management practices as "heroic farming," and his insights about this style of "farming" are worth quoting at length.

The wild game of the country is his crop. Autumnal fires were his reapers, to aid in collecting and harvesting. Much evil was done; also some good. Let us examine the matter a moment. Indian countries are *clean* countries. No muddy roads for want of men and vehicles to travel them. No underbrush or decayed logs and rubbish in their woods, for the annual fires clean up everything, leaving but the greenest trees with thick bark. No dilapidated tenements; for the buildings seldom get old enough to rot. No tumbled down fences to mark the ownership of farms; for a purely Indian country is not worth owning. This style of farming is exhaustive and destructive tending to sterility where sterility is possible.

Yet, though he exhausts the surface and banishes the rains, the Indian does not exhaust the soil below the surface, for he does not stir it. And in destroying everything and feeding nothing, he invariably delivers his country into the hands of white men, free from those noxious insects, which prey upon the grains and fruits of civilized culture.[51]

Copley and Bell had made similar observations three years before. Copley's own investigations and his discussions with others on the matter led him to the conclusion that only the "annual fires that sweep through the dry grass" had prevented the region from being fully wooded.

As Gardner approached Salina, the effects of railroad building on the land showed only in their infancy. Gardner caught something highly significant in a photograph taken at a small settlement called Abilene, twenty miles to the east of Salina (see photograph 43A). Hardly more than a hotel and a few roughly built structures, Abilene also contained a stockyard and livestock cars waiting to load cattle driven from Texas for the great urban markets of the industrial Midwest and eastern seaboard. Joseph McCoy had invested over $30,000 (when an average yearly income in the United States hovered between $300 and $500) in building the stockyard, hotel, and loading pens and in advertising the advantages to Texas cattlemen of shipping their beeves out of Abilene on the UPED line.[52]

McCoy's and the UPED directors' development of the Texas cattle trade provides an additional excellent example of how Euro-American cultural and economic values transformed a wild grassland into a thoroughly domesticated one. The Chisholm Trail, a region encompassing the grasslands from central Texas north to central Kansas, should be more readily understood as a transitional ecosystem itself rather than simply as a pathway for Texas cattle herds. As an ecosystem, or a dynamic community of life forms and physical forces, the Chisholm Trail was ephemeral, bridging a previous ecosystem that had been largely shaped by the presence of American Indian peoples, and a later one formed when farmers dominated the landscape.

From 1860 to 1885, Texas drovers endeavored to control the water and solar energy sources of the Chisholm Trail in culturally shaped pursuits. In doing so they altered the dynamic properties of the Chisholm Trail environment. These changes remade not only the plants, animals, and water resources of the trail but also the culture and lives of the people who occupied the region.

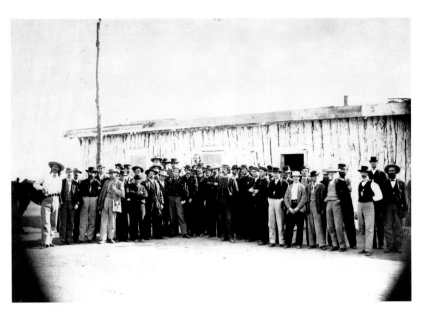

Figure 5. Group at Fort Harker. This Gardner photograph is akin to his journalistic format. The striking figure in the far left-hand frame is William Butler Hickok, or as otherwise known, "Wild Bill." The officer in uniform standing in the middle is most likely Col. Henry Inman, the quartermaster at the post. See also Joseph G. Rosa, The West of Wild Bill Hickok (Norman: University of Oklahoma Press, 1982). Photograph by Alexander Gardner, courtesy J. Paul Getty Museum, Los Angeles, CA.

As farmers took hold of the Chisholm Trail environment by the early 1870s, they constructed an entirely new biome, one conducive neither to open-range cattle operations nor to American Indian hunting practices. The long-standing biomes of American Indian peoples, prairie grasses, and animals disappeared. The grassland biome, necessary to Texas drovers, gave way to agricultural biomes that displaced the wild grasslands altogether. For both American Indians and Texas drovers the results were the same: they could not maintain their material cultures.[53]

More than an American Indian–managed landscape had to give way before the Union Pacific Railway Company, Eastern Division, could operate; backers of the UPED line wanted American Indian peoples removed from their way, and the state readily performed this task. At the time that Gardner took his photograph of the Seventh Cavalry at Fort Harker in the fall of 1867 (see photograph 53A), General Hancock was already engaged in displacing American Indians in the western portion of Kansas in order to make way for the rails. According to Hancock's worldview, rails represented the advance of civilization, while American Indians represented an unproductive wilderness.

The bison was as doomed as were the Southern Cheyennes who attempted to remain on the plains. Copley gave voice to a common Euro-American assumption when he claimed that bison "cannot be domesticated, nor the Indian civilized, so they are apparently alike devoted to extermination."[54] Similarly, General Hancock boasted to his assembled guests at the fort in June 1867 that it was "a privilege to be able to welcome you here to the confines of the land of the buffalo and the wild Indian. It has been but a few days since that the buffalo were right here in sight of the post. This may never occur again. It has been but a year or so that a careless soldier was scalped by Indians on the bank of the little stream where you camped last night. This will never occur again. This great railroad brings civilization with it. It has brought civilization here."[55]

Beyond Fort Harker lay the still largely wild shortgrass domain of the Great Plains, which stood in contrast to the region around Lawrence that showed the marks of the grid system. For more than two hundred years, American Indians had engaged in market activities with Euro-Americans that had left physical marks in the grasslands and on their own communities. Still, American Indians harvested wild animals, and wild animals flourished so long as wild grass species flourished. As already pointed out, American Indians managed these animals and plants to their own advantage even if bison and buffalo grass remained wild. The advancing shock waves of the railroad foretold the arrival of something that would transform the grasslands, enabling them to support

domesticated cattle and other farm animals along with tame grasses such as rye, oats, barely, corn, and, above all, scores of varieties of wheat. Although Gardner's photographs of this part of the state show some of the last remnants of the short-grass plains, he intended to illustrate something other than the magnificence of unfenced grassland. Rather, his earlier photographs depicted what was to come, and they depicted how this landscape would soon take on the appearance of the domesticated, gridded landscape then taking form around Lawrence, Kansas.

As Copley observed the scene:

> So far as I saw, the buffalo grass region, or the "plains," as this portion of our continent has long been called, is a beautiful and cheerful-looking country—gently undulating, and here and there presenting hills or buttes that partake of the character of ruggedness. In some places, distant from watercourses, it looks like the ocean, and like the sea, it has its wrecks; for look over it when and where you will, you see the stark remains of its monarchs, the buffaloes, bleaching in the sun and wind. Waste and desolate as it appears to the weary traveler in its natural condition, *it only awaits the hand of enlightened industry and taste to make it beautiful and home-like*—more beautiful than Illinois, for it is not so monotonous.[56]

Copley's words undeniably envisioned a Great Plains short-grass biome that an advancing railroad would rapidly transform into a "beautiful and home-like" environment. Gardner's photographs visually attest to the same understanding of railroad building as was held by its proponents.

In June 1867, Senator Yates perfectly summarized how railroads served as the harbinger of the American empire. He said:

> I will venture the assertion that there is no portion of the earth, where, during the present decade, the triumphs of peaceful industry, and the advance of improvement and material progress will be more visible and marked, then in this heaven-favored region west of the Mississippi river. If "the lines ever fell to a people in pleasant places," they have fallen to these people out on the western plains, who occupy these grand outposts of settlement in the progress of civilization and Christianity, and in the triumphal march of the star of empire on its western way.[57]

As we have seen, the Union Pacific Railway Company, Eastern Division, served as the spearheading agent of this empire. In its tow were powerful urban, cultural, and economic forces that spread across the grasslands to shape entirely new ecosystems. The grasslands reacted to and were transformed by this railroad that subsumed the resources of the region into a powerful Eastern trans-Atlantic urban economic system. By 2000, the Euro-American–managed landscape of domesticated grasses (especially brome, wheat, and corn) and domesticated animals (especially cattle, hogs, and sheep) showed little, if any, trace of the formerly American Indian–managed landscape of buffalo grass and bison. The 1867 photographs by Gardner and the rephotographs taken by Charlton in 1996 provide stark testimony to this transformation.

In the photographic pairings that follow, John R. Charlton's photographs reveal the American empire as it now exists. Not everything occurred as President Perry anticipated for the UPED line. Not every town along the line would flourish, and not every American farmer or rancher made good at attempting to transform a "wilderness" into a marketable cornucopia. Still, as Charlton's photographs attest, much of what Gardner's photographs and the promoters of the railroad foretold came to pass.

Map 1. St. Louis, Missouri (1873)

IMPERIAL PHOTOGRAPHIC PAIRINGS

Kansas on the Edge

Most of the Gardner photographs that follow in this section depict an area of Kansas that bears the marks of those people who inhabited the area prior to when Kansas became a state in 1861. Shown are roads surveyed and graded by the U.S. soldiers stationed at Fort Leavenworth. The towns of Leavenworth and Kansas City, Missouri, initially served soldiers, overlanders, Santa Fe traders, and fur traders. Beginning in the 1830s, the federal government removed several American Indian nations to what would become the state of Kansas. Many had taken up American-style farming techniques and had prospered fairly well before being driven out of the state to meet the needs of railroad building.

At first glance, Charlton's rephotographs of Gardner's images reveal a similar landscape. But a closer look soon demonstrates the effects of automobile transportation, and rapid urbanization in the eastern part of the state shows a landscape dramatically transformed by a culture of consumerism.

1A. Levee, St. Louis, Missouri (1867)

In this print, Gardner captures the river-borne commercial bustle and hustle of St. Louis. It was scenes like this that led William Bell to exclaim that St. Louis was "perfect as a picture of American progress."[1] Soon, railroads would eclipse the transportation role of steam riverboats on the Mississippi. Nonetheless, river traffic had made St. Louis the third largest city in the nation at the time. Stacked burlap packets of grain, stone rubble, timber, and barrels of goods are shown being loaded and unloaded on the St. Louis & Quincy Packet Landing on boats lined up along the levee below downtown St. Louis. The landing was near the old St. Louis courthouse in the center of the city. The steamboat *Arabian* is on the river beyond the landing.

Photograph by Alexander Gardner (1867)
Photograph courtesy J. Paul Getty Museum
Los Angeles, CA
Albumen silver print
13 × 18¹¹/₁₆ in. Mount: 18¹⁵/₁₆ × 24¹/₁₆ in.

1B. Levee, St. Louis, Missouri (1994)

This 1994 photo shows riverboats along the west riverbank, although most are permanently docked as floating casinos. The levee, recently a tourist destination in the central city near the courthouse and the St. Louis Arch, caters to gamblers and visitors buying hamburgers at an ever-present McDonald's restaurant. Opened in 1874, Eads Bridge, the first steel rail bridge constructed across the Mississippi River, is shown upstream and still bears light rail traffic across the river. A casino boat is on the East St. Louis bank near that end of the bridge. Since this photo was taken, the parked–casino-boat industry has moved to other locations. Steamboat traffic still goes up and down the Mississippi River, but the boats are hauling tourists rather than commodities. Commodity traffic still continues on the river.

Photograph by John R. Charlton (1994)

2A. Office of the Union Pacific Railroad Company, St. Louis, Missouri (1867)

John Perry, president of the Union Pacific Railway Company, Eastern Division (UPED), conducted the business at this Fifth and Clark Street location in downtown St. Louis just west of the Second Presbyterian Church (Fourth and Walnut Streets), seen in the background. The two- and three-story brick buildings were typical in the commercial district of the city, where prior to this several fires had destroyed earlier wooden-framed and wooden-clad structures. The bare trees along the streets indicate that Gardner probably made this photo for the company in late winter after his return from surveying the West Coast. It was likely a warm late winter day given the dress of the boys on the office steps and the open windows on the top floor of the building.

Photograph by Alexander Gardner (1867)
Photograph courtesy J. Paul Getty Museum
Los Angeles, CA
Albumen silver print
12³⁄₄ × 18¹⁄₁₆ in. Mount: 19 × 24¹⁄₁₆ in.

2B. Office of the Union Pacific Railroad Company, St. Louis, Missouri (1994)

This 1994 photo includes the downtown Busch Stadium and nearby Marriott Hotel complex. The business of railroading has now given way to tourism and professional baseball games in this district of the city. The stadium, home of the St. Louis Cardinals, has since been expanded, replacing the original midcentury-modern style with a postmodern style.

Photograph by John R. Charlton (1994)

3A. Depot, St. Louis, Missouri (1868)

Gardner's photograph shows the UPED depot located south of the company offices at Seventh and Poplar Streets in downtown St. Louis. Prior to obtaining control of the Union Pacific Railway Company, Easter Division, financier John D. Perry directed the Pacific Railroad, a St. Louis, Missouri, company that Congress in 1862 had authorized to connect with what would later become the UPED line on the eastern fringe of Kansas. In February 1864, Samuel Hallett, then the under-siege director of the Union Pacific Railway Company, Easter Division, brought Perry into the company to solidify his control of it. Upon Hallett's murder by a disgruntled employee on July 27, 1864, Perry gained complete control of the Union Pacific Railway Company, Easter Division, though by 1867 he still had not changed the Pacific Railroad lettering on the depot to read "UPED." The ticket office and passenger waiting area are in the foreground. The freight depot is below, and large warehouse buildings are beyond it. The people in front of the depot seem to be posing for Gardner's photograph. This depot formed a new matrix of commercial and industrial traffic in the city. The trains carried passengers and freight west and east, eventually surpassing the north-south commerce on the river after the Eads Bridge connected East St. Louis, Illinois, with St. Louis, Missouri.

Photograph by Alexander Gardner (1867)
Photograph courtesy J. Paul Getty Museum
Los Angeles, CA
Albumen silver print
13$\frac{1}{8}$ × 18$\frac{5}{8}$ in. Mount: 19$\frac{3}{16}$ × 23$\frac{15}{16}$ in.

3B. Depot, St. Louis, Missouri (1994)

In 1994, the downtown Union Pacific depot was several blocks west of the old depot, which had been located in what later became the parking lot south of nearby Busch Stadium, both the old one and the current one. Concrete covers the old tracks in this view. The Choctaw Highway overpasses the lot to cross the city and the river. A fleet of city school buses are parked on the other side of the stadium city lot, and the Purina processing plant stands beyond the parking lot to the south.

Photograph by John R. Charlton (1994)

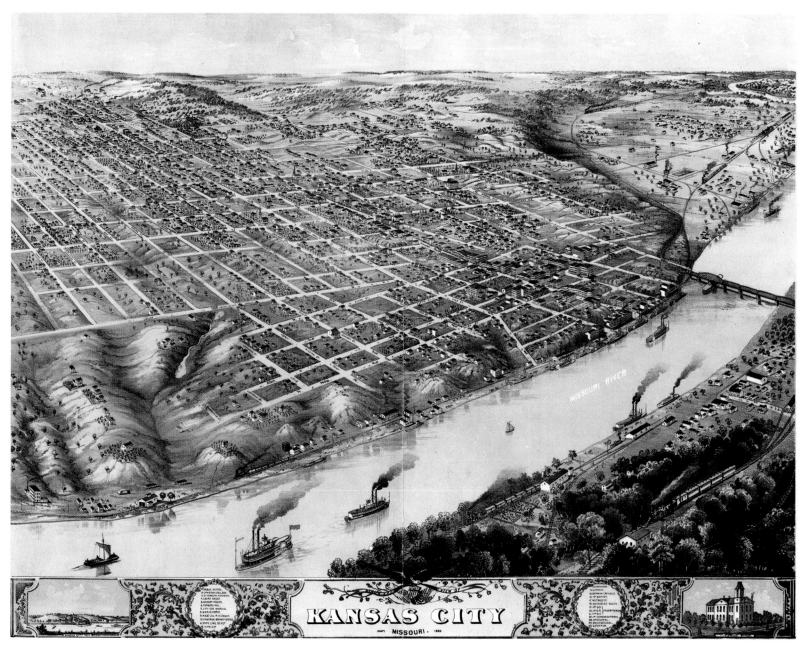

Map 2. Kansas City, Missouri (1869)

4A. Kansas City, Missouri (1867)

Gardner photographed downtown looking north from the bluffs above the Missouri River and the Missouri Pacific depot after arriving there by train from St. Louis. Most of the downtown buildings were one- and two-story clapboard businesses selling dry goods and lumber to settlers arriving by train going west. In the years before, this departure would have been at Westport Landing for the Santa Fe Trail. In 1867, the Hannibal and St. Joseph Railroad Company hired Octave Chanute, an acclaimed engineer, to design and build a bridge spanning the Missouri River. Upon its dedication in 1869, this bridge served to connect the UPED line to at least six other railroad lines, including the Missouri Pacific, that were headed to eastern cities. Ladder bridges served as sidewalks across gullies carved into the loess bluffs. Most trees were cut, leaving large stumps in their place. The slope on the right shows the rooftops and chimneys of a new mansion overlooking the river and located on Main Street, downtown Kansas City, Missouri.

Photograph by Alexander Gardner (1867)
Photograph courtesy J. Paul Getty Museum
Los Angeles, CA
Albumen silver print
$12^{13}/_{16} \times 18^{11}/_{16}$ in. Mount: $19 \times 24^{1}/_{16}$ in.

4B. Kansas City, Missouri (1994)

Today downtown is on bluffs overlooking the River Market and Hannibal Street Bridge to the north. The new, elevated vantage point from the sixth floor of a parking garage permits a view of the north bluffs of the Missouri River. At the north end of Main Street is a bridge over Interstate 70 leading to the warehouse district, now gentrified with bars, restaurants, galleries, the Steamboat *Arabia* Museum, and a farmer's market. The steamboat *Arabia* was not the one photographed by Gardner along the St. Louis levee. This *Arabia* sank in 1856 and was discovered buried in a field near Parkville, Missouri. Its artifacts are a testament to trans-Missouri trade prior to railroad construction through the same region, which began with the UPED and Union Pacific lines to the north.

Photograph by John R. Charlton (1994)

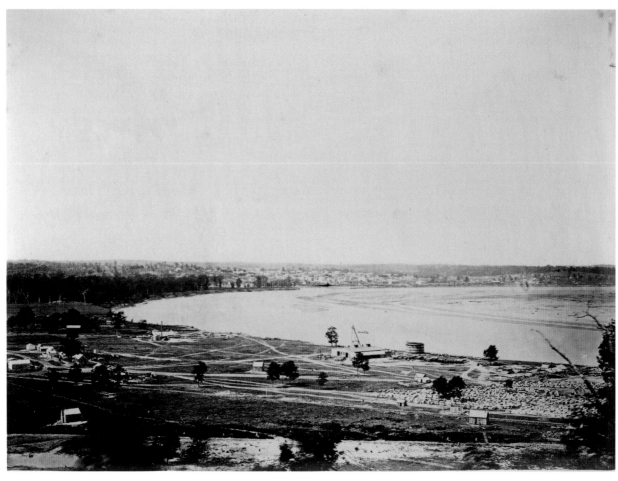

5A. Great Bend of the Missouri River (1867)

This view from the bluffs looks west, over the west bottoms flood-plain and the great bend of the Missouri River, which flows south to merge with the north-flowing Kansas (Kaw) River.[2] The rivers then merge and continue flowing east toward the Mississippi River at St. Louis. The city of Wyandotte, Kansas, lies on the west bank of the confluence and bend of both rivers in the distance. New features of industrial development can be seen below in the west bottoms. The Missouri Pacific line is at the base of the bluffs connecting the Kansas City, Missouri, depot along the river with the new Union Pacific depot at State Line in the west bottoms.

Photograph by Alexander Gardner (1867)
Photograph courtesy DeGolyer Library
Southern Methodist University
Dallas, TX
Ag1982.0214

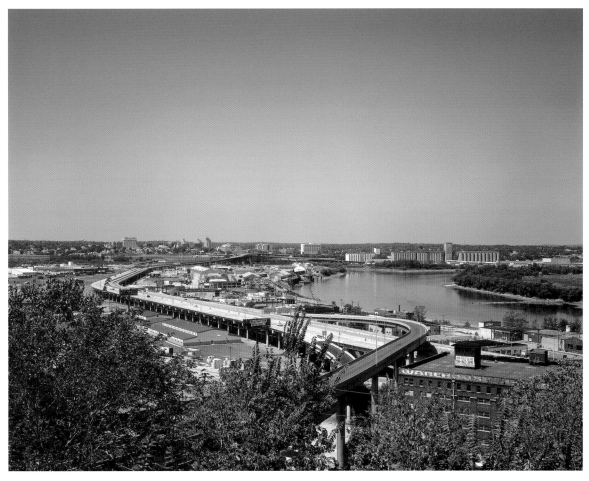

5B. Great Bend of the Missouri River (1993)

The modern view here is a vast infrastructure of highways, streets, warehouses, railroads, traffic, and Interstate 70, which connects Missouri and Kansas. After numerous historical floods, especially the devastating one of 1951, both rivers have been constrained by levees that narrowly saved the west bottoms from flooding the year this photograph was taken. North of the Missouri River is the city's old municipal airport, which stands behind the trees along the bank. The extended confluence point of the Kansas River merging with the Missouri River is seen in the middle of the frame with industrial storage tanks and buildings on it. Strawberry Hill and tall business and civic buildings, including the federal courthouse, can be seen in present-day Kansas City, Kansas. In the middle right-hand portion of the frame are grain elevators along the railroad and the Missouri River.

Photograph by John R. Charlton (1993)

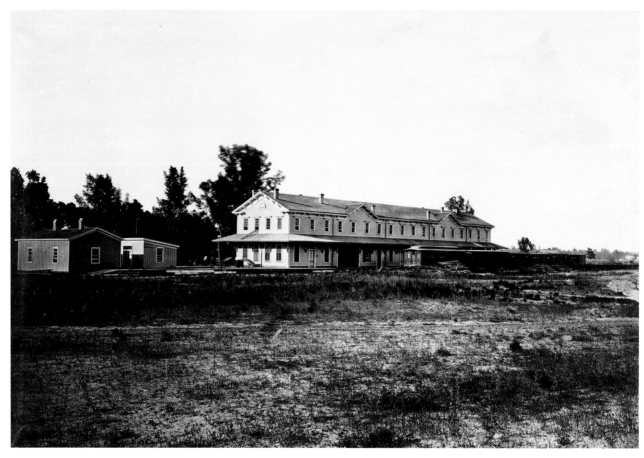

6A. State Line Hotel, Kansas (1867)

This was the new hotel/depot at the state line in the west bottoms below the high bluffs of Kansas City, Missouri, on the east side of the Kansas River. Clapboards are piled alongside UPED cars parked next to the depot. This location marked where the Missouri Pacific from the east connected with the westward-headed Union Pacific. The new railroad bridge over the Kaw linked this depot with the Wyandotte depot across the river and also with the older Missouri Pacific line located along the west side of the Missouri River to Leavenworth. Gardner photographed important travelers, such as UPED guest railroad commissioners, while they awaited trains. Less well-connected travelers, like immigrant families, often camped at nearby west bottom alternatives like the less elegant Hotel de Dutton (see photograph SS12). The foreground looks like scoured floodplain, and the depot foundation seems slightly raised from the ground.

Photograph by Alexander Gardner (1867)
Photograph courtesy J. Paul Getty Museum
Los Angeles, CA
Albumen silver print
12⁹/₁₆ × 18⁵/₈ in. Mount: 19¹/₁₆ × 24¹/₁₆ in.

6B. State Line Hotel, Kansas (1993)

The location now is a large warehouse district in a railroad hub in the west bottoms. Trains pass by but rarely stop for people or freight. Highway traffic moves on its overhead infrastructure. While the bottoms are now protected from flooding, the rivers came within inches of breaching the levees during floods in the summer of 1993. For years the area was the terminal of the Kansas City livestock shipping and meat-processing plants. Now it is near the former Kansas Commodities exchange and the old American Royal arena.

Photograph by John R. Charlton (1993)

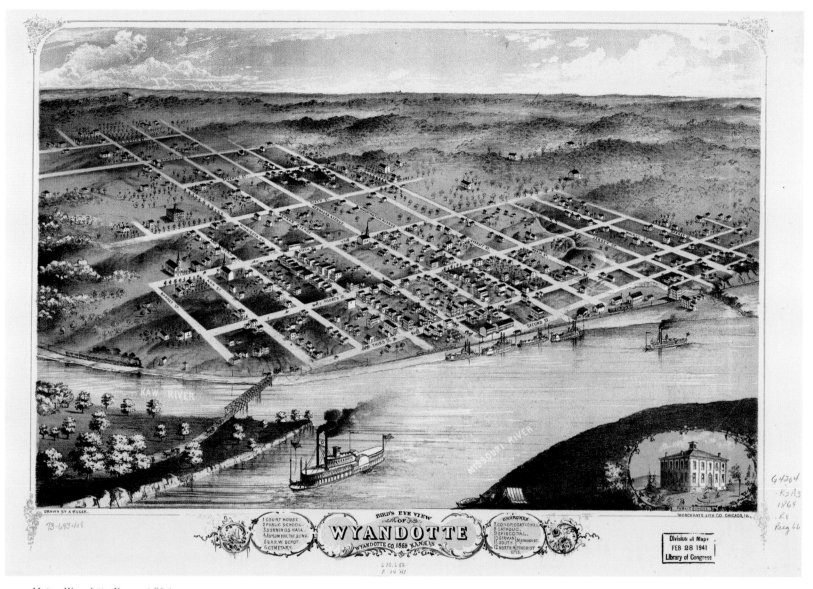

Map 3. Wyandotte, Kansas (1869)

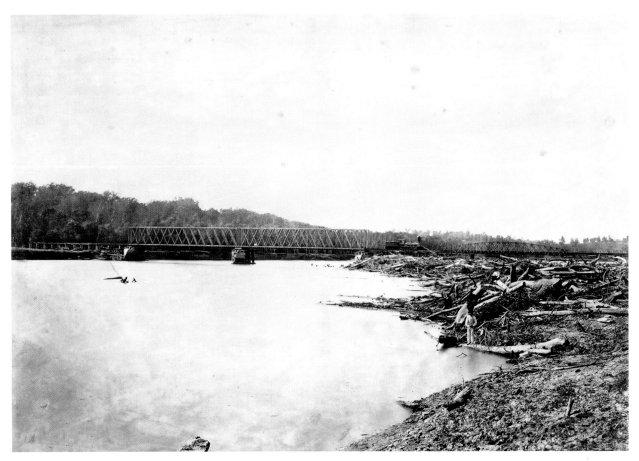

7A. Railroad Bridge across the Kaw at Wyandotte, Kansas (1867)

A view from upstream on the east bank of the Kaw shows the first railroad bridge, which has an engine and cars on it. The train is headed back to the State Line Hotel from Wyandotte across the Kansas River. It may be coming to take Gardner and his photographic equipment, assistants, and the railroad commissioners back across the river to the UPED depot and offices in Wyandotte. The banks on the right are covered with debris deposited from the previous summer flood of 1867. Immigrants from the Hotel de Dutton are fishing in the Kaw from the shoreline debris. Across the river is tall riparian tree growth lining the riverbank.

Photograph by Alexander Gardner (1867)
Photograph courtesy J. Paul Getty Museum
Los Angeles, CA
Albumen silver print
13 × 18³⁄₄ in. Mount: 18¹⁵⁄₁₆ × 24¹⁄₁₆ in.

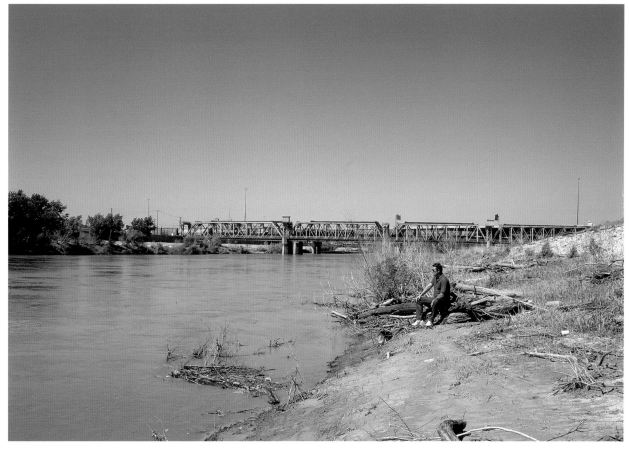

7B. Railroad Bridge across the Kaw at Wyandotte, Kansas (1993)

There is also a Union Pacific train on the bridge in this photograph, although there is no longer a State Line Hotel. The riverbanks are scoured by the recent 1993 flood, which also left behind debris as the flood waters receded. Some trees still line the west bank of the river and riprap covers the east bank, protecting the west bottoms from flooding. There are several highway bridges below the railroad bridge and the mouth of the Kaw River. In the foreground, Kansas Geological Survey geologist James McCauley contemplates the streaming waters of the Kaw.

Photograph by John R. Charlton (1993)

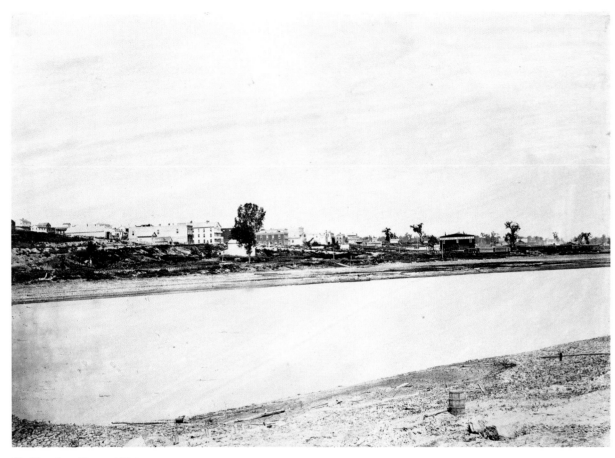

8A. Wyandotte, Kansas (1867)

Wyandotte was photographed here from the east end of the turnpike bridge over the Kaw River just upstream from the confluence with the Missouri River. The town was platted as a grid with a large new building descending the slope to the railroad bank. The UPED depot, company office, rail yard, and shops are on the west bank to the right by the train. Previous flooding had scoured both banks and trees. This was also the site of the murder of UPED company president Samuel Hallett in July 1864. His death brought railroad construction to a halt just east of Lawrence until John D. Perry bought out Hallett's widow and resumed the UPED competition with the Omaha line to become the first transcontinental railroad. From Wyandotte Gardner rode the Missouri Pacific line north to Leavenworth, Kansas, and the U.S. garrison stationed at the fort there.

Photograph by Alexander Gardner (1867)
Photograph courtesy J. Paul Getty Museum
Los Angeles, CA
Albumen silver print
$12^{15}/_{16} \times 18^{11}/_{16}$ in. Mount: $19 \times 24^{1}/_{16}$ in.

8B. Wyandotte, Kansas (1993)

The contemporary view here was made from a condemned bridge below the Lewis and Clark Viaduct. The highway and railroad bridges span the Kaw and go over the original depot and yards sites, now occupied by the grain elevators. A UP train can be seen starting across the railroad bridge to the right. The river is narrower and deeper here now, and the tracks are elevated on the levee for protection from floods. There is a wreck of a tourist steamboat by the bank to the right of the railroad bridge, the result of a collision during the flood that summer. The railroad is still busy in Wyandotte with lines going west along the Kansas River and north along the Missouri River.

Photograph by John R. Charlton (1993)

9A. Confluence of the Kaw and Missouri Rivers at Wyandotte, Kansas (1867)

The view looks east, across the Kaw point confluence and toward Kansas City, Missouri, which lies on the bluffs overlooking the Great Bend of the Missouri River. Some downtown buildings are visible. The UPED line is in the foreground with stacked crossties destined for track construction across the Plains. A footbridge crosses a loess gully above the engine, which rests on a track bridge. The engineer and other crew pose on the parked train for Gardner. Kaw Point was also known as Lewis and Clark Point, an expedition campsite. The tree-covered point marked the confluence of the two rivers, at right-center in the view. A wide floodplain extends from the Missouri River north bank at the bend, defining the river channel at low-flow levels.

Photograph by Alexander Gardner (1867)
Photograph courtesy J. Paul Getty Museum
Los Angeles, CA
Albumen silver print
12^{11}/$_{16}$ × 18^{11}/$_{16}$ in. Mount: 19 × 24 in.

9B. Confluence of the Kaw and Missouri Rivers at Wyandotte, Kansas (1993)

This 1993 view includes the various infrastructures crossing the rivers, including the Lewis and Clark Viaduct in the foreground. On the horizon is the downtown Kansas City skyline overlooking the Missouri River and the west bottoms. The roof of the Wyandotte Animal Shelter is in the left foreground. The confluence point, extended by the Army Corps of Engineers to create flood control, is now in the center of the view and is covered with industrial tanks. The municipal airport runways on the north bank are protected by tree-covered levees. The Union Pacific Railroad line below the viaduct now runs up the Kaw on the levee here. This is the busiest freight line in the state.

Photograph by John R. Charlton (1993)

10A. Turnpike Bridge across the Kaw River near Wyandotte, Kansas (1867)

This view upstream of the Kaw from the west bank of the confluence at Wyandotte includes the turnpike bridge that accommodated foot and horse-drawn traffic between the west bottoms and Wyandotte. This bridge and the railroad bridge upstream deliberately impeded steamboat traffic up the Kaw River. The wide-scoured floodplain below the west bank and the debris upstream on the east bank resulted from flooding in the Smoky Hill and Republican Rivers, which are the sources of the Kaw, during the summer of 1867. Farther upstream is piling construction for another new bridge over the Kaw.

Both riverbanks are lined with trees. Several horse-drawn carriages are crossing the turnpike bridge in Gardner's picture.

Photograph by Alexander Gardner (1867)
Photograph courtesy J. Paul Getty Museum
Los Angeles, CA
Albumen silver print
13 × 18^{11}/$_{16}$ in. Mount: 19^{1}/$_{16}$ × 24^{1}/$_{16}$ in.

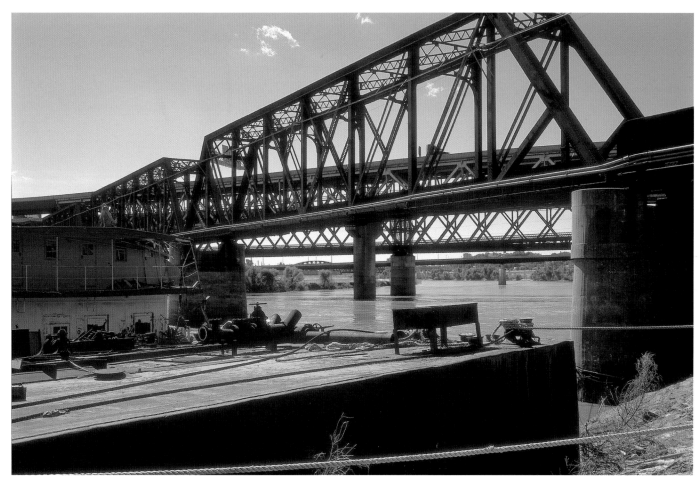

10B. Turnpike Bridge across the Kaw River near Wyandotte, Kansas (1993)

This 1993 view reveals a narrower, deeper channel constrained by tree-lined levees that protected the city from the flood that summer. The railroad bridge is in the foreground and the Lewis and Clark Viaduct is above it. Another highway bridge is farther up the river and the original railroad bridge location is beyond that. The moored facsimile steamship in the foreground, formerly used for river tours around the confluence area, was ripped from its mooring by the flood and rammed into one of the many bridges crossing the river. The ornamental smokestacks were sheared off, along with part of the pilot's cabin. At the time of this photograph, the river levels were still higher than normal.

Photograph by John R. Charlton (1993)

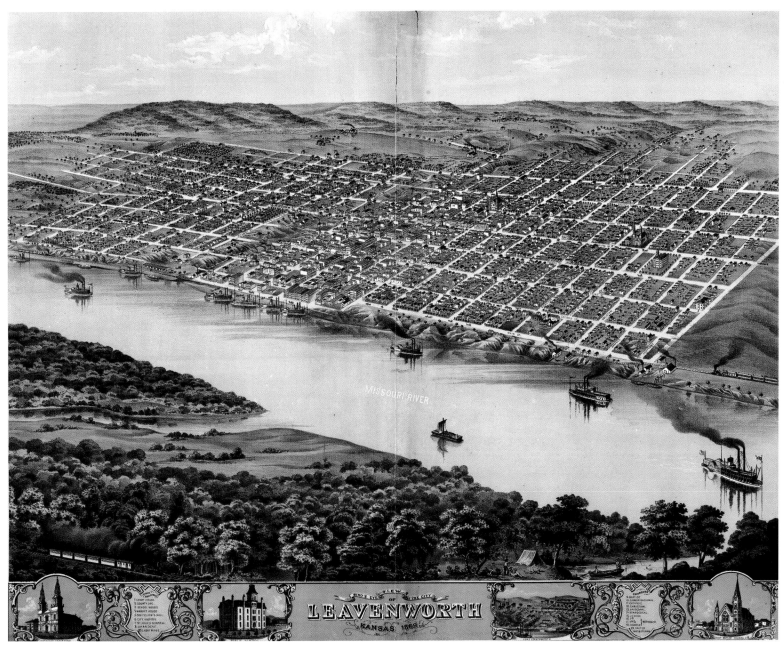

Map 4. Leavenworth, Kansas (1869)

11A. Fort Leavenworth, Kansas (1867)

When Gardner made his view overlooking the fort from the hills that shielded its west side, Fort Leavenworth was already the oldest U.S. military outpost west of the Missouri River. Beginning in 1827, the fort served as the base for a series of outposts guarding settler routes and the railroad construction across western Kansas. Pictured here are garrison buildings, including stables, barracks, officer's quarters, a hospital (in center frame), and parade grounds. The hillside vantage point also views the Missouri River Valley's far-side banks in the distance beyond the main fort grounds. In the floodplain below were farms for the fort on the old Kickapoo Indian reserve. Trees can be seen at the base of the hill around the fort perimeter, but the hillside itself is grassy and barren of trees. City buildings can be seen on the right, outside the perimeter of the post.

Photograph by Alexander Gardner (1867)
Photograph courtesy J. Paul Getty Museum
Los Angeles, CA
Albumen silver print
13 × 18^{11}/$_{16}$ in. Mount: 19 × 24 in.

11B. Fort Leavenworth, Kansas (1994)

The hills along Sheridan Drive still overlook the fort and many of the same brick buildings from Gardner's time—and newer ones as well. The post cemetery is at the base of the hill. Only a glimpse of the fort tower can now be seen through the high treetops that now cover the hillside. Horse trails and roads lead from the fort to the hilltop, which is used for military training. Besides trees, wild grasses and wildflowers cover the hillside. The east bank of the Missouri River can also be glimpsed through the trees.

Photograph by John R. Charlton (1999)

12A. Leavenworth, Kansas (1867)

This view of the city from the hillside west of town, Pilot Knob Ridge, was taken near the fence-lined Military Road that led west to Fort Riley. The highest buildings in the city, a new cathedral and a public schoolhouse, can be seen above the city in the distance and the wooded eastern Missouri riverbank in the far distance beyond. The road to the city is deeply rutted from heavy wagon traffic, including from Gardner's portable darkroom wagon.

Photograph by Alexander Gardner (1867)
Photograph courtesy J. Paul Getty Museum
Los Angeles, CA
Albumen silver print
$12^{15}/_{16} \times 18^{11}/_{16}$ in. Mount: $19 \times 24^{1}/_{16}$ in.

12B. Leavenworth, Kansas (1994)

The road from the town is now interposed by the buildings and grounds of the Leavenworth Federal Penitentiary, or "the big house." Still an active part of the federal penal system, it has incarcerated escaped slaves, warring American Indians, World War I captives, bootleggers, Mafioso, drug offenders, and terror suspects. A razor-wired ballpark and exercise field are now where the old road west of town ran. The Missouri Valley is clearer in the distance, and the view from the hillside is taken from next to the guarded penitentiary warden's residence, which overlooks the operations below.

Photograph by John R. Charlton (1994)

13A. View in Salt Creek Valley, Kansas (1867)

Gardner's photograph taken atop the hills to the west of the fort overlooks Salt Creek Valley to the west. The hilltops are bare of the trees that line the creek along the valley below. The fenced farms and a field of stacked cornstalks along the road bordering the creek show the outlines of the Euro-American grid system for defining property boundaries. This road had been the major thoroughfare westward from Leavenworth before the UPED branch line was built to Lawrence. Signage on the center building in the view advertises groceries, wine, liquor, and tobacco to travelers. This landscape is not dissimilar to eastern landscapes Gardner knew and photographed in the painterly style of most American and European photographers.

Photograph by Alexander Gardner (1867)
Photograph courtesy J. Paul Getty Museum
Los Angeles, CA
Albumen silver print
13 × 18¹¹/₁₆ in. Mount: 19 × 24¹/₁₆ in.

13B. View in Salt Creek Valley, Kansas (1995)

The gravel road in the new westward view from the hilltop now splits off from a state highway through a valley of relatively idyllic pastures and farms. Near the state highway some of the homesteads from Gardner's time still stand, but they now serve as bed-and-breakfast retreats. The hillside itself is partially cleared of trees for residences and commercial use. The hills in the distance are partially developed but still remain largely tree covered. Although much has changed in this natural and developed landscape, it is still one of the most picturesque settings from the Gardner series.

Photograph by John R. Charlton (1995)

14A. Moore's Summit, Kansas (1867)

Gardner's stereograph title here includes a "view embracing 12 miles of prairie from Moore's Summit, on the branch road between Lawrence and Leavenworth." It must have seemed like a summit to Gardner's assistants, his brother James and William Pywell, as they clambered uphill with the imperial camera and portable darkroom. This view seems to have impressed Gardner for the distance that could be seen from it. UPED builders planned this site for a future depot that was later built in the nearby town of Tonganoxie. The prairie is actually cultivated ripe cornfields. Gardner stopped here for pictures on the Leavenworth, Lawrence, Galveston branch line, which can be seen at the base of the mound.

Photograph by Alexander Gardner (1867)
Photograph courtesy J. Paul Getty Museum
Los Angeles, CA
Albumen silver print
$12^{15}/_{16} \times 18^{9}/_{16}$ in. Mount: $19 \times 24^{1}/_{16}$ in.

14B. Moore's Summit, Kansas (1994)

Viewed from an overgrown quarry site near present Jarbelo Hill, the scene below in this print reveals an area undergoing the transition from agricultural to rural housing subdivisions. A natural gas substation and a cell phone tower have replaced the Moore farmstead at the base of the hill. This area has become rapidly developed in recent years as areas of Kansas City, Leavenworth, and Lawrence triangulate it. The old branch line was removed in the 1970s. As in the 1867 view here, the old track line still runs through a cornfield. Native grasses and wildflowers flourish on the hillside above the tree line.

Photograph by John R. Charlton (1994)

15A. Indian Farm on the Delaware Reservation, Kansas (1867)

Gardner took this photograph while traveling on the main UPED line between Wyandotte and Lawrence, probably on the return trip. Perhaps Gardner took this photograph in the winter, as the bare trees indicate a time later than his late summer views. The federal government had encouraged members of the transplanted Delaware Indian nation living on its reserve along the north bank of the Kaw River to take up American-style farming methods. The outbuildings of this farm illustrate the extent to which some Delawares had acculturated. Across the road from the main barn, and in front of the cabin, is a fenced orchard. According to several historians, by questionable treaty negotiations the federal government moved the nation again to Indian Territory, present-day Oklahoma, to gain right-of-way for the UPED tracks.

Photograph by Alexander Gardner (1867)
Photograph courtesy J. Paul Getty Museum
Los Angeles, CA
Albumen silver print
$12^{15}/_{16} \times 18^{5}/_{8}$ in. Mount: $19 \times 24^{1}/_{16}$ in.

15B. Indian Farm on the Delaware Reservation, Kansas (1993)

This photograph, taken in the late fall, still provides nearly the same vista overlooking the Kansas River. A private drive now replaces the Delaware Indian farm road. The landscape includes signs of harvested cropland and mixed grass covered with riparian tree growth along the Kansas River below. If Gardner's photo were made in the fall, then most likely his brother, James, took it on his return trip east from western Kansas. James took several photographs on this leg of photographic expedition in order to fill in missing gaps. Gardner charged James with taking all of the Kansas plates back to the Washington, D.C., studio for printing and mounting while Gardner traveled on west with William Palmer's survey party along the 35th parallel.

Photograph by John R. Charlton (1993)

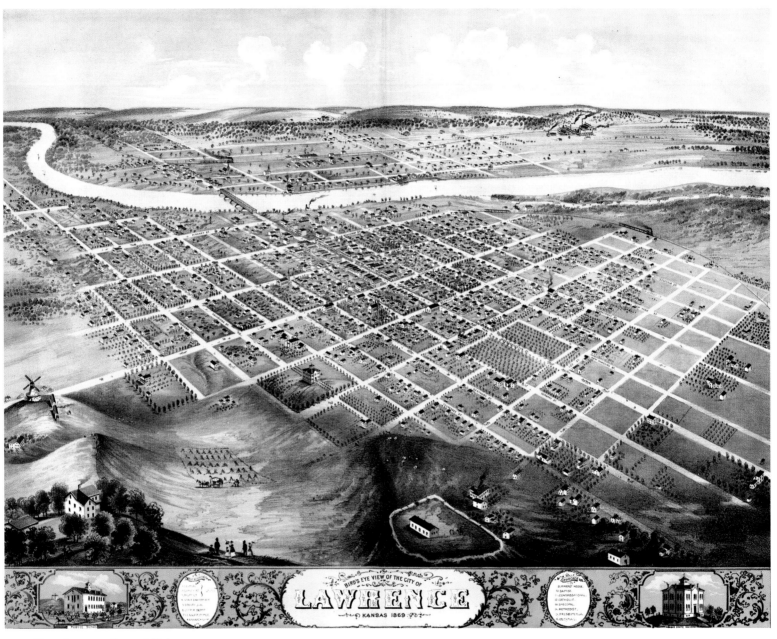

Map 5. *Lawrence, Kansas (1869)*

The "Free State" District

In this next section, Gardner's photographs are of that portion of the state where Euro-Americans had arrived after the federal government had formed Kansas as a territory in 1854. From 1854 to the beginning of the Civil War, many Americans labeled this part of the state "Bleeding Kansas" because of the violent conflict over whether or not Kansas would enter the Union as a free state, one devoid of slavery.

Free-Soilers and abolitionists largely built the towns of Lawrence, Topeka, and Manhattan. Their Northern and Midwestern institutions of government and education would leave enduring social and economic marks on these cities. Their notions of property ownership and landscape beauty would also change the open grasslands into gridded farmland and heavily treed cities, transformations of landscape displayed in Charlton's photographs.

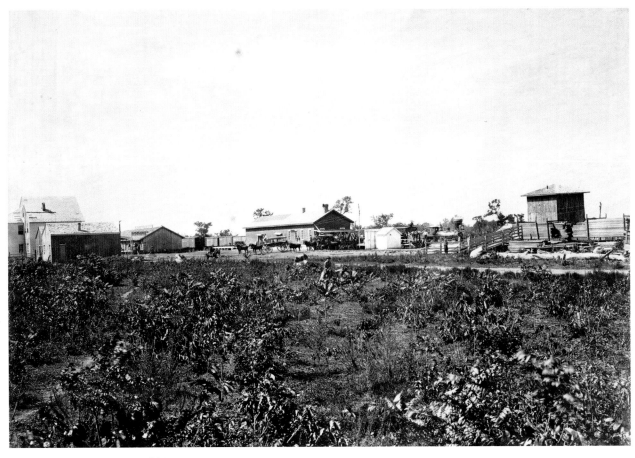

16A. Depot, Lawrence, Kansas (1867)

The UPED railroad ran north of the Kaw River where it had a stop at the Lawrence depot. The north bank of the river had been known as the City of Jefferson and had formerly been part of the Delaware Reserve. The railroad had rapidly made steamboat and wagon freighting commerce unprofitable. UPED freight cars regularly arrived and unloaded building materials and supplies for rebuilding the city after it was burned in Quantrill's Raid in August 1863. That raid took place just four years before Gardner arrived and took photographs there. Lumber is seen here on the south side of the depot and train. UPED cars also unloaded coal used for fuel, since early residents here had quickly depleted the little timber to be found, even along the river, for fuel and construction. A boy poses on a stump in the foreground for Gardner. Travelers and carriages are waiting at the depot, taking the train to and from the city.

Photograph by Alexander Gardner (1867)
Photograph courtesy J. Paul Getty Museum
Los Angeles, CA
Albumen silver print
13 × 18^{11}/$_{16}$ in. Mount: 19 × 24^{1}/$_{16}$ in.

16B. Depot, Lawrence, Kansas (1995)

There is no train depot here now, although some old commercial and warehouse buildings still remain across Locust Street. Much of North Lawrence is still semirural residential, but new suburbs and commerce have recently begun changing the area. The depot, built in the classic Union Pacific style, including a tall steeple, was relocated two blocks west from here. The city restored it, and the depot now houses the Lawrence Visitors' Center. Union Pacific trains still pass by frequently, but they have not stopped at Lawrence for several decades now.

Photograph by John R. Charlton (1995)

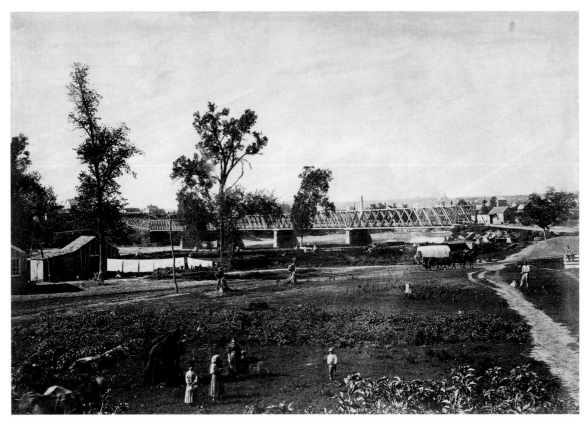

17A. Turnpike Bridge at Lawrence, Kansas (1867)

This is a view from the north bank of the Kaw River looking south-west at the turnpike bridge at the northern end of the city. The foreground, along the north bank, includes an interesting assortment of local people posing for Gardner. They include the boy photographed in the depot scene. He is perched on another tree stump along with a friend. Women and children posed in a gardened area in the foreground near Gardner's portable darkroom with the draped outline of one of his assistants preparing a glass negative of another plate shot here. A mule is blurredly visible in the left corner. Several African American women are hanging laundry out to dry by a washhouse on the left. On the right, a man holds his rifle beside a covered wagon just below the bridge. On top of the bridge entry

stand other boys posed in the distance. There is an air of occasion and welcome for Gardner's camera. Indeed, the *Lawrence Tribune* had announced Gardner's arrival that day (September 21, 1867) and urged the citizens to welcome the visitor and present the city at its best for him. Gardner made more photographs in Lawrence than in any other place in his series across the continent.

Photograph by Alexander Gardner (1867)
Photograph courtesy J. Paul Getty Museum
Los Angeles, CA
Albumen silver print
12^{15}/$_{16}$ × 18^{11}/$_{16}$ in. Mount: 19 × 24^{1}/$_{16}$ in.

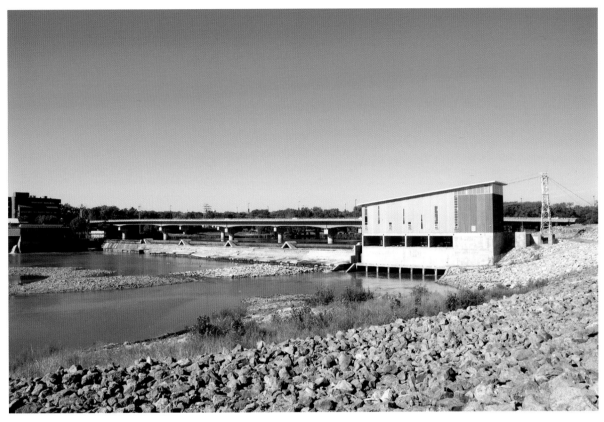

17B. Turnpike Bridge at Lawrence, Kansas (2013)

The Kansas River has flooded and destroyed at least two bridges at Lawrence since Gardner made his photograph here. The contemporary bridge is high enough to have withstood the most recent flood of 1993. North Lawrence was also spared due to the high levee above Gardner's vantage point here. Even the river is higher behind the Bowersock Dam, originally built a few years after Gardner's picture. It is even higher behind the inflatable new dam top built to control flow levels for the Bowersock North Powerhouse. Besides a few smaller turbines on the south bank, this is the only hydroelectric power in the State. This photograph was retaken on the 146th anniversary of Gardner's trip here, on September 21, 2013.

Photograph by John R. Charlton (2013)

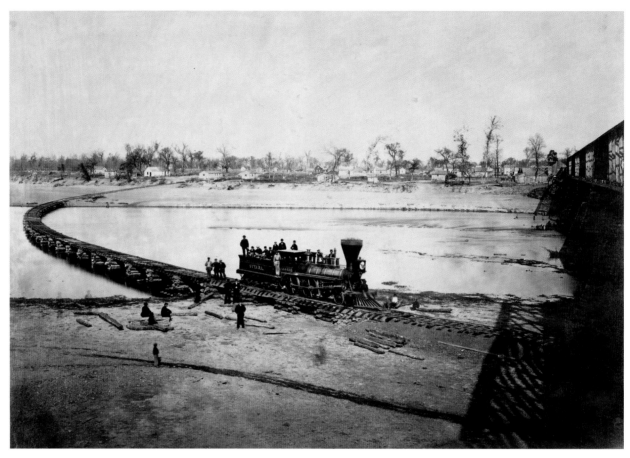

18A. Leavenworth, Lawrence, and Galveston Railroad Bridge across the Kaw River at Lawrence (1868)

Gardner made several views on both sides of the bridge at Lawrence, including this view of the temporary pontoon railroad bridge from the south bank just upstream from the turnpike bridge, which is visible on the right side of the large-format view. The pontoon bridge is not seen in the September picture, however, because it was not completed until later that fall. As the bare trees on the north flood bank indicate, either Gardner's brother, James, took this photograph in the fall of 1867, or Alexander did later during his return trip to Washington in the winter of 1868.

Photograph by Alexander Gardner (1867)
Photograph courtesy J. Paul Getty Museum
Los Angeles, CA
Albumen silver print
13 × 18^{11}/16 in. Mount: 19 × 24 in.

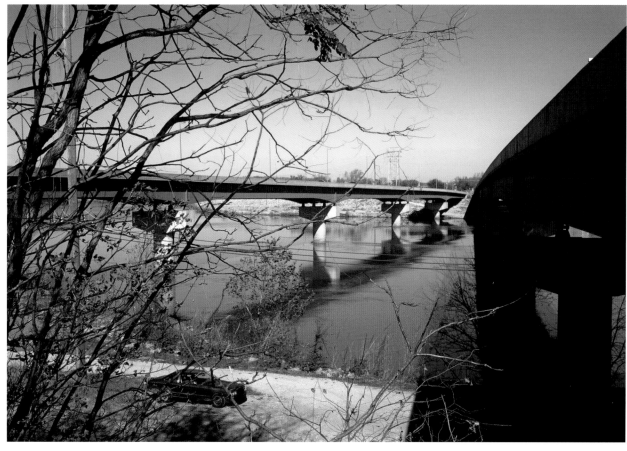

18B. Leavenworth, Lawrence, and Galveston Railroad Bridge across the Kaw River at Lawrence (1993)

The vantage point is now just upstream from the northbound bridge with the southbound bridge crossing the river. Below it and beyond one can see the north bank levee, which now obscures the buildings and trees in North Lawrence. The foreground southern embankment has been the line for the Atchison, Topeka & Santa Fe (now BDSF) railroad since the 1870s. The Bowersock Dam impounds the river for powering the small hydroelectric turbines housed in the mill building. This facility generated the only hydro power in Kansas before the recent completion of the plant on the north bank of the river. This view was made in early winter.

Photograph by John R. Charlton (1993)

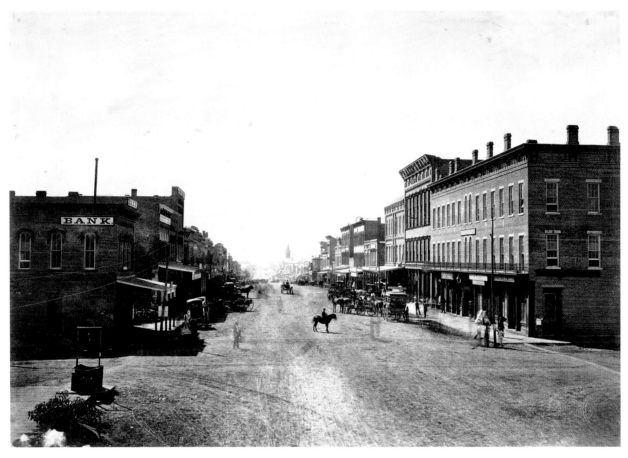

19A. Massachusetts Street, Lawrence, Kansas (1867)

This was a well-known place in Kansas due to the border wars and Quantrill's Raid. The townsfolk wanted Gardner's picture to advertise how quickly they had raised their city from the ashes of Quantrill's Raid. The Eldridge House at the right stood as a shining example of their progress. Virtually the entire population of the city lined the entire length of Massachusetts Street for Gardner's pictures. He took several views with numerous groupings of people, wagons, and livestock milling around in the foreground. Some people appear ghostlike, the result of their moving during the long time it took Gardner to expose a glass plate. The Eldridge House and many more downtown buildings were built with brick and thick fire-walls. Many, including the Miller Building just south of the Eldridge, still stand, housing businesses downstairs and apartments upstairs.

Photograph by Alexander Gardner (1867)
Photograph courtesy J. Paul Getty Museum
Los Angeles, CA
Albumen silver prints
$12^{15}/_{16} \times 18^{11}/_{16}$ in. Mount: $19 \times 24^{1}/_{16}$ in.

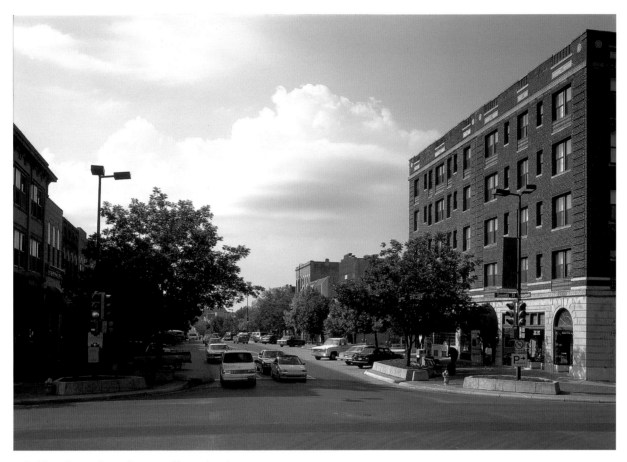

19B. Massachusetts Street, Lawrence, Kansas (1993)

The Miller Building can still be seen on the west side of Massachusetts Street a few doors down the block from the latest incarnation of the Eldridge Hotel on the corner of Seventh and Massachusetts Streets. Other buildings along both sides of the street have had facades over them for decades. More recently, some of these facades have been removed to reveal original building fronts from all periods of downtown Lawrence history. Although many new commercial areas have developed around the city, downtown Lawrence is still the main commercial and cultural center for tourists and city residents.

Photograph by John R. Charlton (1993)

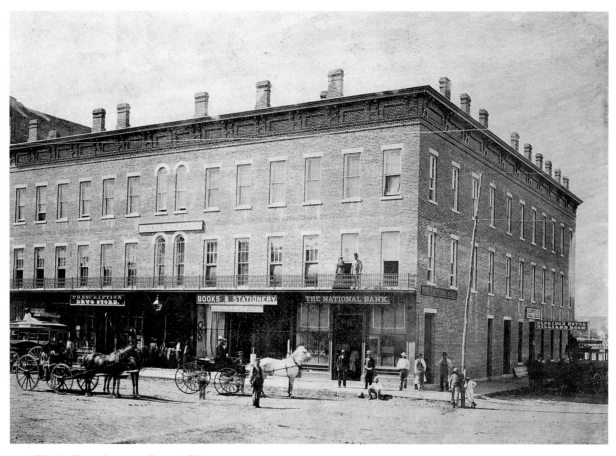

20A. Eldridge House, Lawrence, Kansas (1867)

The Eldridge House, new in Gardner's time, has horse-drawn carriages in front on Massachusetts Street that take its patrons to and from the railroad depot across the bridge and over the Kaw River. The hotel was constructed of handmade brick and housed the Western Union Telegraph office as well as the UPED land office, a local bank, and retail businesses. A gentleman in a stovepipe hat and a young woman are posed on the second-floor balcony outside a corner suite for Gardner's picture. This is likely Kansas Gov. Samuel J. Crawford with Florence, his daughter. Governor Crawford was closely involved with the UPED efforts to construct the first transcontinental railroad. Most likely in attendance with the governor, but not pictured here, were UPED company officials and federal railroad commissioners.

Photograph by Alexander Gardner (1867)
Photograph courtesy J. Paul Getty Museum
Los Angeles, CA
Albumen silver print
13 × 18¹¹/₁₆ in. Mount: 19 × 24 in.

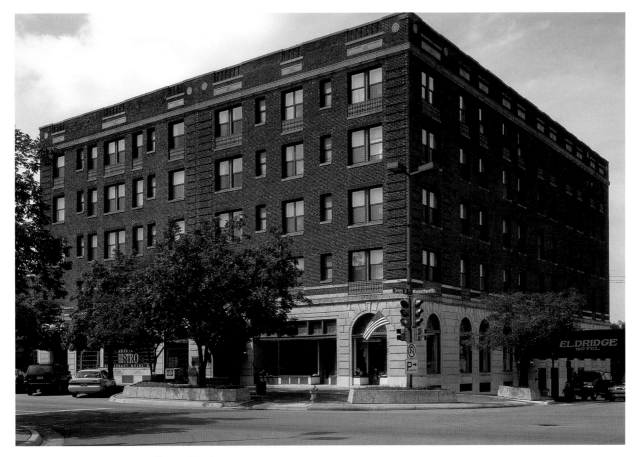

20B. Eldridge House, Lawrence, Kansas (1993)

The present Hotel Eldridge is a larger building, five stories instead of three, but it stands at the same location as the older Eldridge House. The original hotel was the Free State Hotel, commissioned by the New England Immigrant Aid Society, the Boston-based abolitionist organization that founded Lawrence. Built in 1855, it was burned down by Sheriff Sam Jones the next year because it was a free staters' bastion. In 1857, Shalor Eldridge rebuilt it and renamed it the Eldridge Hotel. After Quantrill and his raiders burned it to the ground in 1863, the building was once again rebuilt as the Eldridge House as seen in Gardner's photographs. The present-day Hotel Eldridge was rebuilt in 1923 and appears on the National Register of Historic Places.

Photograph by John R. Charlton (1993)

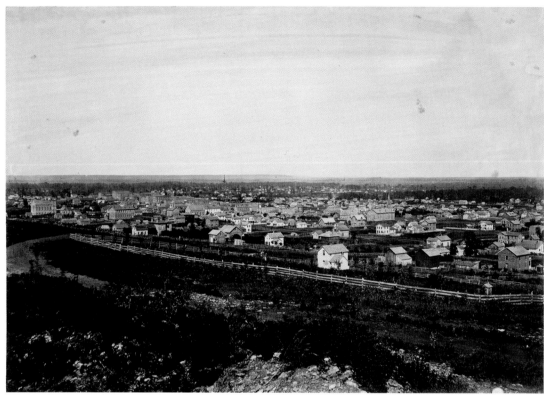

21A. Lawrence, Kansas, from Mount Ariad (1867)

Gardner's studio made a few errors in labeling the mounting boards for the series, which was produced in haste as soon as the photographs arrived in Washington, D.C. Either Gardner or his assistants had mislabeled this imperial print "Mount Ariad" rather than "Mount Oread." Nonetheless, the view from Mount Oread provides great panoramas of the Kaw and Wakarusa River Valleys. The top of Mount Oread became the site of the new state college that was opened in 1866. This view over the newly rebuilt town from the northeast side of Mount Oread (about Eleventh and Louisiana Streets) includes downtown, trees along the Kansas River, and the Kaw Valley escarpment on the horizon. A remnant of Indian burning practices, this broad vantage point was completely unobstructed by any tree cover whatsoever on the hill or in the city. Moreover, any growth that may have existed in the area had long since been harvested for fuel or building during territorial times. New buildings were constructed with handmade brick, native limestone from Mount Oread, or lumber brought to Lawrence on the new railway. Shortly before Gardner's visit, an English immigrant named John Charlton moved to the city and began a lucrative business selling fire and casualty insurance to the local businesses and residents.

Photograph by Alexander Gardner (1867)
Photograph courtesy J. Paul Getty Museum
Los Angeles, CA
Albumen silver print
$12^{15}/_{16} \times 18^{11}/_{16}$ in. Mount: $19^{1}/_{16} \times 24^{1}/_{16}$ in.

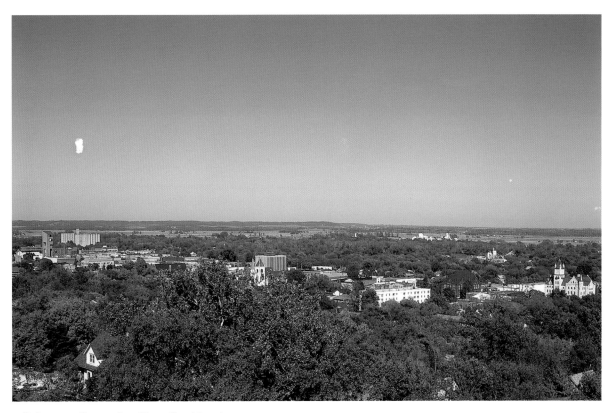

21B. Lawrence, Kansas, from Mount Oread (1993)

This more recent photograph overlooking Lawrence from Mount Oread was made from the roof of the KU Alumni Center, somewhat south of Gardner's vantage point, which enabled a view over the treetops that now cover Oread and much of the city. The New England settlers equated trees with civilized life, so they imported numerous eastern varieties. These imported plantings and efforts to suppress grassfires turned the city and the University of Kansas campus into an urban forest. Many of the newly built homes along the hillside leading down to the town in Gardner's picture are still inhabited today, and several are in the National Register of Historic Places. The clock tower shown at the south end of Massachusetts Street is part of the Douglas County Courthouse, designed by state architect John Haskell in 1904. It is also on the National Register.

Photograph by John R. Charlton (1993)

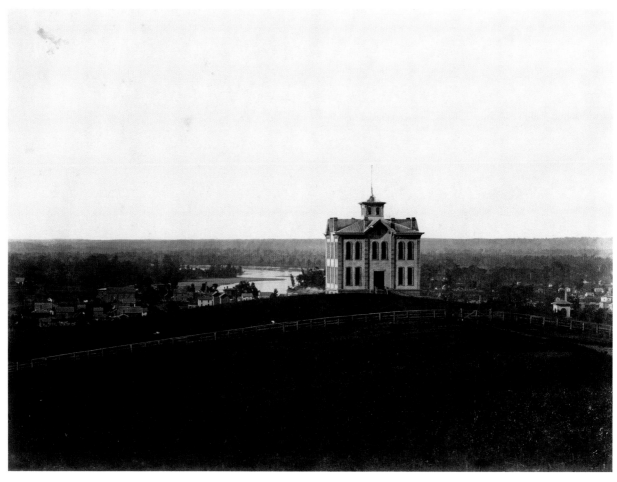

22A. Overlooking Lawrence and the Kansas River (1867)

In 1866, the state college opened North College on the north end of Mount Oread. It was the first college building erected for what eventually became the University of Kansas. Gardner captured the view of the city below the hill with the Kansas River upstream in the background on the left. Fencing around the hall kept Charles Robinson's cattle from grazing on campus. The university brought a variety of faculty, students, and scholars to Lawrence and helped establish the city as a college town for the rest of its history. Gardner had a strong interest in presenting the advance of American institutions that the railroad, the "new agent of civilization," brought into the eastern region of the state. Gardner's photograph suggests the future prospects for similar developments to accompany the UPED line as it advanced westward.

Photograph by Alexander Gardner (1867)
Photograph courtesy DeGolyer Library
Southern Methodist University
Dallas, TX
Ag1982.0214

22B. Overlooking Lawrence and the Kansas River (1993)

This photograph, also taken atop the KU Alumni Center, overlooks water towers in the foreground and the trees canopying the hillside, city, and even the northern Kaw Valley escarpment on the horizon. The Kansas River is below the Kansas Turnpike bridge in the distance to the left. Today, two women's dormitories, Corbin and Pearson, are at the site of old North College, which was removed in 1919. Across the river are rich farmlands in the floodplain of the Kaw River Valley and the old Delaware Indian Reserve. Recently, the Delaware nation purchased ninety acres of land on their former reservation in North Lawrence. The nation intends to relocate their governing headquarters, currently in Oklahoma, to this location.

Photograph by John R. Charlton (1993)

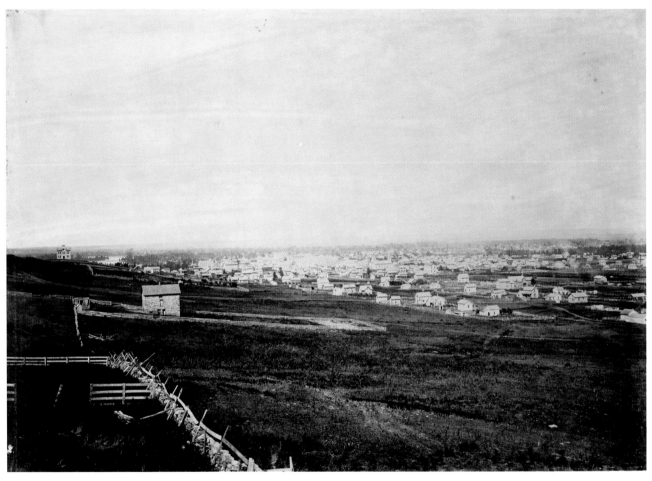

23A. Lawrence, Kansas, from Fort (1867)

Looking northeast from the south end of Mount Oread, North College appears in the distance on the left. At this south end, Fort Union still stood. Abolitionists had built the fort to guard against attacks emanating from pro-slave forces attempting to cross the Wakarusa Valley. Ironically, Quantrill attacked Lawrence from the east and escaped from Union-cavalry pursuit to the south across the Wakarusa River. Here again Gardner photographed the city to include the entire eastern slope of Mount Oread overlooking the southern end of Lawrence. The native limestone building down the slope was a cattle barn owned by Charles Robinson, the first Kansas governor and the landowner of most of Mount Oread before he bequeathed it to the state.

Photograph by Alexander Gardner (1867)
Photograph courtesy J. Paul Getty Museum
Los Angeles, CA
Albumen silver print
$12^{15}/_{16} \times 18^{11}/_{16}$ in. Mount: $19 \times 24^{1}/_{16}$ in.

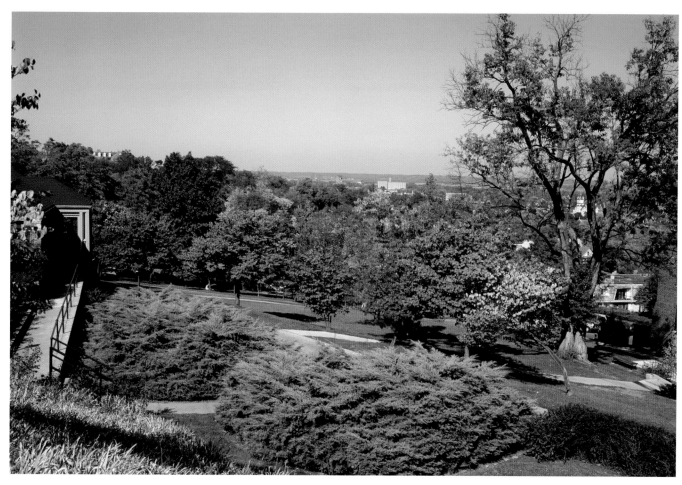

23B. Lawrence, Kansas, from Fort (1994)

The newer photograph is taken from the present-day university chancellor's residence near the site of the old fort, with the guesthouse to the left. The foreground is a cultivated landscape of imported trees, shrubs, and grass typical of the relandscaping of Mount Oread, begun in the 1870s by Chancellor James Marvin. On the hill at the upper left is the KU Alumni Center rooftop, and in the far distance across the river is a grain elevator along the Union Pacific line near the original depot. Mount Oread and the City of Lawrence sit in an urban forest surrounded by natural regrowth riparian woodlands in the Kaw and Wakarusa River Valleys. Charles Robinson's limestone barn still stands as a university annex for Western Civilization Studies.

Photograph by John R. Charlton (1994)

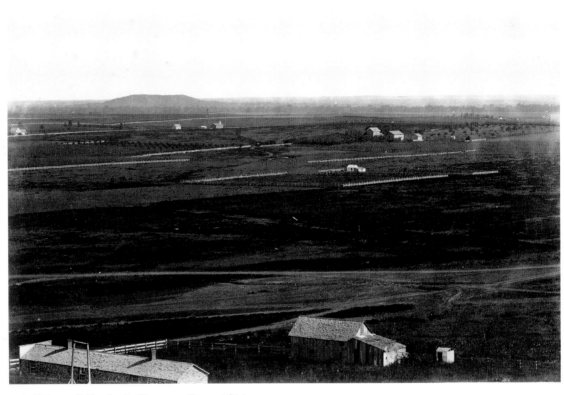

24A. Wakerusa Valley, South of Lawrence, Kansas (1867)

Gardner misspelled "Wakarusa" in this title. The perspective takes in the Wakarusa Valley to the southeast from the south end of Mount Oread. While riparian woodlands line the Wakarusa River in the distance, the only other trees in this frame are orchard saplings surrounded by fences in the farms scattered across the valley between the hill and the river. What is so striking about this view is how the grid system is clearly imprinted on the landscape. No longer an open grassland, the landscape in Gardner's photograph reflects Euro-American cultural values of land ownership and property demarcation. The white fences were meant to keep animals out of the orchards, gardens, and crop areas rather than to contain livestock.

The Fort Scott Road in the foreground led from the town out across the valley and its wetlands to Blanton's Crossing. This was Quantrill's escape route after he nearly burnt Lawrence to the ground just four years earlier. Blue Mound is on the left, so named because of the light cast when backlit from the dawn sunlight every morning.

Photograph by Alexander Gardner (1867)
Photograph courtesy DeGolyer Library
Southern Methodist University
Dallas, TX
Ag1982.0214

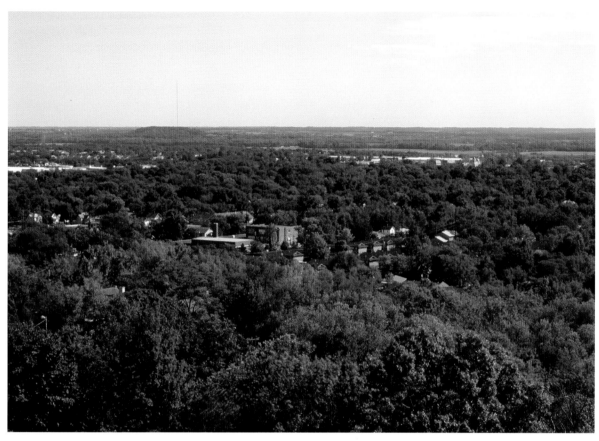

24B. Wakarusa Valley, South of Lawrence, Kansas (1994)

This photograph was taken from the roof of Blake Hall on the southern end of Mount Oread, near the Chancellor's residence. Beyond the treetops is the present-day Wakarusa River Valley and the southeast end of the Lawrence city limit. Cordley School, named for Reverend Richard Cordley, and Haskell Indian Nations University, named for state architect John Haskell's brother Dudley Haskell, the school's first superintendent, can be seen in the sea of trees.

Recently Blue Mound has a green cast to it given its thick cover of trees. Around 600,000 years ago, the Kansan glacier, several hundred feet high and tapered down to the southern perimeter of the Wakarusa Valley where it stopped, began melting and flooding the valley with glacial till over the course of several centuries. This created some of the richest farmlands on the North American continent.

Photograph by John R. Charlton (1994)

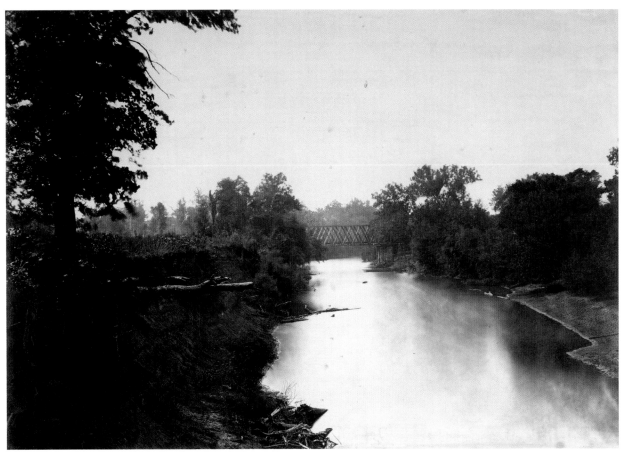

25A. Railroad Bridge across Grasshopper Creek, Kansas (1867)

Grasshopper Creek is a major northern tributary into the Kansas River that flows just beyond the railroad bridge. This view looks downstream to the bridge located just east of Perryville, which is named after John D. Perry, president of the Union Pacific Railway Company, Eastern Division. Gardner made a point of photographing all rivers and creeks that the new rail line crossed to show the numerous watered regions capable of supporting agriculture and town building along the line. His goal was to counter the widespread impression among easterners that Kansas was the "Great American Desert." This image represents one of the last painterly, landscape-style views that Gardner would frame as he traveled farther west. William Bell purposely misnamed this same print in his *New Tracks in North America* to represent the Purgatoire River Valley in the eastern, semiarid High Plains of Colorado, to give his readers the impression of a well-watered region.

Photograph by Alexander Gardner (1867)
Photograph courtesy J. Paul Getty Museum
Los Angeles, CA
Albumen silver print
13 × 18¹¹/₁₆ in. Mount: 18¹⁵/₁₆ × 24¹/₁₆ in.

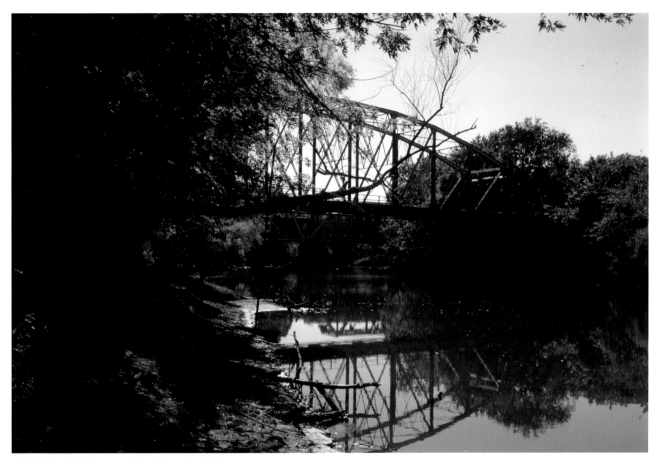

25B. Railroad Bridge across Grasshopper Creek, Kansas (1994)

The railroad bridge still crosses the creek, which was later sensibly renamed the Delaware River after the tribal reserve. Now it flows down to the Kaw River from the spillway of the dam that forms Lake Perry State Reservoir. Upstream in the foreground of the photograph, beside the reconstructed railroad bridge, is a county-road bridge crossing the creek. This stretch of railroad is still one of the most active in the country, carrying freight and coal. Riparian tree growth along this portion of the river has remained constant over the years.

Photograph by John R. Charlton (1994)

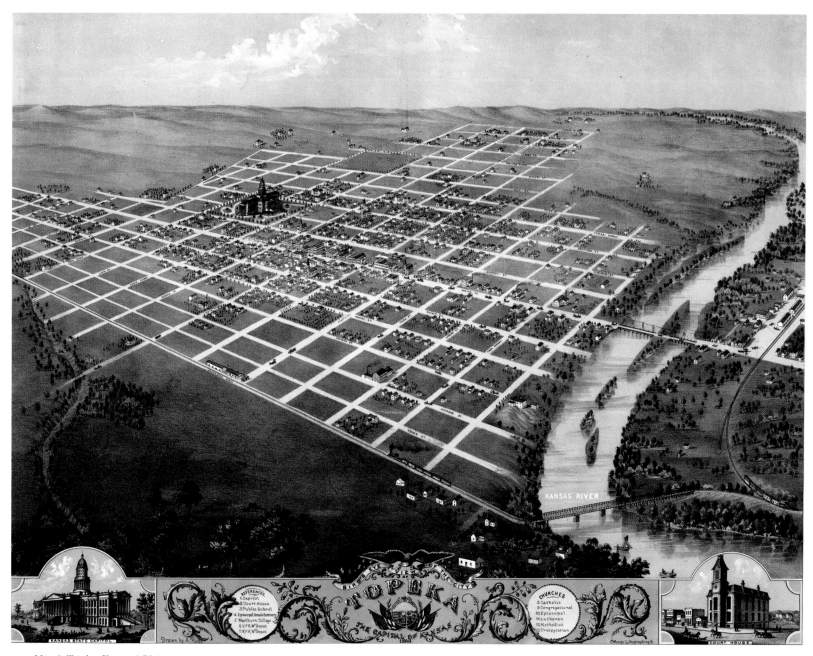

Map 6. Topeka, Kansas (1869)

26A. Depot, Topeka, Kansas (1867)

This photograph offers a southern view of the standard Union Pacific depot and freight warehouse building north of the Kansas River at the new state capital city of Topeka. A train is parked on the track on the other side of the building. A railroad commissioner is among the group, standing on the dock with workers and a dog. A simple advertisement is painted along the dock's edge: "Roback's Blood Purifier is sold by Druggists." North Topeka is also near the Kansas River and the UPED line with the main part of the city located to the south. The ground in the foreground appears recently scoured by the river.

Photograph by Alexander Gardner (1867)
Photograph courtesy J. Paul Getty Museum
Los Angeles, CA
Albumen silver print
12 ¾ × 18¹¹/₁₆ in. Mount: 18¹⁵/₁₆ × 24 in.

26B. Depot, Topeka, Kansas (1993)

The Union Pacific depot, built in 1927, is now restored as the Great Overland Express railroad museum. This neoclassical depot replaced an earlier Victorian depot/hotel building east of this location across Kansas Avenue. This is by far the largest Union Pacific depot in the state. This photograph only shows the west wing of the building where the original depot stood. A graffiti-covered warehouse is just across the tracks. The 1951 Kansas River flood inundated the depot, although it survived, and the company continued to use it until it closed in 1988. Railroad Heritage Inc., formerly Topeka Railroad Days, raised funds to restore the building and preserve it as a historical museum and centerpiece of economic revitalization in North Topeka and on the riverfront. Opened as the Great Overland Station in 2004, the depot also serves as a World War II memorial. Occasionally, attendees of depot fundraisers board passenger cars that are pulled by steam engine locomotives and bound for round trips between Kansas City and Topeka.

Photograph by John R. Charlton (1993)

27A. Pontoon Bridge at Topeka, Kansas (1867)

No bridges crossed the Kansas River upstream from Lawrence except this military pontoon bridge, which connected North Topeka and the UPED tracks to the rest of the city south of the river. The temporary bridge in the distance upstream was needed to transport the heavy limestone blocks brought back from stone quarries near Junction City for construction of the capitol in downtown Topeka. A few years later, a wooden turnpike bridge spanned the river as an extension of Kansas Avenue, the thoroughfare of Topeka. After later flooding an iron one replaced it. In this photograph, the Kaw River appears wide with sandbars and dense riparian foliage lining both banks.

Photograph by Alexander Gardner (1867)
Photograph courtesy J. Paul Getty Museum
Los Angeles, CA
Albumen silver print
13 × 18^{11}/$_{16}$ in. Mount: 19 × 24^{1}/$_{16}$ in.

27B. Pontoon Bridge at Topeka, Kansas (1993)

In this photograph, the riparian woodlands no longer line the river-banks. Now steel, concrete, and riprap reinforce levees designed for flood control. These levees contained raging flood waters early in the summer of 1993 on the Kansas River. As a result of levee construction, the riverbed is now narrower and deeper than before. The previous bridges have been replaced by the current Kansas Avenue bridge, which connects Kansas Avenue on the south to Quincy Street in North Topeka. Two railroad bridges also cross the river now, one connecting to the shops of the Burlington Northern Santa Fe Railway on the south side of the river, and the other providing a rail line for the Union Pacific to the south and west.

Photograph by John R. Charlton (1993)

28A. Topeka, the Capital of Kansas (1867)

This photograph looks south down Kansas Avenue, the main commercial street of downtown Topeka. Some of the buildings are stone, probably built with local Topeka limestone, while many others are sided with clapboard. One sign on the left side reads, "Land Office," and this building likely sold the UPED land grants. Company officials and federal agents had negotiated purchases of large tracts of land in the Delaware Reserve and were treating with the Potawatomi nation for right-of-way through its reservation, which was located to the west of Topeka. Wagons can be seen parked along the side of this wide street and horse riders appear in the distance.

Photograph by Alexander Gardner (1867)
Photograph courtesy DeGolyer Library
Southern Methodist University
Dallas, TX
Ag1982.0214

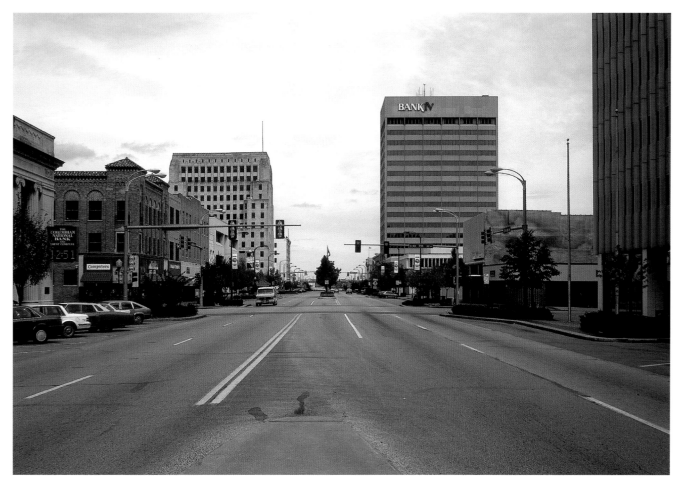

28B. Topeka, the Capital of Kansas (1994)

The 1994 view displays the intersection south of Seventh Street and Kansas Avenue. Some of the old stone walls remain in old downtown buildings that were refurbished long after Gardner's time, including Wolfe's Camera Shop on the left near the old Land Office. The tall concrete art deco–style bank on the left has since been imploded and replaced by a glassy new office building. The structure on the right now houses the Bank of America.

Photograph by John R. Charlton (1994)

29A. Topeka, Kansas (1867)

This is a view northeast of the city from the second floor of the east wing of the new state capitol under construction near Jackson Street in downtown Topeka. Large blocks of limestone recently delivered by UPED cars are readied for the huge construction project. Construction crews had begun laying the foundation the year before with locally quarried limestone, which weathered badly and was quickly replaced by the finer limestone blocks from the Junction City area. The stone building across the capitol grounds on the left is St. Joseph's Church. Downtown Topeka is framed in the center and east Topeka is to the right. The railroad and capitol rapidly created a bustling city named after the Potawatomi Indian word for potato.

Photograph by Alexander Gardner (1867)
Photograph courtesy J. Paul Getty Museum
Los Angeles, CA
Albumen silver print
13 × 18¹¹/₁₆ in. Mount: 19 × 24¹/₁₆ in.

29B. Topeka, Kansas (1994)

This 1994 photograph was taken from the entrance portico of the eastern wing of the capitol, which was designed by State Architect John Haskell. The new St. Joseph's Cathedral is across the grounds, and the city's Jayhawk Tower is in the center with downtown office buildings off to the right. Haskell's capitol project was completed in 1892. In recent years the legislature has funded expensive interior and exterior restorations of the building.

Photograph by John R. Charlton (1994)

30A. State Capitol, Topeka, Kansas (1867)

This view is the south side of the east wing of the capitol as it underwent construction. The building is surrounded by large blocks of limestone, hoists, and a stone shed where blocks were cut, chiseled, and finely ground for placement in the building. On the left stands Gov. Samuel J. Crawford greeting UPED company president John D. Perry and vice president Adolphus Meier. Governor Crawford served as chairman of the oversight committee for the state house project, and John Perry's railroad company made handsome profits by hauling the building materials to the construction site.

Photograph by Alexander Gardner (1867)
Photograph courtesy Spencer Art Museum
University of Kansas
Lawrence, Kansas
1978.0026.02

30B. State Capitol, Topeka, Kansas (1994)

This 1994 photograph shows the massive east wing's columned portico in front of the original east wing of the capitol in Gardner's view. The quarter-century-long project was the capstone of Haskell's long productive career as state architect. Legislative offices and the governor's office overlook the grounds here from the floors above. Standing on the portico is the first woman state representative from Lawrence, Betty Jo Charlton, at the end of her fifteen years of service in the legislature. The second floor of the capitol also houses the famous murals by John Stuart Curry, including that of John Brown in the "Tragic Prelude."

Photograph by John R. Charlton (1994)

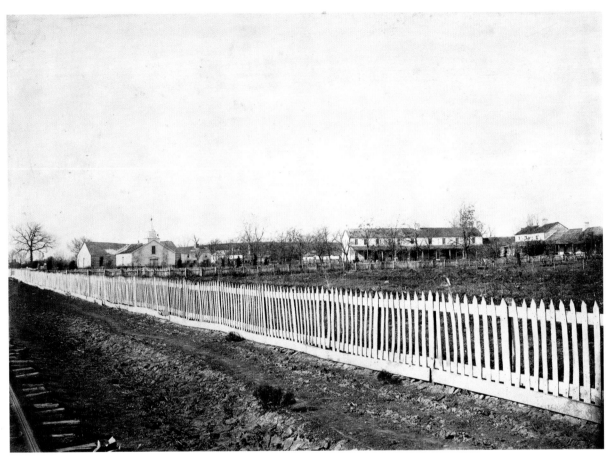

31A. St. Mary's Mission, Kansas (1867)

St. Mary's Mission had been a French Jesuit Indian mission since 1848. In 1867, it still served the children of the Potawatomi nation. At the time, UPED officials were seeking to acquire right-of-way through the Potawatomi reservation. The mission included a church (left frame), and boys' and girls' dormitories on the right. The mission sought to convert the students to Catholicism and to aid their assimilation into the dominant Euro-American society. This "enlightened" approach ended abruptly with the building of the UPED line farther west, which precipitated the American Indian war of 1867. A similar approach to educating American Indian children resumed at the Haskell Indian School in Lawrence after the treaties in the fall of 1867 removed Plains tribes from the state. Looking closely at the photograph, American Indian students are on the dormitory porches, and a mission orchard is in the foreground surrounded by a fence.

Photograph by Alexander Gardner (1867)
Photograph courtesy J. Paul Getty Museum
Los Angeles, CA
Albumen silver print
$12^{11}/_{16} \times 17^{13}/_{16}$ in. Mount: 19×24 in.

31B. St. Mary's Mission, Kansas (1993)

In Charlton's photograph, the orchard still remains in the foreground without the fence. Grassy lawns are spread over the campus of St. Mary's College now. The old mission buildings are long gone, and brick buildings comprise the present-day Catholic college, which no longer serves the Potawatomis, whose reservation is located to the north. A large Sioux quartzite glacial boulder now marks the site of the original church building shown in Gardner's photograph.

Photograph by John R. Charlton (1993)

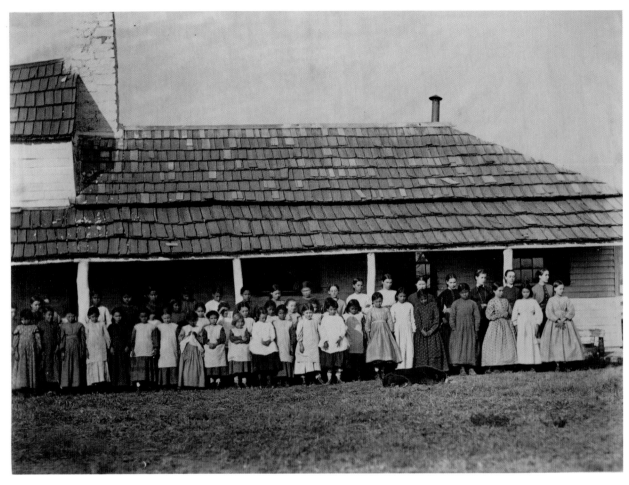

32A. St. Mary's Mission, Kansas (1867)

Young Potawatomi Indian girls in dresses are lined up in front of the girls' dormitory at the mission along with the nuns who supervised and taught them. Among the girls appear several Métis, offspring of Euro-Indian relationships. The children have pensive expressions, partly from the act of posing for Gardner, but also likely from the strict disciplinary atmosphere at the institution. The children were not allowed to speak their native language nor engage in native customs or practices. They were educated to become submissive housemaids and seamstresses for their future in the white world. Most of the nuns seem kindly in their expressions, at least in comparison to the boys' supervisors.

Photograph by Alexander Gardner (1867)
Photograph courtesy DeGolyer Library
Southern Methodist University
Dallas, TX
Ag1982.0214

32B. St. Mary's Mission, Kansas (1993)

The St. Mary's College administration building replaced the girls' dormitory when the children's school became an adult college. The college curriculum is one of traditional and orthodox Catholicism. Most of the faculty members are still nuns. The college, in the present-day town of St. Marys, Kansas, sits along the Union Pacific line. One of the main industries in the town is stonecutting, much of the material being native limestone found in the nearby Flint Hills.

Photograph by John R. Charlton (1993)

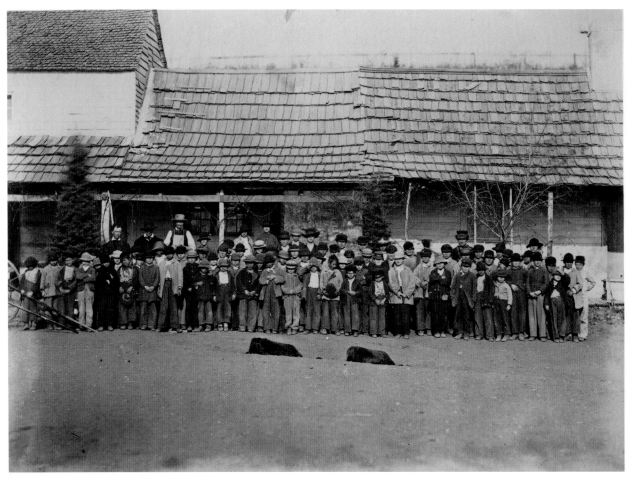

33A. St. Mary's Mission, Kansas (1867)

The boys' dormitory was east of the girls' at the mission. The young boys, both Métis and fullbloods, are lined up wearing non–American Indian apparel. The boys were primarily taught to work as farmhands and laborers, although nuns were in charge of what amounted to their formal education. The adult males in the group were likely the supervisors hired by the mission to administer discipline, roughly if necessary, especially as the boys grew in size or tried to escape the mission. The locals had low regard for American Indians off the reservation or the mission. The dogs in the foreground are displaying a bored repose for Gardner.

Photograph by Alexander Gardner (1867)
Photograph courtesy DeGolyer Library
Southern Methodist University
Dallas, TX
Ag1982.0214

33B. St. Mary's Mission, Kansas (1993)

A college church was built on top of the hill behind the former boys' dormitory site. It was used for services for the Catholic faculty and students for many years until lightning sparked a fire that gutted the church. The church stood many years in this condition until it was finally repaired and reconstructed several years after this photograph was taken. Although some staff at the college may have wondered whether the lightning strike was a kind of penance for the earlier original mission, the irony was probably not lost on the present-day Potawatomis who still reside on the nearby reservation.

Photograph by John R. Charlton (1993)

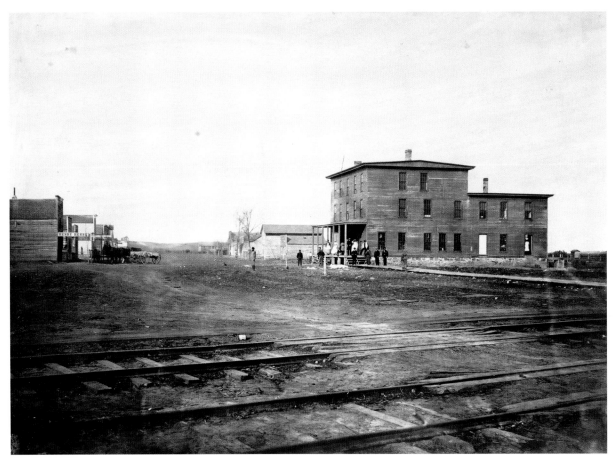

34A. Lincoln Avenue, Wamego, Kansas (1867)

Lincoln Avenue was the only street in Wamego, Kansas, at the time Gardner took this photograph. He must have liked the fact that the town had named its street for his old friend, the former president, although the railroad company may have had a hand in the naming, too. The town's developers anticipated a UPED roundhouse and shops, but this never materialized. The building right across the tracks was obviously built to accommodate travelers and rail crews, but probably never had more guests than when the local rail construction was happening nearby. A few guests, staff, and/or townspeople are posed beside it along with an African American maid in an apron. Close examination reveals tall fencing around the newly planted trees along Lincoln Avenue to protect them from horses. The open treeless hills on the horizon show the effects of American Indian–set, annual prairie fires on shaping the grassland ecology of the Flint Hills.

Photograph by Alexander Gardner (1867)
Photograph courtesy J. Paul Getty Museum
Los Angeles, CA
Albumen silver print
$12^{15}/_{16} \times 18^{11}/_{16}$ in. Mount: $18^{15}/_{16} \times 24^{1}/_{16}$ in.

34B. Lincoln Avenue, Wamego, Kansas (1993)

In 1993, citizens of Wamego still identified their city as a Union Pacific railroad town. Outside the left of the frame along the tracks is a railroad park, complete with a caboose. Late nineteenth-century local limestone buildings replaced the original frame structures, and many still stand along Lincoln Avenue. Lincoln Avenue is also the location of the restored Columbian Theatre, adorned with state murals made for the 1893 Chicago World's Fair. With the suppression of prairie fires, trees now easily thrive along city streets, and the town has grown and prospered despite the abandonment by the railroad company because it enjoys a robust agricultural economy in some exceptionally rich river valley farmlands.

Photograph by John R. Charlton (1993)

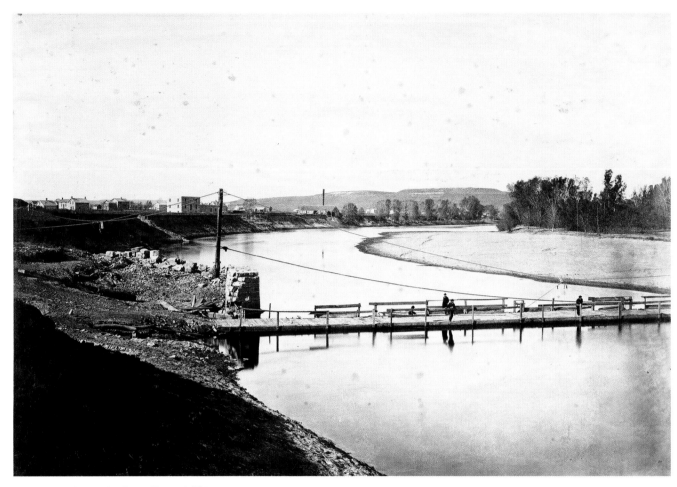

35A. View on the Big Blue River, Kansas (1867)

Looking northwest up the Big Blue River from the west end of the new railroad bridge at Manhattan, Kansas, Gardner took this photograph of the pontoon bridge crossing the river to Poyntz Avenue, the main commercial street of Manhattan. In the foreground is a permanent bridge abutment under construction. The city of Manhattan can be seen above the bend of the bank on the left, and the bank along the right is floodplain. In the distance are the exposed limestone ridges of a treeless Bluemont Hill overlooking the river valley. Two figures stand on the bridge over the languid Big Blue. Many early travelers and explorers observed in their journals that the landscapes around Manhattan were among the most beautiful in the entire Kaw River Valley.

Photograph by Alexander Gardner (1867)
Photograph courtesy J. Paul Getty Museum
Los Angeles, CA
Albumen silver print
12^{13}/$_{16}$ × 18^{11}/$_{16}$ in. Mount: 19 × 24^{1}/$_{16}$ in.

35B. View on the Big Blue River, Kansas (1994)

This scene is surely less scenic, even with the tree-covered Bluemont Hill and the blue water tank in the background. The foreground reveals a filled-in channel of the Big Blue River with buried flood-control infrastructure that channels water runoff from the nearby concrete highway and mall parking lot surfaces into the Kansas River. The highway now follows the former riverbank around its old bend with commercial structures and hotels across the highway. Only occasional slab-based shops and garages are on this side of the highway due to the still-present potential for flooding.

Photograph by John R. Charlton (1994)

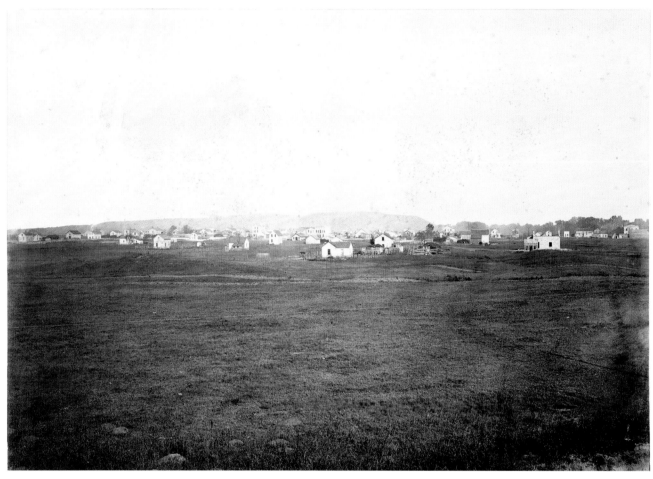

36A. Manhattan, Kansas (1867)

This photograph shows the southern portion of the city with Bluemont Hill in the distance to the north. Gardner took this shot while standing on a train car on the UPED tracks on the south edge of town. The trees east of town on the right are along the Big Blue River Valley before it joined with the Kaw River. Bluemont Hill is barren of trees, although it is not evident in the faded horizon in this photograph.

Photograph by Alexander Gardner (1867)
Photograph courtesy J. Paul Getty Museum
Los Angeles, CA
Albumen silver print
13 × 18¹¹/₁₆ in. Mount: 19¹/₈ × 24¹/₁₆ in.

36B. Manhattan, Kansas (1994)

The new vantage point of this photograph is on a levee embankment along Wildcat Creek that protects the concrete operation in the fore-ground. The railroad tracks are now just north of this location. With the suppression of prairie fires, Bluemont Hill is now covered with red cedar and deciduous trees, as is evident in this newer, clearer view. The city has sprawled much farther west of here, but this area still bares the street grid of its original territorial plat.

Photograph by John R. Charlton (1994)

37A. Bluemont College, Manhattan, Kansas (1867)

This is the only known photograph of Bluemont College, founded just to the west of the city limits and dedicated in 1859. Named for the mound it was built on, it overlooked the town, rivers, and valley below. Several faculty members are pictured beside the college building. The first state geologist, Benjamin Mudge, was among the original Bluemont faculty. He made the earliest thorough reports of the state's geology and natural resources. In September 1863, the rededicated and renamed college opened its doors as Kansas State Agricultural College, the first operational school in the nation operating under the provision of the Morrill Land Grant College Act of 1862. When the building was dismantled, the stone arch with the college name over the window in the gable was saved and was installed over the fireplace in the Kansas State University Alumni Center. The print is unfortunately damaged. It came from the estate of William A. Bell.

Photograph by Alexander Gardner (1867)
Photograph courtesy Kansas State Historical Society
Topeka, KS
Albumen silver print

37B. Bluemont College, Manhattan, Kansas (1994)

This photograph captures the site of the original Bluemont College building. There is a commemorative garden and interpretation station for it on the nearby street corner. It is on the western edge of the main campus, which has many newer buildings and a stadium built with native stone. The university is a full-fledged university, but is still widely known as the state "ag school." A testament to the agricultural mission of the university, this photograph shows the bull barns of the university. Since this photograph was taken, the college sold this ground to a developer who built a bank on the same site.

Photograph by John R. Charlton (1994)

38A. Fort Riley, Kansas (1867)

The stereograph version of this view is subtitled, "No Longer an Outpost," a title suggesting that Fort Riley had replaced Fort Leavenworth as the main staging site for soldiers and supplies for the military outposts further west, such as Forts Harker, Hays, and Wallace. This role was particularly true for the post as its officers and soldiers participated in the Indian Wars beginning that spring. The fort itself was a tranquil place surrounded by settled towns, and it supplied its UPED rail connection to Fort Leavenworth. This scene looks south from Custer Hill across the fort's limestone barracks and parade grounds to the Kaw River Valley and the Flint Hills beyond.

There is a riparian tree line visible along the river, but otherwise open grasslands prevail even if relatively grazed off by livestock and horses from the fort.

Photograph by Alexander Gardner (1867)
Photograph courtesy J. Paul Getty Museum
Los Angeles, CA
Albumen silver print
$12^9/_{16} \times 18^{11}/_{16}$ in. Mount: 19 × 24 in.

38B. Fort Riley, Kansas (1995)

Grasses are higher on this hill now since burning has been suppressed near populated areas, and the fort is now nestled in a riparian gallery forest filling the Kaw River Valley. The tops of some of the historic buildings can be seen over the treetops. The hillside does get occasional mowing because it is used as a park. The Flint Hills in the distance across the valley are still treeless due to controlled burning practices that support early spring cattle grazing.

Photograph by John R. Charlton (1995)

39A. View on the Kansas River at Fort Riley, Kansas (1867)

In this picture, the Union Pacific track closely follows the Kansas River below the steep bank leading up to the fort. The Flint Hills grade was too steep for the tracks to reach the fort above. Local limestone provided hard building material for the fort and local settlement but was too thick and steep for railroad building, although even here the bank had to be cut in order to lay the track. The sparse riparian trees along both banks of the river had been scoured months earlier from flooding. Wagon tracks and footprints are seen in a trail down from the fort and along the river's sandbanks. James

Gardner is standing on the tracks, and a telegraph line can also be seen leading up to the fort.

Photograph by Alexander Gardner (1867)
Photograph courtesy J. Paul Getty Museum
Los Angeles, CA
Albumen silver print
$13 \times 18^{11}/_{16}$ in. Mount: $19 \times 24^{1}/_{16}$ in.

39B. View on the Kansas River at Fort Riley, Kansas (1995)

In this view up the tracks a dense, tall, and lush tree growth completely lines the riverbank below the track. It is so thick that it now obscures the river all the way upstream. Lush growth also blankets the hillside above the tracks. The dense growth along the banks helps to keep them intact during floods. Only two years before, the Kansas River inundated this entire area, yet the riparian tree growth held the track line in place. Telephone lines have long since replaced the telegraph lines that once followed the tracks.

Photograph by John R. Charlton (1995)

40A. Railroad Bridge across the Republican, Kansas (1867)

To take this photograph, Gardner climbed down a steep bank near the junction of the Republican and Smoky Hill Rivers that forms the Kaw River. He set his camera on a thick sandbar formed earlier during the summer flooding. He took his shot looking north, upstream, to the UPED bridge that crossed the Republican River. This bridge had been damaged in the floods. Gardner's photograph reveals some possible repair work taking place just below the mid-river pier. A pontoon bridge just upstream connected non-rail traffic between the fort and Junction City. The horsemen riding across the shallow water in front of the bridge indicate the presence of a firm riverbed that supported both bridges. There are two figures in repose on the sandbank.

Photograph by Alexander Gardner (1867)
Photograph courtesy J. Paul Getty Museum
Los Angeles, CA
Albumen silver print
12^{15}/$_{16}$ × 18^{11}/$_{16}$ in. Mount: 19 × 18 in.

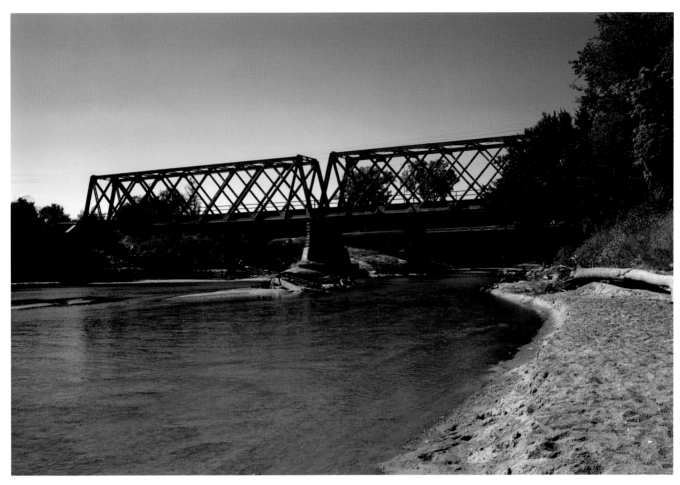

40B. Railroad Bridge across the Republican, Kansas (1995)

The vantage point for this photograph, which restricts an upstream vista, is from a low quicksand bank much closer to the eastern confluence point of the Republican and Smoky Hill Rivers than where Gardner took his photograph. The Union Pacific railroad bridge spans the river, like in the original, and behind it is the Highway K-18 bridge. Over the years, riparian growth has crowded in on the Republican River. The Army Corps of Engineers now controls the river flow with releases from Milford Dam. Spillover from the dam along with flooding on the Smoky Hill River in 1993 overtopped the tracks in this area and caused the accumulation of debris below the bridges.

Photograph by John R. Charlton (1995)

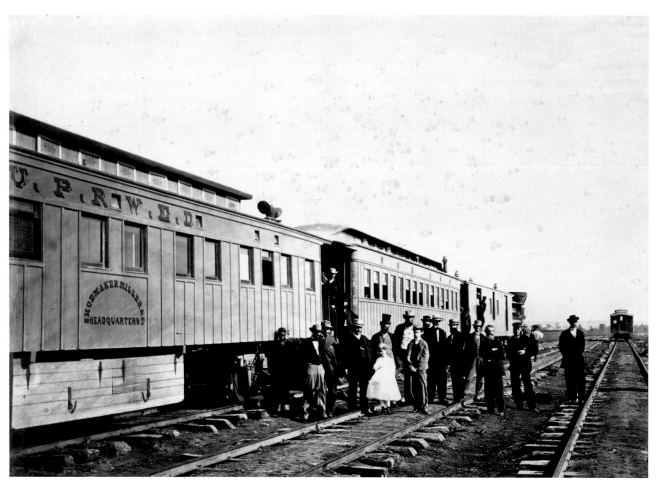

41A. Group at Junction, Kansas (1867)

Gardner took this VIP group picture at the UPED depot in Junction City. Shoemaker, & Miller Co. were the contractors laying the tracks across the state, and the company provided its contractors' car for a private excursion over recently constructed tracks and afterward for a meeting location at Junction City. Next to the palace car are railroad commissioners who had arrived from Wyandotte along with other railroad contractors. Also in the group are pictured the three main UPED officers, John Perry, Charles Lamborn, and Adolphus Meier. Other guests include Kansas Gov. Samuel Crawford and his daughter, Florence. The boy on the left may have been a servant on the contractors' car.

Photograph by Alexander Gardner (1867)
Photograph courtesy J. Paul Getty Museum
Los Angeles, CA
Albumen silver print
13 × 18^{11}/$_{16}$ in. Mount: 19 × 24^{1}/$_{16}$ in.

41B. Group at Junction City, Kansas (1995)

This 1995 photograph at the old Junction City depot location now includes old sidetracks beside the Geary Train Elevator. Junction City is the county seat of Geary County, so renamed in 1888 for a former territorial governor of Kansas who had distinguished himself as a Union officer during the Civil War. Kansans routinely named nearly all of the counties to the west where the UPED line ran for Civil War heroes. Prior to the Civil War, Geary County had been named Davis County in honor of former U.S. secretary of war and later president of the Confederacy Jefferson Davis. After the Civil War, the name seemed inappropriate for the local citizens, and they requested the name be changed to Geary. The riparian tree line in the distance marks the course of the Smoky Hill River.

Photograph by John R. Charlton (1995)

42A. Junction City, Kansas (1867)

Junction City was the farthest destination located in the Kaw River Valley. The city's location near Fort Riley and the junction of the three rivers assured its location since territorial times. The UPED was now the "new agent of civilization" that conveyed people, commerce, and American culture westward into the Great Plains. With the exception of Salina, Kansas, beyond this point all the towns west would begin as new railroad towns. The house shown in this photograph, the one with the cupola roof, still stands on the third block of Jefferson Street.

Photograph by Alexander Gardner (1867)
Photograph courtesy J. Paul Getty Museum
Los Angeles, CA
Albumen silver print
13 × 18¹¹/₁₆ in. Mount: 19³/₁₆ × 24¹/₁₆ in.

42B. Junction City, Kansas (1995)

Junction City still thrives due to its proximity to Fort Riley and several exits on Interstate 70. This contemporary view was taken in a private residential cul-de-sac on a hillside now covered by trees. This spot is located below a hilltop rimrock quarry that was used as one of the early sources of construction stone for building the east wing of the state capitol. Several quarries farther west were also sources of construction stone for building the capitol over the next decades. The street going downhill here is Chestnut Street.

Photograph by John R. Charlton (1995)

Trails to Rails in Kansas

When the UPED began building west of Junction City, it entered a portion of the state where not one single town of any significance existed, where hardly an acre of ground had been prepared for farming, and where only a freighting and fur trade economy had previously prevailed. In 1867, from Junction City to Fort Hays, the Union Pacific Railway Company, Eastern Division, served as *the* catalyst for transforming the economy, social relations, and ecology of this portion of the state.

Today, Interstate 70 serves as the main transportation link through this corridor. While trucks and automobiles have reshaped large elements of the economy and social structure that was put into place by the UPED lines, they still follow and conform to the structures of urban growth and land use set into motion by the building of the UPED tracks that propelled the "new agent of civilization" into the central region of Kansas.

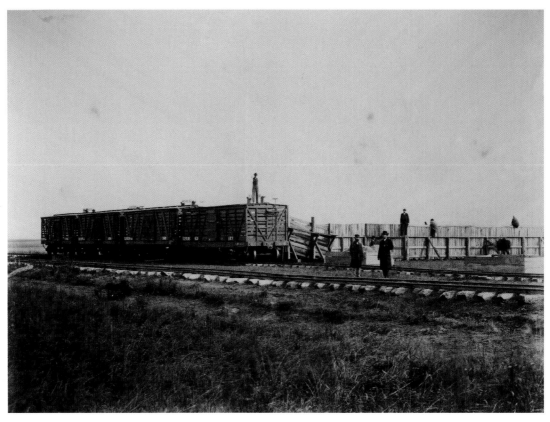

43A. Shipping Point for Texas Cattle, Abilene, Kansas (1867)

As railroad building moved west, one of the first commercial enterprises it fostered was the Texas cattle trade northward on the Chisholm Trail. Beginning with Abilene, the Union Pacific Railway Company, Eastern Division, created transport facilities at railheads for loading cattle destined for eastern urban markets and processing plants largely centered in Kansas City and Chicago. These rail towns also provided raucous entertainment for Texas cowboys. Joseph McCoy, an Illinois stockbroker, worked with UPED officials to establish Abilene as the shipping location for Texas cattle. He induced Texas cattlemen to drive their herds to Abilene while he also provided the saloons and billiard halls that fleeced cowboys of their paychecks. He also built a hotel, the Drover's Cottage, where

eastern buyers and Texas drovers could cut their deals over fine meals. McCoy's cattle pens, shown in this photograph, were next to the tracks, and nearly everyone in Abilene either worked directly or indirectly for him. This view outside the stock pens shows wranglers watching from the fence as cattle are loaded into the freight cars on the sidetrack next to the pens.

Photograph by Alexander Gardner (1867)
Photograph courtesy DeGolyer Library
Southern Methodist University
Dallas, TX
Ag1982.0214

43B. Shipping Point for Texas Cattle, Abilene, Kansas (1996)

The former stockyards are now an empty lot beside an Archer Daniels Midland (ADM) grain elevator along the Union Pacific tracks. ADM is one of the largest agribusiness conglomerates. Farmlands and products have become increasingly concentrated in conglomerate systems as generational family farms cease to exist and land holdings are concentrated in large companies for crops and mineral rights. Across the tracks, north of the elevator, still stands the grand house Joseph McCoy built to oversee his cattle operations and the Drover's Cottage. A few blocks to the north is the boyhood home of Dwight Eisenhower and the Eisenhower Presidential Library and Museum.

Photograph by John R. Charlton (1996)

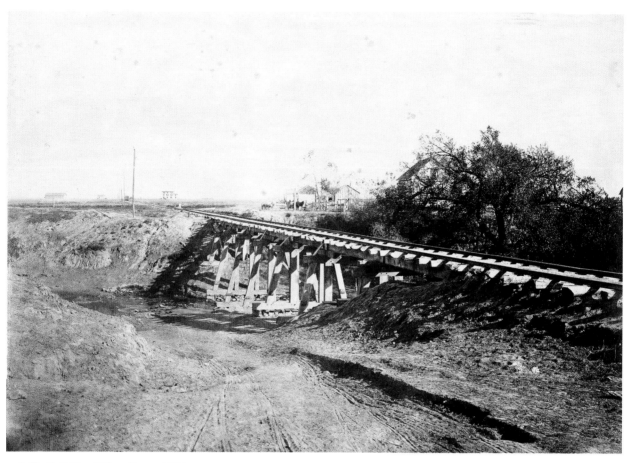

44A. Trestle Bridge, Abilene, Kansas (1867)

Gardner aimed his camera lens to the east from the trestle bridge over Muddy Creek and took this shot of a distant train stopped at the newly opened Drover's Cottage. Abilene was young, but it would develop into a major trade center along the Smoky Hill River, first from the Texas cattle trade there and later as more would-be entrepreneurs and farmers arrived on the trains. Eventually the townspeople grew wary of rowdy Texas cowboys and their saloons and gambling houses south of the track. By 1872, they were happily celebrating the move westward of the Texas cattle drives to Ellsworth, Kansas, another new shipping point on the UPED line. Even Joseph McCoy had loaded up his Drover's Cottage on a flatbed car and transported it to Ellsworth to accommodate the cattlemen arriving there. The only trees in view here are the ones along Muddy Creek, which looks well traveled.

Photograph by Alexander Gardner (1867)
Photograph courtesy J. Paul Getty Museum
Los Angeles, CA
Albumen silver print
13 × 18¹¹/₁₆ in. Mount: 18¹⁵/₁₆ × 24 in.

44B. Trestle Bridge, Abilene, Kansas (1996)

A steel railroad bridge and steel rails have long since replaced the old wooden bridge and iron tracks shown in Gardner's photograph. The old State Highway 40 bridge is on the left. South of the tracks stand many old buildings dating to a much earlier time, though many are dilapidated, including the Belle Spring Creamery built in 1901. The building was placed on the National Register in 1985, but severe deterioration of the building led to it being demolished in 1998. The rest of the town is quiet and well south of Interstate 70. Mud Creek is lined by levees to protect the surrounding area from flash floods in an otherwise nearly dry creek. There are several old mansions around the town that date to the cattle-boom years, but Abilene is best known now for the Eisenhower Presidential Library and Museum.

Photograph by John R. Charlton (1996)

45A. Salina, Kansas (1867)

From the back of a rail car, Gardner set his camera to capture the emergence of Salina, a toehold of civilization in a vast region of shortgrass prairie. A narrow band of riparian woodland lines the Smoky Hill River in the background of the small collection of buildings that its owners purported to be a town of great importance. It never developed as a Texas cattle railhead, as UPED construction had recently bypassed it in favor Ellsworth, while Abilene, to the east, was still the main trailhead. Salina had a more established and tranquil rural population already living along the river and had provided last-stop services to the Smoky Hill Trail travelers prior to the arrival of the railroad. Eventually, the railroad did bring in many more travelers and settlers to Salina. The company located its tracks a little to the north of the platted townsite, which allowed the city—including, for example, Mother Bickerdyke's hotel for Civil War veterans near the railroad depot—to develop out toward it. Worn wagon ruts can be seen in the foreground between the railroad and the town. The foreground is covered by a thick blanket of buffalo grass.

Photograph by Alexander Gardner (1867)
Photograph courtesy J. Paul Getty Museum
Los Angeles, CA
Albumen silver print
12^{15}/$_{16}$ × 18^{11}/$_{16}$ in. Mount: 19 × 24 in.

45B. Salina, Kansas (1996)

This photograph was taken just north of the UP lines. It shows how the railroad became the agricultural transport center, with tracks closer to the river and the old town than to the development northward toward the Interstate. The old Gooch elevator shown in this print has been demolished since this photograph was made, as the city's economy has since diverged away from rail traffic in favor of the transport trucks coursing over I-70 and I-135 that intersect immediately to the northwest of the city.

Photograph by John R. Charlton (1996)

46A. Indian Inscription Rock, at Indian Cave, on Mulberry Creek, Kansas (1867)

After departing Salina, Gardner began nearing "Indian Country." Gardner took this first photograph of the best-known American Indian petroglyph in the state. It was as famous in Gardner's time, which is why he left the rail line with its armed escort to photograph it. In June 1867, a writer for *Harper's Weekly* had already published an article describing the petroglyph. He had accompanied the UPED survey team when they were setting the route for the tracks. The article had included an engraving made from a surveyor's sketch of the cave and petroglyph shown in this photograph. The ancient Pawnee carving on the south-facing Dakota Sandstone surface of the cave site is of a large resting figure. The inside surface of the cave is filled with small petroglyphs. The author of the *Harper's* piece theorized that if an individual buried nearby the cave "resembled his effigy as is carved upon his monument, [then he] must have been 'one of the most remarkable men of the country.'"[3]

Photograph by Alexander Gardner (1867)
Photograph courtesy J. Paul Getty Museum
Los Angeles, CA
Albumen silver print
13 × 18¹¹/₁₆ in. Mount: 19 × 24 in.

46B. Indian Inscription Rock, at Indian Cave, on Mulberry Creek, Kansas (1996)

An earlier repeat photograph showed the petroglyph partly obscured by a walnut tree tapping the spring below the cave. Bullet holes were visible on the eyes and face of a resting figure. Vandalism and graffiti seem to curse such sites. A smaller eastern cave entrance was on the right.

This 1996 repeat view reveals the bright golden hues of newly exposed Dakota Sandstone after the entire surface layer of the bluff had collapsed due to weathering and recent undercutting by the spring below the rock. Some of the old interior graffiti and petroglyphs still remain inside and on the cave wall, and a few new initials have appeared on the new stone surface. The resting figure petroglyph now lies in the piles of sand on the slope below.

Photograph by John R. Charlton (1996)

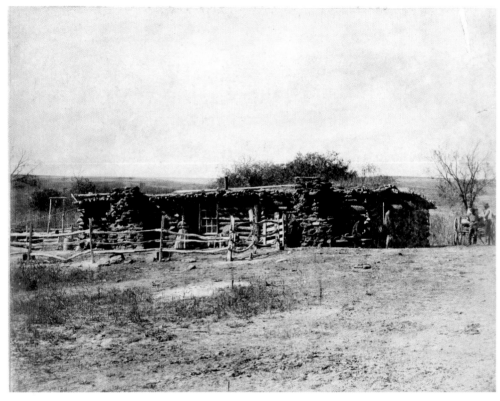

47A. A Ranche at Clear Creek, Kansas (1867)

This log cabin in the Spring Creek Valley near Inscription Rock provided a stopping point for Smoky Hill Trail travelers. An article in *Harper's Weekly* referred to this place as "Look's Ranche on Spring Creek in the Spring Creek Valley." The writer described the ranch as a "'home station' for overland mail—a mixture of 'hotel,' 'grocery,' and farm-house famous for serving 'square meals;' and here the returning plainsman gets his first glimpse of home and civilization."[4]

The chimneys are made with local sandstone and the roof is sod. The family had a pet deer that is standing in the shadow on the right side of the cabin. Gardner also took a stereograph photograph of the cabin and family, which William Bell had made into an engraving for his *New Tracks in North America*. Without any attribution to Gardner, Bell labeled the engraving "A Mormon Family" to illustrate a Mormon family living near Salt Lake City, Utah. It is highly unlikely that this actual Kansas family was Mormon, and besides, even if it were it lived nowhere near Salt Lake City. Nonetheless, this photograph suited Bell's need to illustrate a Mormon family, since he apparently took no actual photographs of Mormons while traversing Utah. Bell's use of this image in his book seems bizarre, but as in the Grasshopper Creek image he substituted stereotypes for reality.

Photograph by Alexander Gardner (1867)
Photograph courtesy Spencer Art Museum
University of Kansas
Lawrence, Kansas
1978.0026.07

47B. A Ranche at Clear Creek, Kansas (1996)

The cabin was replaced by a frame house that has deteriorated to nothing more than a foundation covered in weeds in the middle of a farm field. The house must have been standing in the 1930s. An electric wire post, dating to the early days of rural electrification, still stands by the ruins. Little else at the site reminds anyone of its historical connection to overland travel across the grasslands prior to railroad building.

Photograph by John R. Charlton (1996)

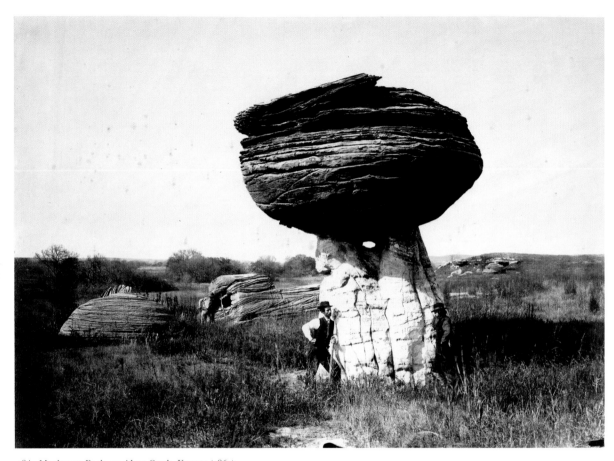

48A. Mushroom Rock, on Alum Creek, Kansas (1867)

This unusual rock formation, technically large Dakota Sandstone concretions perched above Kiowa Sandstone pedestals that are eroded below, forms shapes that appear like stone mushrooms or pulpits. The writer for the *Harper's Weekly* piece, "The Kansas Pacific Railroad," labeled this same formation as "Pulpit Rock on Alum Creek," and had an engraved illustration of it included in the article to portray its unique shape.[5] Gardner drove his wagon away from the UPED rail line in order to reach this location. In Gardner's shot appear a couple of armed escorts who are posing with James Gardner, who is standing beside the rock. Although a couple of recently engraved initials and the dates 1865 and 1867 appear on the soft pedestal surface, there are no obvious American Indian markings on it. Perhaps the lack of any engraving indicates a reverence for this unusual formation.

Photograph by Alexander Gardner (1867)
Photograph courtesy J. Paul Getty Museum
Los Angeles, CA
Albumen silver print
13$^{3}/_{16}$ × 18$^{11}/_{16}$ in. Mount: 19$^{3}/_{16}$ × 24$^{1}/_{16}$ in.

48B. Mushroom Rock, on Alum Creek, Kansas (1997)

Mushroom Rock now stands prominently in the well-visited Mushroom Rock State Park, a few miles north of Kanopolis State Lake. Although the grass is mowed around the formations, the unmoved grasses and trees around it are higher, and they obscure the formation from the road to the north. The riparian tree growth on nearby Alum Creek also obscures the view beyond it, as seen in Gardner's photograph. The area is fenced off from surrounding pastures with barbed wire. Over the years thousands of initials, names, and dates have been inscribed on top of each other on the pedestal. The sandstone concretion seems unscathed due to its height and relative hardness. The large round shape also protects the softer pedestal supporting it from erosion if not people.

Photograph by John R. Charlton (1997)

49A. Indian Hieroglyphic Rock, on Smoky Hill River, Kansas (1867)

Gardner and his escort traveled several miles south of Mushroom Rock to another petroglyph site along the base of a long, high Dakota Sandstone bluff overlooking the Smoky Hill River. Gardner photographed the huge outcrop with escort party members scattered along the individually carved panels along the base. Some spalling appears below the bluff, and mixed grasses grew on the hillside below. Proto Pawnees, who once lived and farmed along the river before invading peoples drove them away, carved the hieroglyphs.

Photograph by Alexander Gardner (1867)
Photograph courtesy J. Paul Getty Museum
Los Angeles, CA
Albumen silver print
13^1/$_{16}$ × 18^1/$_2$ in. Mount: 19 × 24 in.

49B. Indian Hieroglyphic Rock, on Smoky Hill River, Kansas (2001)

This photograph was taken from a higher vantage point on a boat on Lake Kanopolis. The lake is a reservoir formed by damming the Smoky Hill River and forms part of the state parks and reservoirs system. The Army Corps of Engineers dammed the river in 1955. Over the years, as varied watermarks above the shoreline indicate, variations in rainfall have caused the lake levels to rise and fall. At some point the lake rose to a level near the base of the sandstone bluffs where the inscribed panels are. High lake levels have eroded the sandstone and have caused several panels above to spall. Vandals have also damaged the remaining panels, which has resulted in the park staff closing off the area to unauthorized persons. From a boat, a few panel carvings can still be seen with binoculars.

Photograph by John R. Charlton (2001)

50A. Indian Hieroglyphic Rock, on Smoky Hill River, Kansas (1867)

Gardner took this closeup photograph of an inscribed panel at the base of a large outcropping of Hieroglyphic Rock. As of now, the meaning behind these Proto Pawnee Indian petroglyphs is unknown. Images of humans, animals, stars, and possibly superhuman beings are carved into the sandstone. Equinox solar calendar carvings found nearby may have served as the means for timing planting seasons. There were no words or dates carved in the sandstone panels when Gardner photographed the site. Gardner included this detailed photograph in his 1869 album, titled *Across the Continent on the Kansas Pacific Railroad*, which included photographs made of the entire survey route from eastern Kansas to the Pacific Ocean coastline. By the time Gardner published this album, officials had changed the name of their company from the Union Pacific Railway Company, Eastern Division, to the Kansas Pacific Railroad.

Photograph by Alexander Gardner (1867)
Photograph courtesy DeGolyer Library
Southern Methodist University
Dallas, TX
Ag1982.0214

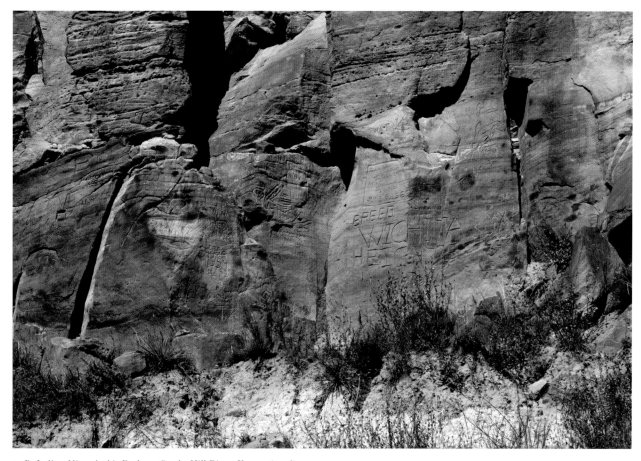

50B. Indian Hieroglyphic Rock, on Smoky Hill River, Kansas (1996)

This rephotograph reveals the effects of spalling on the right panel due to high lake levels of the Kanopolis Reservoir. Dates, names, and the high school "Wichita Heights" have been carved into the spalled surface. Ironically, Wichita was the name for the American Indian peoples who had occupied the region at least two thousand years prior to white settlement. In a graphic manner, these inscriptions represent Euro-American culture nearly erasing previous occupants' effects in shaping and giving meaning to the landscape. Some unspoiled petroglyphs remain above the newer graffiti. The left panel is largely intact and retains several Proto Pawnee petroglyphs that Gardner had photographed. It also has words and dates carved below that date back to 1954, before the Corps built the dam and reservoir. The blue markings are attempts to copy the petroglyphs.

Photograph by John R. Charlton (1996)

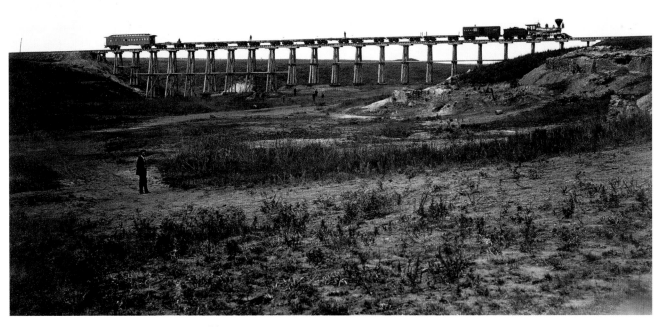

51A. Trestle Bridge Near Fort Harker, Kansas (1867)

This bridge was located a few miles west of Mushroom Rock, where the line crossed a wide draw between two close hills. This view from the south shows an empty supply train stretched across the bridge, headed east for more rails and ties for the western railhead construction. The train is stopped so Gardner can photograph it along with several workers posing on the empty flatbed cars. Several more individuals pose in the draw below the base of the trestle with another standing in the foreground. Below the bridge on the eastern base is a rock dugout for protecting the workmen from American Indian attacks during the trestle construction while the train was away being resupplied.

Photograph by Alexander Gardner (1867)
Photograph courtesy J. Paul Getty Museum
Los Angeles, CA
Albumen silver print
$13^{1}/_{16} \times 18^{1}/_{2}$ in. Mount: $19^{1}/_{16} \times 24^{1}/_{16}$ in.

51B. Trestle Bridge Near Fort Harker, Kansas (1996)

This more recent view shows that the draw has been completely filled in with earth, probably dumped from train cars above. Now the tracks simply cross solid ground. The old trestle bridge is probably embedded in the mounded earth. Trees below indicate the flow of occasional rain runoff through a culvert through the mound. The area of the dugout in Gardner's photograph shows that the stone for the dugout has been removed, but the cuts in the embankment made for the dugout are still visible.

Photograph by John R. Charlton (1996)

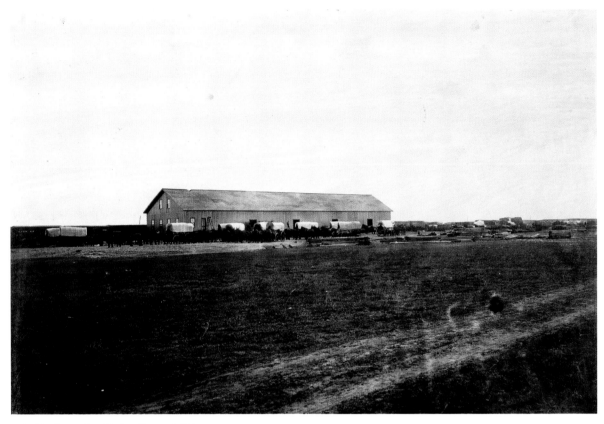

52A. *Warehouse, Fort Harker, Kansas (1867)*

This is the supply warehouse beside the main UPED tracks that were north of Fort Harker. A side track leads down to Fort Harker. This warehouse served not only Fort Harker but also the western forts of Hays and Wallace. The wagon on this side of the warehouse could be loaded with supplies bound for Forts Larned, Zarah, and Dodge that guarded the Santa Fe Trail to the south. At this time, Plains Indian nations that regarded the UPED railroad construction as a serious threat to their hunting cultures were actively engaged in attempting to disrupt the construction crews. Exemplified by the stacks of iron rails to the east of the warehouse, the company had no intention of halting its construction efforts. Given the activity at the forts, the federal government had every intention of protecting the Santa Fe Trail

trade and the construction of the UPED line. Several Army commanders, including General Hancock, for example, believed that the successful construction of the railroad and the implementation of its operations meant the certain end of American Indian presence on the High Plains.

Photograph by Alexander Gardner (1867)
Photograph courtesy J. Paul Getty Museum
Los Angeles, CA
Albumen silver print
$12^{15}/_{16} \times 18^{5}/_{8}$ in. Mount: 19 × 24 in.

52B. Warehouse, Fort Harker, Kansas (1996)

Old freight cars are parked on the sidetrack south of the main line at the site of the fort's old depot/warehouse. A track once leading south to the fort and later leading to the Kanopolis brick plant can be seen on the right. Taller grasses now obscure part of the track as well as any remaining buffalo grass. Trains lightly travel on this portion of the Union Pacific line, and the sidetrack is only used for empty, parked cars. The old cars seen in this photograph have been parked on this siding for years.

Photograph by John R. Charlton (1996)

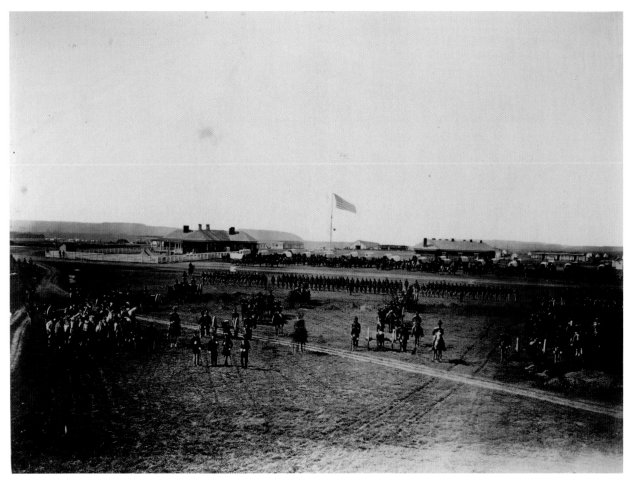

53A. Fort Harker, Kansas (1867)

In 1867, the Army relocated Fort Harker after summer flooding along the Smoky River had inundated the post formerly named Fort Ellsworth. The new location, pictured here, sat on higher ground above the valley. New permanent stone buildings and temporary wooden structures seen in this photograph overlook the parade ground. Most likely Gardner took this shot from a train engine or rail car at the east end of the fort. The entire fort garrison, including its cavalry, mounted officers, and canon, is assembled on the parade ground. Gardner took this photograph to convey confidence in the strong and recently fortified military presence in the area. A giant Union Jack unfurls in the strong southern wind at the west end of the grounds over the assembled troops.

Photograph by Alexander Gardner (1867)
Photograph courtesy DeGolyer Library
Southern Methodist University
Dallas, TX
Ag1982.0214

53B. Fort Harker, Kansas (1996)

After the Indian Wars the Army decommissioned the fort, and agricultural towns emerged and grew, including Kanopolis. The wooden buildings of the fort are long gone, but several buildings of Dakota Sandstone, including the former officers' barracks and the post jailhouse, still stand in the center of town. Today they are residences as well as tourist sights. The Kanopolis brick plant at the east edge of town took advantage of the fort's old side rails to market locally manufactured bricks. The plant served as the main employer in Kanopolis for years. The state historical society staff has made efforts to research the old fort site. In the center of this picture stands a tornado siren, located in a park on the former parade grounds surrounded by residences of the small quiet town. Buffalo grass remnants in the park hearken back to a time when this grass blanketed the entire region.

Photograph by John R. Charlton (1996)

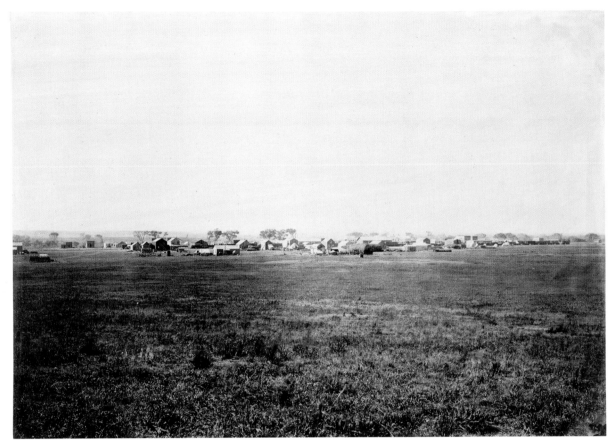

54A. Ellsworth, Kansas (1867)

The town of Ellsworth was only three months old when Gardner arrived there. The "old town" of Fort Ellsworth, just west of Fort Harker by the Smoky Hill River, had been washed away by spring flooding in 1867. The new Ellsworth was built a few miles west on a hillside overlooking the Smoky Hill River. It was already giving Abilene stiff competition for control of the Chisholm Trail cattle trade, and soon its cow town status would make its new sheriff, Wild Bill Hickok, a western legend. Gardner's view of the town is taken from the north, with the trees lining the Smoky Hills visible in the distance. The railroad depot was in the middle of town with the UPED line running east and west. Mainly saloons and billiard halls flourished on the south side of the tracks. To augment the cattle trade, stockyards and loading pens would soon line the railroad.

Photograph by Alexander Gardner (1867)
Photograph courtesy J. Paul Getty Museum
Los Angeles, CA
Albumen silver print
$12^{15}/_{16} \times 18^{5}/_{8}$ in. Mount: $19 \times 24^{1}/_{16}$ in.

54B. Ellsworth, Kansas (1996)

This rephotograph was taken from a shaded neighborhood on the hillside north of town. The city has maintained its character as a historic, rural cow town, in part because Interstate 70 was constructed several miles to the north of the city limits, and consequently fewer fast food franchises and less highway commerce have effected it. It remains prosperous and proud of its notorious western heritage. The same Smoky Hills that Gardner's photograph captures are visible in this one across the river between the tall shade trees in midframe.

Photograph by John R. Charlton (1996)

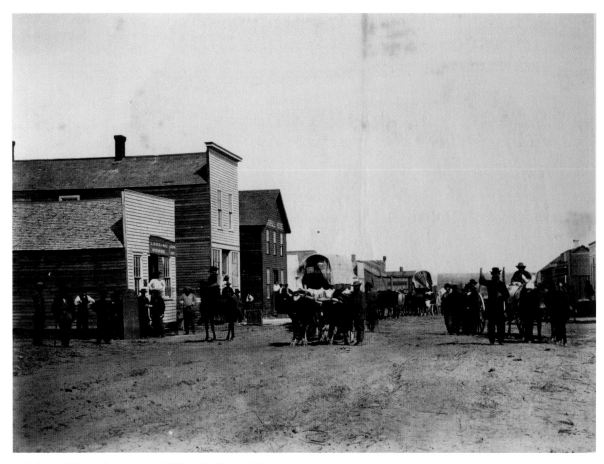

55A. Santa Fe Train Passing through Ellsworth, Kansas (1867)

Gardner is facing north, taking a photograph of oxen-pulled Santa Fe Trail trade wagons ready and loaded for the journey. The wagon owners and townspeople are lined up in front of new clapboard buildings and are posing for Gardner's camera. This part of town lay south of the tracks, and in this frame appear many advertisements for lodging and restaurants intended for cowboys flush with pay and Smoky Hill Trail travelers on their way west to Santa Fe or the Rocky Mountains. Drivers headed to Santa Fe approached a crossing on the Smoky Hill River to the south of Ellsworth, a site that Gardner also photographed (see photographs SS144 and SS145). In a few years, Joseph McCoy would relocate his Drover's Cottage to this part of town and build a stone mansion on the hill across the river so he could oversee his cattle and saloon operations.

Photograph by Alexander Gardner (1867)
Photograph courtesy DeGolyer Library
Southern Methodist University
Dallas, TX
Ag1982.0214

55B. Santa Fe Train Passing through Ellsworth, Kansas (1996)

Today Walnut Street is named Douglas Street, and also as State Highway K-14 it connects to U.S. Highway 56, which follows the old Santa Fe Trail diagonally across the state. Some historic sandstone buildings still stand up the street on the south side of the tracks. Joseph McCoy's stone mansion survives on the hill south of the river overlooking the town. The riverbanks above the old crossing have been excavated and filled for the bridge structure.

Photograph by John R. Charlton (1996)

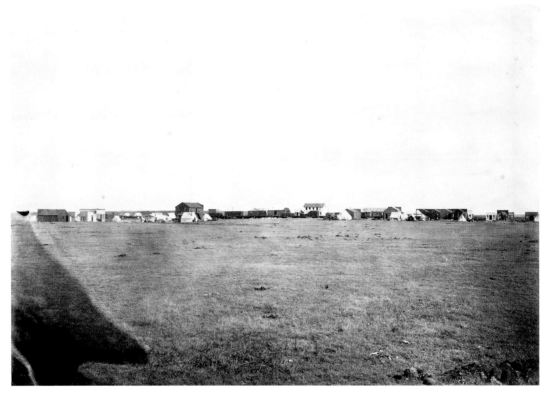

56A. Hays City, Kansas, Aged Four Weeks (1867)

Some contemporaries called Hays City "Hell on Wheels," a phrase describing a roving collection of wagon-borne businesses, such as bars, brothels, and gambling houses, that followed railroad construction crews. These businesses, not known for their decorum, lived up to their trademark. Hays, merely a four-week-old town consisting mainly of railroad workers, bars, and a lodging house or two, which were mainly tents with storefront facades, quickly established a well-deserved reputation for resembling Hell on Wheels. In its early years, the residents of Hays failed to the meet the standards of "civilization" that Copley and his peers thought the railroad would bring to the Great Plains. As did Abilene and Ellsworth before it, Hays would take its turn to serve as a shipping point for Texas cattle and also become a new battleground for drunken cowboys, soldiers,

townspeople, and Wild Bill Hickok. Tent structures that suggest the beginnings of town development dot both the north and south sides of the tracks. Soldiers stationed at nearby Fort Hays were patrolling stage lines, railroad construction, and wagon trains besides pacifying High Plains Indian peoples. In Gardner's photograph, buffalo grass covers the entire area, indicating how town development preceded any agricultural development in this vicinity.

Photograph by Alexander Gardner (1867)
Photograph courtesy J. Paul Getty Museum
Los Angeles, CA
Albumen silver print
$13 \times 18^{11}/_{16}$ in. Mount: 19×24 in.

56B. Hays City, Kansas (2006)

Hays serves as the county seat of Ellis County. Its courthouse is pictured on the left side of this photograph. Union Pacific tracks still run east and west through the middle of downtown Hays. Plaques on the buildings on each side of the tracks give brief histories of the earliest town establishments—saloons, hotels, brothels, and other cow town businesses. The city is now one of the largest in western Kansas and has a diverse economic base, including Fort Hays State University. The streets around the courthouse are brick, and the New Deal, Works Progress Administration–style courthouse was built with local fencepost limestone.

Photograph by John R. Charlton (2006)

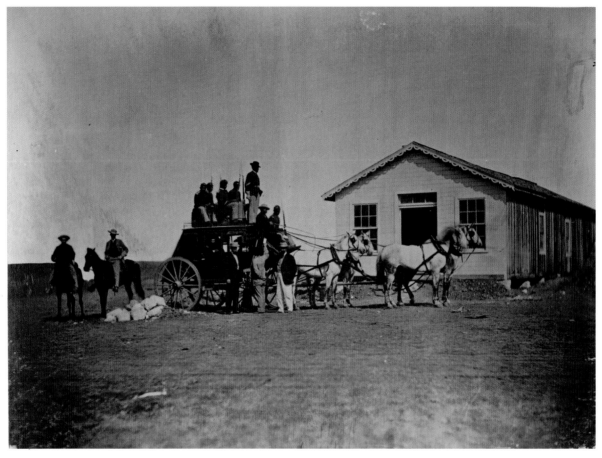

57A. United States Overland Stage Starting for Denver from Hays City (1867)

When Gardner took this photograph, Hays was the last rail stop on the UPED line. From this point to Denver and beyond, travel was either by stagecoach, covered wagon, horse, or, worse, by foot (not recommended by anyone at the time). Gardner took this photograph looking from the south of the tracks, and it takes in the Butterfield Overland station, which was one of the few frame buildings in Hays at the time. Buffalo soldiers from the fort rode on top of the stage to protect the mail and passengers and to shield the driver from American Indian attacks, which were happening with increasing frequency to anyone who transgressed the buffalo grounds. Two railroad commissioners stand beside the stage, ready to travel west to inspect construction progress on the line. William Bell used this Gardner image as an engraving in his *New Tracks*, but he incorrectly labeled it as Fort Wallace and neglected to attribute it to Gardner.

Photograph by Alexander Gardner (1867)
Photograph courtesy DeGolyer Library
Southern Methodist University
Dallas, TX
Ag1982.0214

57B. United States Overland Stage Starting for Denver from Hays City (2006)

Today, a plaque with a brief history of the Butterfield Overland Dispatch and the early days at Hays can be found on the current storefront at his location. Historic buildings remain in the area, and newer ones as well, made from locally quarried limestone. Fort Hays Niobrara Limestone has excellent structural qualities proven to withstand weathering unlike the Smoky Hill Niobrara Limestone found farther to the west.

Photograph by John R. Charlton (2006)

When Gardner arrived at Hays, Kansas, he had reached the last fledgling urban outpost on the UPED line. From this point on west, no rail line connected the Front Range cities of Colorado. No farmers cultivated the western third of Kansas, and Colorado was still a federal territory with only a minute scattering of settlements within the eastern third of its boundaries. By 1920, the western half of Kansas and the eastern third of Colorado had reached the apex of population growth. Several railroads, besides the Union Pacific, had fostered stock raising and farming in this, the High Plains of North America. The entire economy of the region depended upon railroad connections to ever-growing urban markets in the industrial East and the great urban shipping cities along the West Coast. When the economies in the East and West Coasts would sneeze, the economy on the High Plains caught pneumonia, as it did after World War I and then again during the Great Depression.

After World War II, mechanized farming along with automobile transportation and highway construction completely recast the economy of the region and stimulated a population decline that has continued unabated into the present. Cities and townsfolk no longer relied exclusively on railroad transportation for themselves or their products. As a result, several towns completely lost their economic relevance and population and were left unincorporated. The technology of farming, especially that of center-pivot irrigation, dramatically changed the ecology of agriculture with corn now one of the main crops harvested for the feeding operations of mega feedlots that supply huge meat-processing plants in a few cities in western Kansas and Nebraska. The region is starting to have a more open feel to it, perhaps similar to that of Gardner's time. But the ecosystems of the region resemble little, if at all, those of 1867. The UPED and other lines initiated an "American Empire" in the region, the reverberations of which, for good or ill, as revealed in the following photographs, are still felt today.

58A. On the Great Plains, Kansas, September (1867)

Gardner took this photograph between present-day Yocemento and Hays. The tree line in the background appears to follow Big Bend Creek, which flowed between Hays and Yocemento. The smaller cars with the doors open were most likely stockcars that hauled horses and mules. Toward the end of the train, horses are grazing and some small wagons are parked. The locomotive, towing freight cars loaded with construction materials, was well ahead of this disconnected train of passenger and boxcars.

Photograph by Alexander Gardner (1867)
Photograph courtesy DeGolyer Library
Southern Methodist University
Dallas, TX
Ag1982.0214

58B. On the Great Plains, Kansas, September (1996)

This photograph was taken from the same location as photograph 60B, only here the view is to the northeast. The trees along Big Bend Creek are similar in both Gardner's photograph and this one. State Highway K-40 is in the foreground with Interstate 70 a few miles farther to the north in the far distance. Rather than buffalo grass as in Gardner's times, the ground is now covered by hayfields and crops, including round hay bales just north of the line. New housing developments are being built, mostly on the south side of the highway between Hays and Yocemento.

Photograph by John R. Charlton (1996)

59A. On the Great Plains, Kansas (1867)

This photograph shows railroad construction at the time well beyond Hays and out onto the open Great Plains. The landscape in this photograph bears fully the marks of management and occupation by American Indian peoples. The "new agent of civilization" had just begun entering this realm of the High Plains. Gardner took this photograph looking to the west, and it reveals a series of high ridges capped by limestone several feet above the flat plains where construction crews were laying track. The UPED line paralleled these ridges as it moved westward for several miles past Fort Hays. The construction train is stopped nearby, perhaps so the seated group of workers could lunch while the mounted figures on top of the ridge rode looking for any signs of approaching trouble.

Photograph by Alexander Gardner (1867)
Photograph courtesy DeGolyer Library
Southern Methodist University
Dallas, TX
Ag1982.0214

59B. On the Great Plains, Kansas (1996)

This rephotograph shows the limestone ridge in Gardner's print still intact on the foreground bluff, but the ridge rock in the distance has been quarried, possibly by the railroad builders and probably by the workers at the Yocemento cement plant located below the bluff just north of Highway K-40. The factory now stands in ruins beside the Yocemento grain elevator. There is a slump on the slope in the foreground, indicating subsurface subsidence, perhaps caused by dissolution of salts and minerals from rainfall. Other sinkholes in western Kansas are caused by oil extraction in the oil fields. Large-scale grazing operations predominate in this part of the state while some small farms, like the ones in this photograph, still operate. The kind of farming republic envisioned by Copley and other writers following the promise of railroad building in the West never took hold, while vast changes to the ecosystems on the High Plains did. Farmers plant and harvest wheat and soybean fields and tend irrigated acres of corn and alfalfa for the cattle and meat-processing industries in the western portion of Kansas. Only fragments remain of the shortgrass High Plains ecosystem once controlled by American Indian peoples.

Photograph by John R. Charlton (1996)

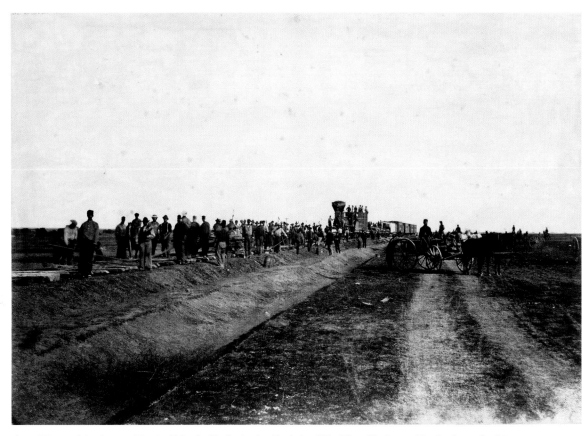

60A. "Westward the Course of Empire Takes Its Way"—Laying Track 600 Miles West of St. Louis, Mo. October 19th, 1867

This is the most iconic image that Gardner made in his railroad series. The title he gave it, "Westward the Course of Empire Takes Its Way," had become the motto of Manifest Destiny. William Bell even used the photograph as the lithographic frontispiece of his *New Tracks in North America*. Many in this large construction crew stand posed for Gardner, while some blurred figures are actually laying track. The locomotive engine, the *new* agent of civilization, looms behind the work force and appears almost impatient to begin its progress across the Plains. Several wagon teams—probably there for moving people and supplies, including Gardner and his darkroom equipment—pose beside them. Rail ties are being unloaded from a back car. Wanting to be in Gardner's photograph, the engineer leans out of the window of the locomotive. As shown by the title, Gardner was clearly proud of this image and was keenly aware of its significance to the series. This photograph of railroad building in progress has a dynamic that is not present in the iconic image of the two lines meeting at Promontory Point, Utah.

Photograph by Alexander Gardner (1867)
Photograph courtesy J. Paul Getty Museum
Los Angeles, CA
Albumen silver print
$13^{1}/_{16} \times 18^{3}/_{4}$ in. Mount: $19^{3}/_{16} \times 24$ in.

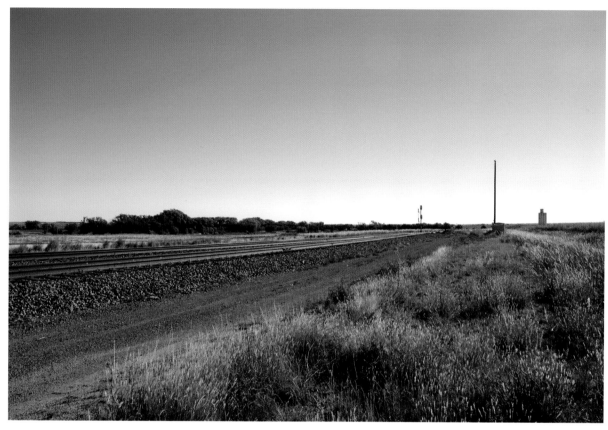

60B. "Westward the Course of Empire Takes Its Way" (October 2008)

The photograph of this "empire" has a funny kind of look to it today. It is a much quieter scene now on the eastern edge of Trego County, with the Riga elevator in the distance, than it was during the heady days when Gardner traveled the land. The agent of civilization has run its course, and it now forms just one of the three major modes of transportation in the United States along with automobiles and airplanes. The Union Pacific trains now largely haul freight and raw natural resources, such as grain crops, to large urban markets. The line runs parallel to Interstate 70, and the fields of grass surrounding the tracks range from imported varieties, such as brome and alfalfa, which are used for cattle grazing, to reintroduced mixes and shortgrass prairie mixes used for soil conservation and subsidized by the federal government. A dwindling population owns ever-larger expanses of range and farmland. Since World War II, population declines in this portion of the state have resulted in some counties that only have one town remaining, the county seat. Other towns are no more than a name on the map, having long lost their economic relevance. The UPED tracks never reached Colorado, and the company, renamed the Kansas Pacific Railway Company, went broke shortly after it reached the state line. Jay Gould bought up its assets for a song, then he sold them for a huge profit to the Omaha-based Union Pacific Railroad Company, still the parent company today.

Photograph by John R. Charlton (2008)

61A. On the Great Plains, in Kansas, near Monument (1867)

Gardner mounted his photographs on boards, and he labeled each board with the title of the print and the distance in miles from the eastern border of Kansas to the location where he took his photograph. While the place name on the board, "Monument," might have meant something in 1867, it has lost its relevance today. Fortunately, the railroad miles printed on the boards help provide accurate information as to where Gardner took his photographs. In 1867, beyond Hays, only the Butterfield Stage stations stood along the route heading to Denver. Monument happened to be one of the stage stations, but the UPED surveyors had routed the rail line several miles to the north of the stage route along the Smoky Hill River.

Gardner was now headed to New Mexico to meet General Palmer, who was in charge of the 35th parallel survey for the Union Pacific Railway Company, Eastern Division. While en route, he took this photograph from the western edge of Trego County. A formation later called Wildcat Canyon was just to the east of this location. The high bluffs that appear far away just above the western horizon in his photograph are a conglomerate rock strata that caps the Niobrara Chalk beds. A horse on the right and several others in the distance are grazing on the sagebrush, and buffalo grass is growing on the chalk beds. This entire area appears to have been previously and heavily grazed, perhaps by migrating bison herds.

Photograph by Alexander Gardner (1867)
Photograph courtesy DeGolyer Library
Southern Methodist University
Dallas, TX
Ag1982.0214

61B. On the Great Plains, in Kansas (1996)

Farmers now cultivate the chalky sage land, turning it into expansive cropland with contour planting to prevent soil erosion. The capped chalk bluffs can still be seen on the horizon although the foreground is changed due to many years of cultivation. Some dryland farming, like that pictured in this photograph, is still practiced in this area, though many other farmers have turned to center-pivot irrigated fields of corn and alfalfa. The great worry among many economists, ecologists, and farmers is how long the Ogallala Aquifer can continue to supply water for this type of crop production. And when the water runs out, then what?

Photograph by John R. Charlton (1996)

62A. Castle Rock, Kansas, on the Smoky Hill (1867)

Castle Rock is several miles north of the Smoky Hill River on the Smoky Hill Trail. It was a landmark for travelers as well as the Butterfield Overland stage drivers. It can be seen from miles away along with the high bluffs from which it eroded long ago. The chalky limestone formation was made from plankton that settled in the beds at the floor of an inland sea that covered nearly all of present-day Kansas some 82 to 87 million years ago. UPED geologist John LeConte discovered the fossilized remains of giant sea reptiles and flying reptiles in 1867. His discoveries led to competing paleontological expeditions from academic institutions in the east and the eventual founding of the Kansas Geological Survey at the University of Kansas. Gardner had fellow survey members pose on the rock for his picture. The ground cover here is sagebrush and chalk.

Photograph by Alexander Gardner (1867)
Photograph courtesy DeGolyer Library
Southern Methodist University
Dallas, TX
Ag1982.0214

62B. Castle Rock, Kansas, on the Smoky Hill (2001)

Several previous photographs of this formation document the incremental erosion of the powdery chalk limestone supported by shale and capped by weather-hardened marl. However, in the summer of 2001, a hard, driving rainstorm triggered a cataclysmic collapse of the Castle's last towering spire, the collapsed mass shown here to the right of the remaining formation. Although the shale base remains firm, the chalk limestone will continue to dissolve into the ground. Eventually the day will arrive when Castle Rock as an identifiable formation will be forever lost.

Photograph by John R. Charlton (2001)

63A. "Spanish Bayonet," on the Great Plains in Western Kansas (1867)

Although this print was mounted on a Kansas Pacific Railroad board in Gardner's studio and he was identified as its photographer, William Bell actually took this photograph in late June 1867. The railroad company owned all the photographs that both Gardner and Bell had taken, and the company officials determined which photographer eventually ended up with which prints. Consequently, Bell ended up with several of Gardner's photographs that he used as engravings in his published works, and Gardner, likewise, also received several of Bell's glass plates that he incorporated into his photographic album depicting the 35th parallel expedition led by William Jackson Palmer. Gardner gladly incorporated Bell's photographs of places where he had not traveled. While the glass plate for this print was badly cracked, the resulting print is of a flowering plant, which seems to suggest that the Great Plains were not always desert. Moreover, yuccas thrived in the absence of bison that eagerly enjoyed eating them. This is an indicator that bison herds were in retreat from what had once been rich grazing grounds for them. The mounds around the yucca base are prairie dog mounds.

Photograph by Alexander Gardner (1867)
Photograph courtesy DeGolyer Library
Southern Methodist University
Dallas, TX
Ag1982.0214

63B. "Spanish Bayonet," on the Great Plains in Western Kansas (1999)

This photograph was taken at the end of the yuccas' blooming season in June. The blooms on this particular plant have survived because it is growing outside of a barbed-wire fence that contains cattle behind it. As bison would have done, cattle would have eaten all of the blooms off of the yucca if it had been growing on the other side of the fence. Cattle find yucca blooms to be one of their favorite foods. Indeed, the blooms are sweet and make a tasty gourmet garnish on a salad.

Photograph by John R. Charlton (1999)

STEREOGRAPHIC PAIRINGS

Alexander Gardner took many more stereographic photographs than he made in the imperial format. Stereo photographs had immense popular appeal given their 3D effects, and Gardner, being the astute businessman he was, certainly understood the potential market for these photographs.

Charlton undertook a unique method for rephotographing Gardner's stereo prints. He used his own 35mm stereographic camera to rephotograph Gardner's views, and then he replaced the right-hand views in Gardner's print with the right-hand view from his stereo prints. This juxtaposes past and recent views of the same place.

Gardner changed the way that he numbered all of his stereo prints. On his imperial prints, he set the mile indicators to represent the distance from the Missouri-Kansas state line. The stereo mileage indicators, on the other hand, represent the distance from St. Louis, where the UPED headquarters were. Each stereo photograph is numbered in the order that Gardner took his photographs, and the "SS" before each number has been added by Charlton and is shorthand for "stereo series."

All of the following Gardner stereographic photographs are housed in the Kansas State Historical Society Museum, and they represent only a small selection from the over 150 Gardner photographs in the museum. All of these are reprinted courtesy of and by permission of the society.

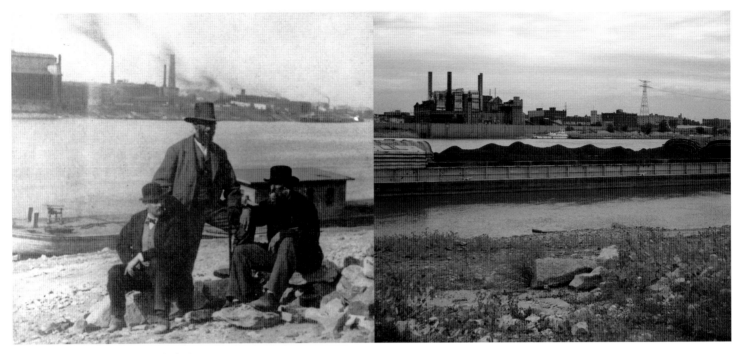

SS6. Col Chas. Lamborn and Friends, St. Louis

The principle company officers of the UPED came to the east bank of the Mississippi River in East St. Louis, Illinois, via ferry, to greet Alexander Gardner and escort him to their offices across the river. Gardner took the occasion to make a portrait of these officials seated before the ferry, the river, and the west shoreline of St. Louis, Missouri. On the left is Adolphus Meier, vice president of the company and owner of the mill on the opposite shore. In the center is Charles Lamborn, company secretary. On the right sits company president John D. Perry. Eads Bridge was in the initial stages of construction, and as yet there was no connection for the railroads from east to west across the river at St. Louis.

Today several bridges span the river, including Eads for light traffic, and massive levees line both banks. The river traffic consists mainly of low barges rather than the high smoke-stacked riverboats of Gardner's time. The 2012 summer almost saw the river levels so low that big barges like the one in Charlton's 1994 view could barely pass due to the drought afflicting the entire Mississippi River Valley system. The building across the river on Laclede's Landing was the defunct Laclede Power Station, and after 1994 it was demolished.

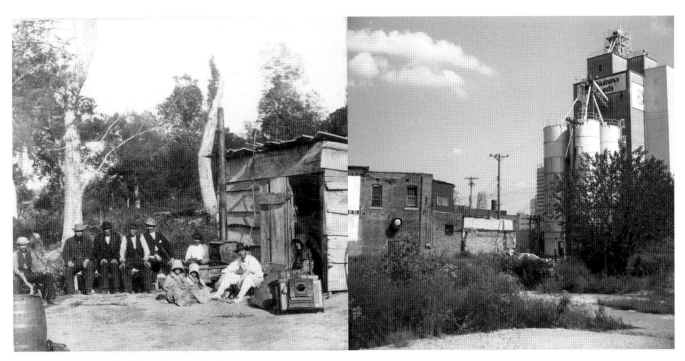

SS12. Hotel de Dutton, State Line, Kansas. 284 mi.

Near the new State Line Hotel and depot, where Gardner and the railroad commissioners stayed in the West Bottoms, was this humbler lodging for poor immigrant travelers. In photograph 7A, several of these same immigrants posed for Gardner's view down the Kaw with the new railroad bridge in the background. The people staying in the Dutton planned to take the railroad, hoping for new lives in Kansas. The commissioners and railroad guests staying in the State Line Hotel, on the other hand, traveled to the end of the line and then returned along the same line. Gardner, however, continued past the end of the tracks and photographed sites along the future proposed survey line, ending with a photograph of Seal Rock near San Francisco, California.

The West Bottoms became a bustling railroad industrial center with storehouses, holding pens, and slaughterhouses for the Texas cattle being shipped in from the western railheads at the end of the Chisholm Trail. Over the next century the industries in the Bottoms shifted to other parts of the state, and the area district became abandoned and dilapidated, as shown in this 1993 image with the high loess bluffs in the background and the Power and Light deco skyscraper in the middle of downtown Kansas City, Missouri, in the center background. That part of downtown Kansas City has since been revived as an active nightlife destination with restaurants and bars.

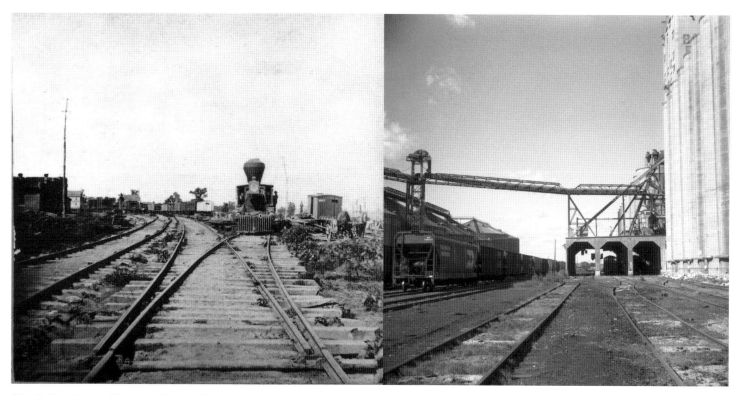

SS15. Railroad Yard at Wyandotte, Kansas. 286 mi.

By the time Gardner took this photograph, the UPED yards in the Kaw River bottoms had assumed major proportions. This was the main staging ground for all UPED traffic, and this photograph shows the same train that is in his imperial print (see photograph 9A).

Nonetheless, river bottom brush still grew along and in between the tracks. When Charlton took his 1993 photograph, the rail yard only served the vast wheat production of central and western regions of Kansas, a partial realization of the economic empire envisioned by the UPED promoters and investors.

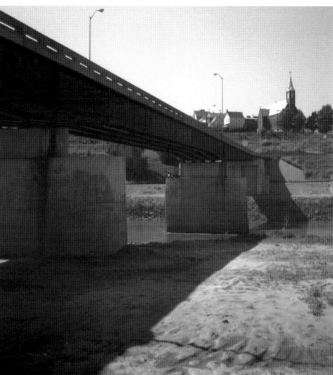

SS17. Building Bridge across the Kaw at Wyandotte. 286 mi.

This view across the Kaw River looking west shows the upstart town of Wyandotte, Kansas, on the bluff. Three Wyandots and four Anglo-Americans formed the original town company. The town company president, a Wyandot by the name of Silas Armstrong, operated the first ferry crossing on the Kaw River beginning in 1858. In 1867, companies began constructing two bridges across the Kaw: one a wooden bridge, and the other this one in Gardner's photograph, a $62,000 iron bridge that connected Wyandotte to Kansas City, Missouri.

When Charlton took his photograph in 1993, the iron bridge had long been replaced by this highway bridge. The west bank of the river has been reinforced with riprap to prevent erosion, and the railroad tracks are still in the same place as in Gardner's photograph. On the bluff is the Strawberry Hill neighborhood where immigrants from Croatia and other Slavic regions once arrived to work the meat-packing companies and stockyards located in the river bottoms. Today, the stockyards no longer exist and the meat-packing industries are relocated to the far western regions of the state.

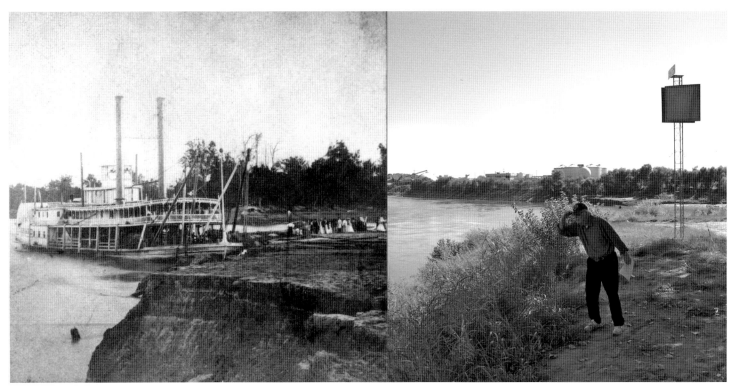

SS19. Steamer Mary MacDonald at Wyandotte, Missouri River, Kansas. 286 mi.

Captain James Gunsollis docked the *Mary MacDonald* in an eddy at the mouth of the Kansas River. Gardner appears to have photographed passengers either unloading or boarding the steamboat, which was designed for the Missouri River. This 563 ton, wooden-hull side-wheeler continued plying the river until it burned in 1873. Between 1854 and 1866, over thirty boats continued up the Kansas River before they bridged at Wyandotte and other points upstream. A decisive blow to river traffic occurred in 1864 when railroad company lobbyists induced the Kansas legislature to pass a bill declaring the Kansas River "unnavigable" and subject to bridging. Besides the act, riverboating on the Kansas River was an iffy proposition in the first place given the shallow, sandy-bottomed nature of the stream.

Charlton's friend Dan Merriam appears to be looking for the arrival of a boat. While at first glance Charlton's 2008 photograph of the junction of the Kansas and Missouri Rivers seems similar to its 1867 appearance, the industrial aspects of the bottoms are visible with the communication tower in the foreground and the oil and grain storage facilities in the background.

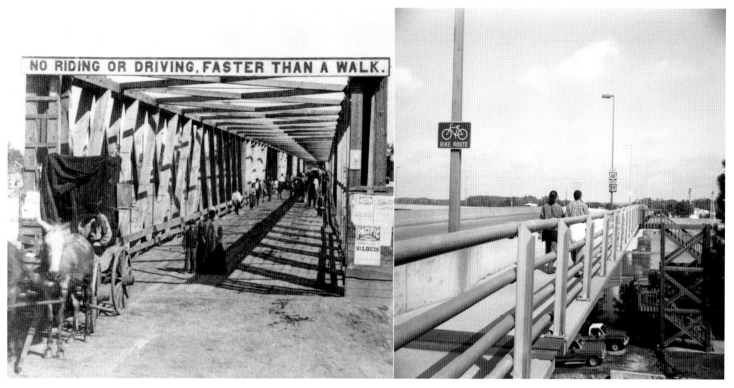

SS28. View Looking across Turnpike Bridge at Lawrence, Kansas. 323 mi.

Alexander Gardner, in his mule-driven portable darkroom at the south end of the bridge, turns around to see the pedestrians and equestrians who were posing for this view taken by his brother, James. The intent here was to produce a 3D effect of the structure with Gardner in the foreground, which was an obvious choice for a stereographic image. The Lawrence citizenry had been alerted to Gardner's arrival that day in Lawrence, and the *Tribune* reported on Gardner's mission in the city that day, September 21, 1867. Handbills on the bridge end include a prominent advertisement for the new railway connection to St. Louis.

The most recent of several bridges over the Kaw at Lawrence was double span: one for northbound traffic and the other for south-bound. Here the northbound span has an older bridge abutment below it from a previous bridge, although it is not from the turnpike bridge in Gardner's picture. The new bridge is also much higher over the Bowersock Dam, which was built later in 1874. Since 1993 the dam has been modernized to accommodate the flow rate for the recently constructed powerhouse of the Bowersock Mills and Power Company on the north bank beside the bridge.

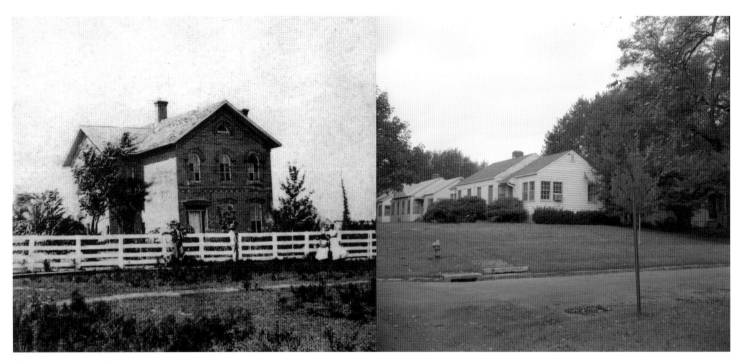

SS40. Gen. J. Lane's House, Lawrence, Kansas. 323 mi.

At the far western edge of the city stood Gen. and Sen. James Lane's Lawrence home and farm. It had been set on fire in 1863 by Quantrill's men, who had come to Lawrence planning to kill Lane in retribution for his raids into western Missouri during the Border War. Lane escaped Quantrill by hiding in a cornfield that led down to the river. When Lane was the state's first senator, Gardner had made formal portraits of him in his Washington studio, having already read of Lane's notorious career as a soldier, politician, and founding father of Lawrence. Lane also had convinced Samuel Hallett and John Perry to regrade the rail line to Lawrence and Topeka, which it originally had skipped. So Gardner made a special effort to include Lane's house, which Quantrill and his bushwhackers had burned during their raid of Lawrence in August 1863. Lane had rebuilt elsewhere, but this house was still standing even after the senator committed suicide in 1866.

The brick Lane house was torn down, and later, as Old West Lawrence developed, many grand Victorian houses were built in the neighborhood. A complex of student apartments now stands on the site of the Lane house. As a senator he negotiated a railroad bill that was approved by the senate and signed into law by his political friend President Lincoln to reroute the line to Lawrence and Topeka, yet Hallett still refused to build the line until Lawrence came up with $100,000. When Hallett and Perry met with Lane in his Washington hotel room for the shakedown, *"His eyes flashed with indignation and contempt, as he raised himself up and replied: 'Before you get a dollar out of that burned and murdered town, you will take up every stump, and every old log you have buried in your grade to save money and stone-ballast every rod to Lawrence; and even then, when you get your first subsidies, let Jim Lane know!' They attempted argument. He waved his hand: 'No words gentlemen—no words.'"*[1]

SS50. Government Farm, Leavenworth, Kansas. 309 mi.

The government farm, as it was called at the time, was located just to the north of the main grounds of Fort Leavenworth. This farm largely supplied the pasture lands for the horses and other livestock of the fort. Also, grains were grown there, again mainly to supply draft and cavalry animals. This location may have been important to Gardner for a reason other than showing government farmlands. Kansas Sen. James Lane, an avid supporter of President Lincoln, lost considerable political favor after Lincoln's assassination, and while attempting to reassess his political future he decided he had none. Consequently, while on an outing on the government farm with two other army captains, he leapt out of the carriage while stopped at one of the gates and shot himself through the roof of his mouth. He lingered for ten days in abject misery and pain before he died on July 11, 1866.

In Charlton's 1994 view, the farm is no longer in use, and the pasture lands beyond the trees became the location for the Sherman Army Airfield. Only this marker is a reminder of what was once a farm; otherwise little in the current-day landscape would suggest it had ever been pasture and grain fields.

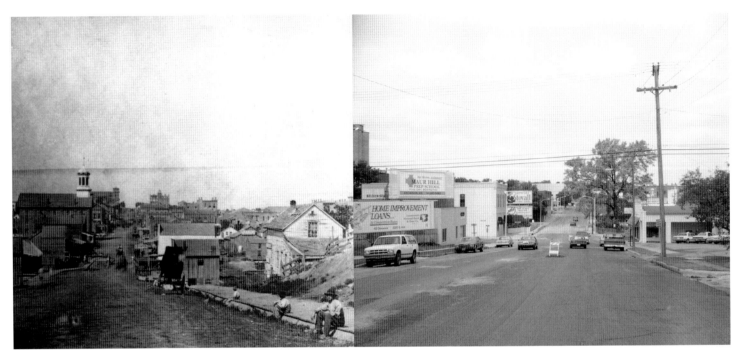

SS52. *Fifth Street, Leavenworth, Kansas. 309 mi.*

When Congress stipulated the start of the main branch of the UPED at the mouth of the Kansas River, Leavenworth promoters began losing their edge in their struggle with Kansas City, Missouri, promoters over which city would ultimately dominate the trade potential to the west. A year before Gardner took this photograph, Congress had already authorized building a railroad bridge across the Missouri River at Kansas City. By February 1867, Kansas City promoters had sealed the deal to connect the Hannibal and St. Joseph railroad, with its Chicago nexus, directly to the UPED line. Ferries transported goods and animals across the Missouri River at Kansas City until July 3, 1869, when the opening of the Hannibal and St. Joseph Bridge linked the Kansas Pacific line (the former UPED line). When Gardner took this photograph of Leavenworth, its promoters still thought that they were in the running for a connection to the Hannibal and St. Joseph line.

As Charlton's 1994 photograph illustrates, the events of the early 1860s had dramatic consequences for the future prosperity of Leavenworth. Still, on the horizon are a more recent cathedral and a school building replacing the ones in Gardner's photograph. Charlton was able to identify the cathedral and the school since Gardner had taken individual photographs of each building.

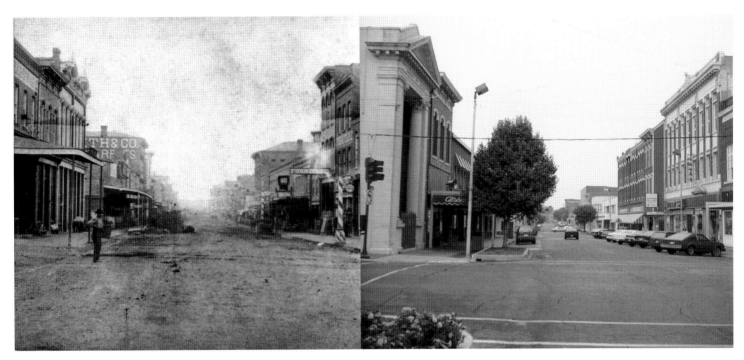

SS53. Delaware Avenue, Leavenworth, Kansas. 309 mi.

In 1860, Leavenworth had a population of 7,500 while its aspiring rivals in Kansas City, Missouri, numbered only 4,500. In both towns promoters vied to be the first to build a rail connection across the Missouri River, thereby sealing a direct route to burgeoning Eastern and European markets. Leavenworth, built directly to the south of Fort Leavenworth, prospered immensely as a result of the Civil War. By 1866, as seen by Ohio newspaper man Albert D. Richardson, the city was the greatest one between St. Louis and San Francisco. Gardner's photograph shows a bustling city that had secured a UPED spur line to Lawrence.

As Charlton's 1994 photograph reveals, Leavenworth, a city of just over 35,200 residents, lost out to City Kansas, Missouri, which had a metro area population of over two million people in 2010. Delaware Avenue marked the middle of Leavenworth's commercial district. Several of the buildings in Gardner's view still remain today. The east end of Delaware Avenue terminates just before reaching the Missouri River. There stands the Union Pacific Depot, which is now a civic center.

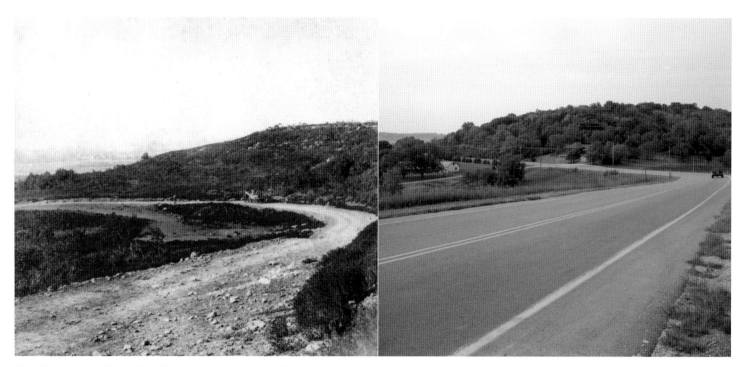

SS59. View on Amphitheatre Road, Leavenworth, Kansas. 309 mi.

This was the main road leading into Leavenworth. On the road is Gardner's mule-drawn wagon with Pywell and James Gardner in the photograph. In Gardner's view the hill is sparsely covered by grass and brush. Below the curve of the road is a side lane with a fairly steep drop-off to the left.

Charlton's 1994 rephotograph shows a farmstead below a modern paved highway that follows the same line as the road in Gardner's photograph. In Charlton's photograph, deciduous trees now entirely blanket the hillside. The steep decline in Gardner's photograph has been filled in and leveled to accommodate the farmstead.

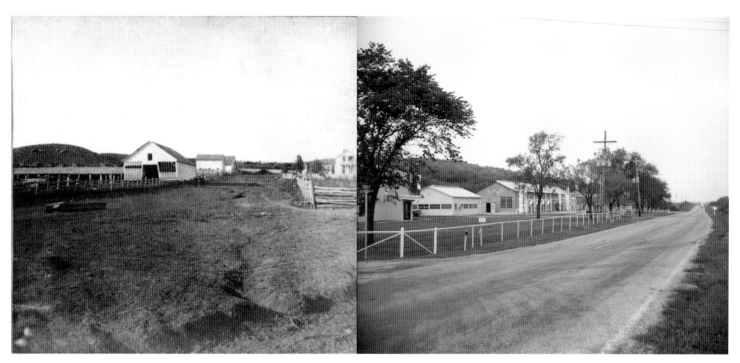

SS60. Moore's Summit, Kansas, on Branch Road between Leavenworth and Lawrence. 309 mi.

A noticeable hill in the open prairie along the branch road connecting Leavenworth to Lawrence was known as Moore's Summit. In 1861, thirty-one-year-old Crawford Moore began building up a prosperous farm where he became renowned for his well-bred herds of cattle and horses and his Poland China hogs. For Gardner, this must have been a sterling example of the rich potential for farming in the state as well as an opportune photograph. Moore's farm also was near the line of track laid by the UPED crews.

Now nothing remains of Moore's farm; the wagon road is a paved highway, and the prairie grass hillside in Gardner's photograph is completely enveloped in trees in Charlton's 1994 photograph. Once a farm, the buildings there now are a natural gas plant (see photograph 14A, which shows Moore's farm from atop the mound with tracks right through the cornfield).

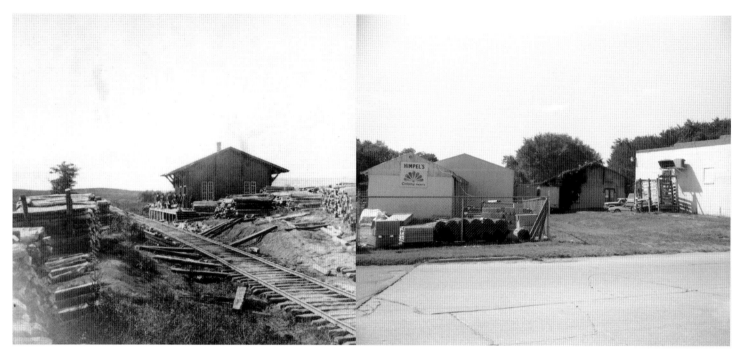

SS66. Depot Tonganoxie on Branch Road between Lawrence and Leavenworth, Kansas. 309 mi.

In 1854, by treaty the Delawares relinquished their lands in Kansas, and these same lands later came into the possession of the Union Pacific Railway Company, Eastern Division (UPED). In 1862, an Englishman by the name of Wilson Fox bought forty acres from the Union Pacific, probably anticipating the rail route that followed the branch road connecting Leavenworth and Lawrence. In 1866, he later sold his holdings to Magdalena Berry, who named the town after Delaware Chief Tonganoxie. When Gardner took his photograph there was not much to the town but a depot surrounded by unimpeded grassland. Near the depot the UPED was storing stacks of rail ties.

By the time Charlton took his photograph in 1994, the Union Pacific company had removed the spur line that had once connected Leavenworth and Lawrence. Tonganoxie no longer has any railroad connections, and now federal two-lane highways link the two cities. The main transportation route, Interstate 70, bypasses Tonganoxie to the south. The interstate eliminated any aspirations that the folks of Tonganoxie had of their town becoming a major trade center. The depot in Charlton's photograph is the same as the one in Gardner's, and today it stands as a reminder of the "new agent of civilization" past. Oddly, this depot without tracks by it remains the only original, intact one built on the UPED line. In a way, however, the "new agent" fulfilled its mission, as Tonganoxie now serves the agricultural economy built around it, and the town exhibits a domesticated landscape of sod and trees.

SS77. State House, Lecompton, Kansas. 338 mi.

During the territorial struggle over the issue of introducing slavery into Kansas, pro-slavery supporters held sway in the town of Lecompton (named after Territorial Supreme Court Justice Samuel Lecompte), located to the northwest of Lawrence, Kansas, which was a free-state settlement. For a while, it appeared that Lecompton promoters might become victorious in securing the state capitol. Ultimately, though, the free staters won out, and the capitol would be built in Topeka. Gardner took this photograph of the unfinished construction work of the capitol in Lecompton. Given his staunchly abolitionist views, in a sense Gardner was illustrating the failed efforts of the pro-slavery movement.

Charlton's 1994 photograph shows the university's two-story building constructed upon the south half of the unfinished capitol in 1882. Institutions of higher learning could anchor the economic future of a city, but this never happened with Lane University. Ultimately it became the local high school in 1903, and by 1927 it had been abandoned to become little more than a storage building. Placed on the National Register of Historic Places in 1971, today the building serves as museum largely highlighting the history of Bleeding Kansas.

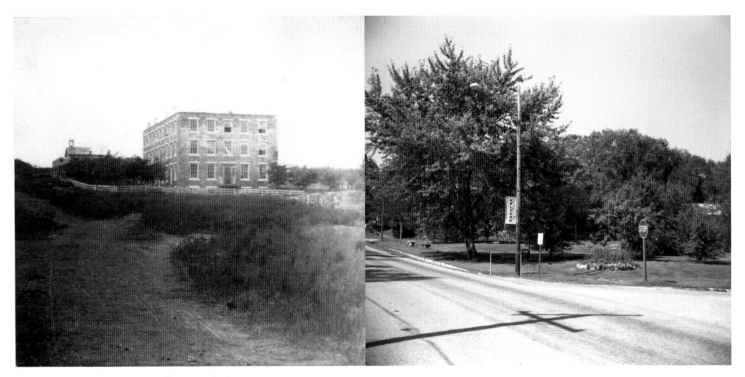

SS78. Lane University, Lecompton, Kansas. 338 mi.

Gardner took this photograph of Lane University, which was formerly the Rowena Hotel. When built, it was the largest hotel between St. Louis and San Francisco. It was in that building that Territorial Governor Denver met with important entrepreneurs to map out what would become the present-day boundaries of Kansas. The roughshod nature of Lecompton is clearly evident in this view. In the foreground the slope is covered by brush, and trees had been planted on either side of the university building in an effort to "civilize" the landscape.

In 1865, the United Brethren in Christ Church acquired the Rowena Hotel, which had been built to accommodate territorial legislators, and opened Lane University in it. They named the institution after Sen. James Lane, who had promised $1,000 to the school but committed suicide before making his donation.

Today, as shown in Charlton's 1994 photograph, the original Lane University building is long gone, and the landscape is dramatically changed with the hillside now totally covered by trees and lawns. The spot, now called Rowena Park, serves the city and is just to the south of Constitution Hall Museum. Part of the limestone wall surrounding the original Rowena Hotel property still stands as part of the park.

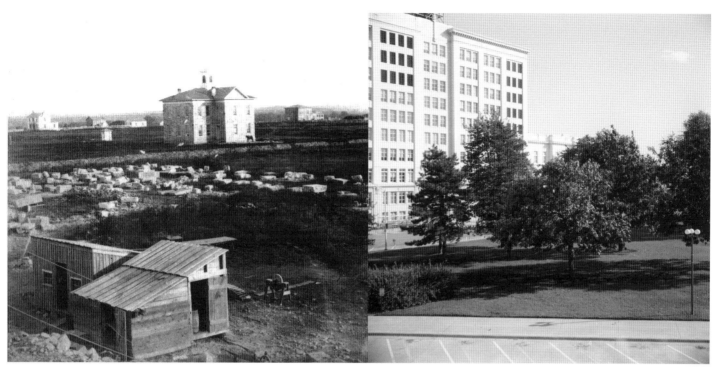

SS87. Lincoln College, Topeka, Kansas. 351 mi.

At the south end of Topeka in 1865, fervent abolitionists John and Mary Ritchie donated a quarter section of their open prairie land next to the capitol grounds to build a college dedicated to the proposition of equal educational opportunities for all, regardless of class, race, or gender. The stone blocks in this view were for the construction of the capitol. The Congregational Church founded the college and named it in honor of former president Lincoln. The stone building in the center of Gardner's photograph was completed in the fall of 1865, and the first class entered its doors in January 1866.

Charlton's photograph of the same site was taken in 1994. By this time, the campus had been relocated a few miles to the southwest, and where the original Lincoln College building once stood now stands Memorial Hall, at one time the location of the Kansas State Historical Society and now the office building for the state attorney general. Institutions like Lincoln College were envisioned by early railroad enthusiasts as the epitome of a civilized landscape and society. Renamed Washburn College in 1868 after Ichabod Washburn, a generous Massachusetts benefactor, the university today has over 7,300 students enrolled in its liberal arts, nursing, and law programs.

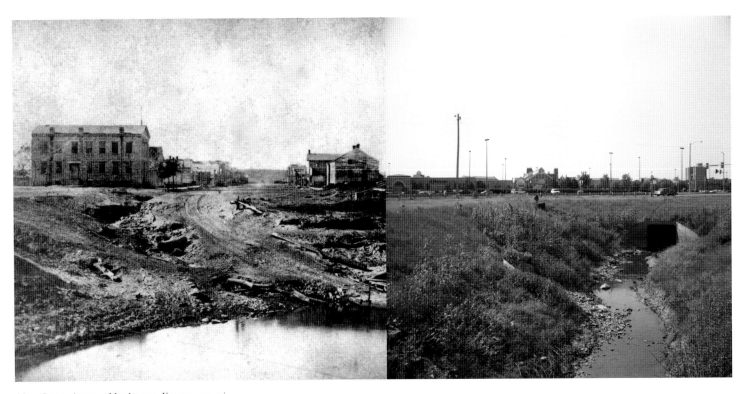

SS97. Poyntz Avenue, Manhattan, Kansas, 402 mi.

The following three pairings illustrate what Gardner was often doing in his photographs and how this helped Charlton determine where to take his views. All three Gardner photographs were taken from the same general location and were intended to give the viewer a more panoramic view of the surroundings. This first photograph was taken on the railroad bridge crossing the Blue River. Just to the bottom left a railing on the Blue River ferry can be seen. In the background is the treeless Sunset Hill. The city council required merchants along Poyntz Avenue to plant trees, which are visible along the street. The two-story building to the left was the Manhattan Hotel. Across the street, on the side of the framed building, are the words "Cheap Cash Store." There are a few horses hitched along the street in the background.

When Charlton took his 1994 photograph, the Blue River had changed course to the east nearly fifty-five years before, and the drainage ditch is the only reminder of the former riverbed. The Downtown Mall parking lot covers where the hotel once stood, and the mall building blots out the view of Sunset Hill, now a thoroughly tree-covered rise where Poyntz Avenue terminates and where the high school stands.

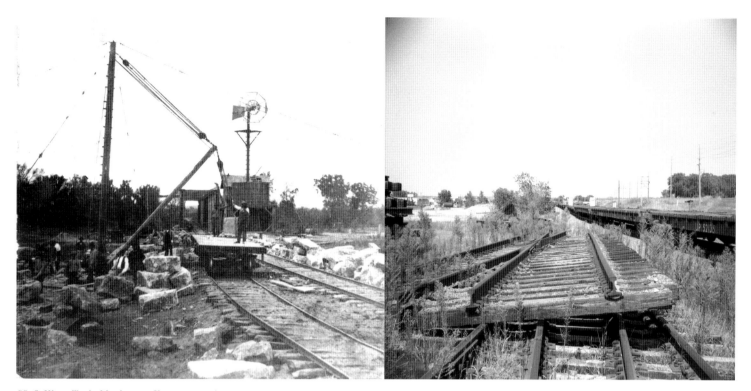

SS98. Water Tank, Manhattan, Kansas. 401 mi.

Gardner has taken his camera west beyond the bridge and turned it to the east to show the Blue River bridge and water tank on the west bank of the Blue River. In this view, crews are unloading Junction City Limestone on a siding for construction of the bridge abutment shown in SS97.

Charlton's 1994 photograph shows no trace of the Blue River, as its mouth is now about a mile east of where Gardner found it. The south bank of the Kansas River is bordered by a flood levee, and the riparian tree line is visible behind the levee. The riparian tree growth along the Blue River in Gardner's photograph has been removed over the years as a result of urban development.

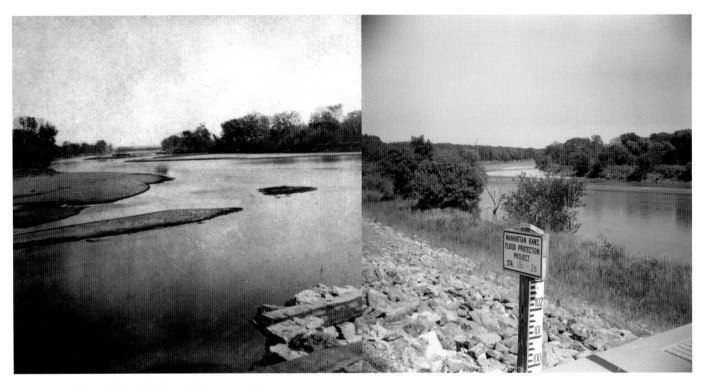

SS99. View on Kansas River, Manhattan, Kansas. 402 mi.

From nearly the same position, Gardner takes his camera to the west end of the bridge so as to have a good view of the mouth of the Blue River where it enters the Kansas River flowing east downstream.

Charlton's 1994 view atop the flood levee shows the same bend in the Kansas River sans the mouth of the Blue River. The riparian tree line in Charlton's photograph is much denser than that in Gardner's photograph.

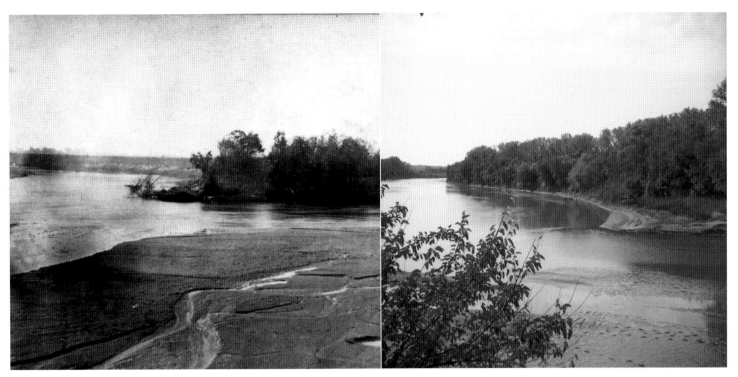

SS105. Republican and Smoky Hill Rivers, the Junction Forming the Kansas River. 421 mi.

At first glance, between 1867 and 1995 it might not seem that much change occurred at the junction of the Republican and Smoky Hill Rivers. A closer look reveals that Gardner's view shows a steeply cut bank on the north side of the Smoky Hill River, and the banks are nearly tree bare.

In Charlton's view, the Smoky Hill banks are heavily treed, and on either side of this junction are the Fort Riley grounds. The mouth of the Republican River is much wider in Gardner's view than it is in Charlton's, which indicates a constricting of the stream over the years. Also, the mouth in Gardner's photograph enters the frame from the right, and in Charlton's it enters from the left. The flow through the Republican River is now controlled by the Army Corps of Engineers through the Milford Dam and Reservoir, which is located upstream from the mouth.

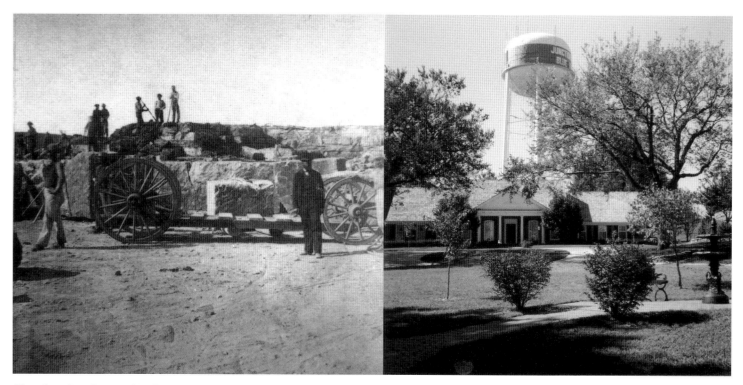

SS111. Quarries at Junction City, Kansas. 423 mi.

In 1867, just to the west of the Junction City limits was a massive stone quarry. Called Fort Riley Limestone, this was excellent building material, and many of the substantial commercial houses in Junction City and Manhattan were constructed with this stone. Several of these buildings are still extant today. This stone was also quarried for the building of the state capitol in Topeka, and it was shipped east on the UPED line for commercial building in other cities.

The landscape presents a bare scene in Gardner's photograph, whereas in Charlton's 1995 view nothing remains of the quarry in what is now a secluded residential neighborhood of lawns and trees near Rimrock Road.

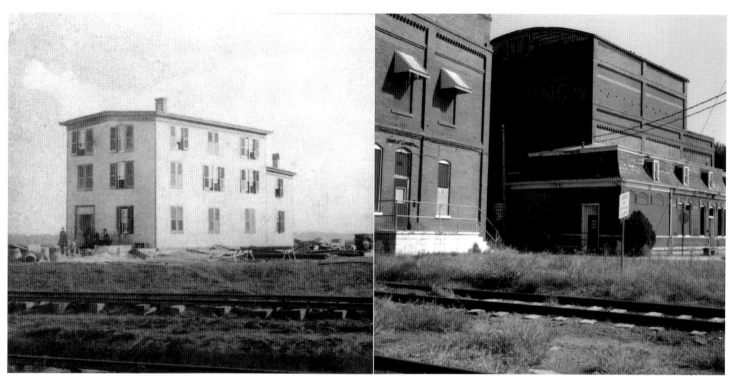

SS114. Drover's Cottage, Abilene, Kansas. 447 mi.

Gardner took this photograph of Joseph McCoy's Drover's Cottage in Abilene when construction of it was nearly finished. The wide-open, mixed-grass prairies surrounding the nascent town of Abilene are quite apparent in Gardner's view. At the time, the Drover's Cottage was the *only* building of any significance at the site. McCoy had invested over $30,000 in building up the stockyards, constructing the Drover's Cottage, and advertising Abilene as the place for Texas cattlemen to ship their herds eastward on the UPED line. Given the typical frontier town demographics, it is notable that Gardner's photograph shows five women posed in front of the hotel. A few years later, the hotel was relocated in Ellsworth, which had replaced Abilene as the shipping point for Texas cattle herds.

In Charlton's photograph, taken in 1996, the Belle Springs Creamery factory stood where the hotel once did, and it blocked out any views of the open lands to the south. Even though it was considered a historic landmark by some who associated the creamery with Dwight D. Eisenhower's and his father's employment there, after 1996 the creamery was demolished. All of the open, mixed-grass prairie lands in Gardner's photograph are either part of the city of Abilene or are agricultural fields dominated by wheat, soybean, and alfalfa production.

SS116. Prairie Dog Town, Abilene, Kansas. 447 mi.

Gardner seemed infatuated with prairie dogs, as he took several photographs of their towns, which at the time had become frequent once out on the open, mixed-grass prairies west of the Flint Hills. This photograph is a nice illustration of how such a town and its inhabitants cleared bare large expanses of grassland. Farmers and ranchers had little tolerance for prairie dogs, as their tunneling quickly denuded crops and pastures. Consequently, ranchers and farmers undertook the eradication of prairie dogs and their coinhabitants, rattlesnakes and burrowing owls. Gardner's photograph also shows the scattering of trees lining the Muddy Creek in the background.

Charlton shows the complete elimination of the prairie dog village in this 2007 photograph. In its place is sod, gravel, houses, commercial buildings, concrete streets, and thicker tree growth. This Anglo-domesticated landscape bears no resemblance to one shaped by prairie dogs. Now, by some estimates, black-tailed prairie dogs, once a ubiquitous presence in the grasslands, have had their numbers reduced by over 95 percent since Gardner took his photograph in 1867. The tracks and riparian line of growth were key indicators for Charlton in locating where he might take his photograph.

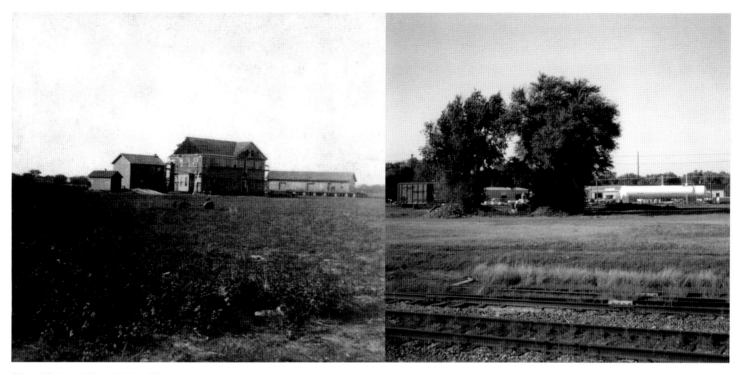

SS120. Hotel and Depot, Salina, Kansas. 470 mi.

At Salina, Kansas, shortly after UPED work crews had completed laying tracks and building the depot, Mrs. Mary Ann Bickerdyke began overseeing the construction of her hotel, which is shown in this Gardner photograph. In this open prairie, with the Smoky Hill River riparian tree line in the background, Salina was little more than one hundred souls without a single framed residential house in the "city." Given Gardner's close associations with Union notables during the Civil War, he was probably more interested in Bickerdyke's undertaking than in illustrating the advance of "civilization." Bickerdyke had served as chief of nursing under General Grant during the Civil War, had established over three hundred field hospitals during the war, and was so well respected that General Sherman had her ride at the head of XV Corps in the Grand Review of the Union Army that celebrated the end of the Civil War in Washington, D.C., in May 1865.

Charlton's 1996 photograph shows no trace of Bickerdyke's hotel, which failed to flourish, nor is she much remembered in Salina or in the state. The area where the hotel once stood is marked by the cluster of trees in Charlton's view.

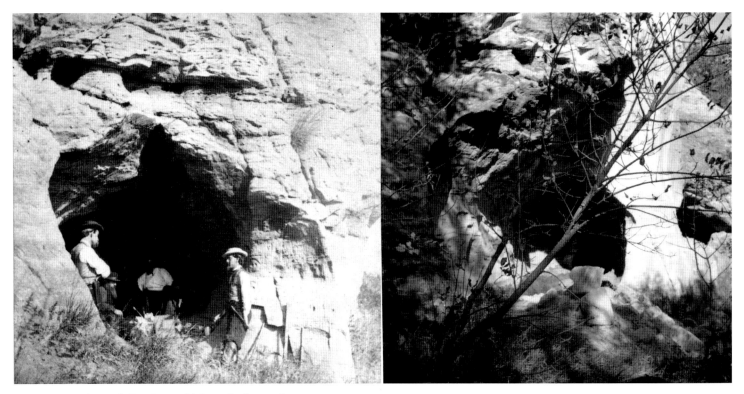

SS135. Picnic in Cave at Indian Cave on Mulberry Creek. 494 mi.

This Gardner view is of the west cave entrance for Indian Inscription Rock, a well-known feature in the middle portion of the state. In the June 15, 1867, issue of *Harper's Weekly*, the cave was a featured illustration. Gardner showed a keen interest in the cave, as he took both imperial and stereo photographs of it. An armed escort accompanied Gardner whenever he left the immediate vicinity of the railroad crews. The escort's rifles are lined up along the outside cave walls.

As Charlton's 1996 photograph reveals, undercutting from spring and winter thaws over the last nearly 150 years resulted in a catastrophic collapse of the bluff, and now the lower slope of it is covered by brush. Nonetheless, Charlton was able to get close to the same angle as in Gardner's view.

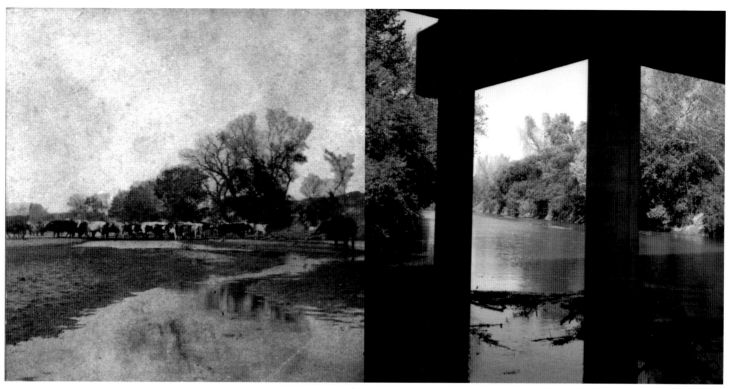

SS144. Cattle Fording the Smoky Hill River at Ellsworth, Kansas, on the Old Santa Fe Crossing. 508 mi.

Traders bound for Santa Fe, New Mexico, could cut time reaching their destination by loading their goods onto UPED cars, unloading them at Ellsworth, reloading them into trade wagons, and heading directly south to reach the Santa Fe Trail at the Great Bend of the Arkansas River. This route crossed a ford of the Smoky Hill River south of Ellsworth, Kansas.

After he took his imperial photograph (see photograph 55A), Gardner relocated his stereo camera down into the ford and took this photograph of the cattle crossing the ford. He then moved his stereo camera to the north bank of the ford and took a final photograph of the bull train as it crossed to the south bank of the river.

Charlton's photograph shows a dramatically changed riverbed by 1996. The streambed is constricted, more steeply cut, and overgrown by trees on both banks. Bridges, like the highway one in Charlton's photograph, have the effect of narrowing the streams they cross.

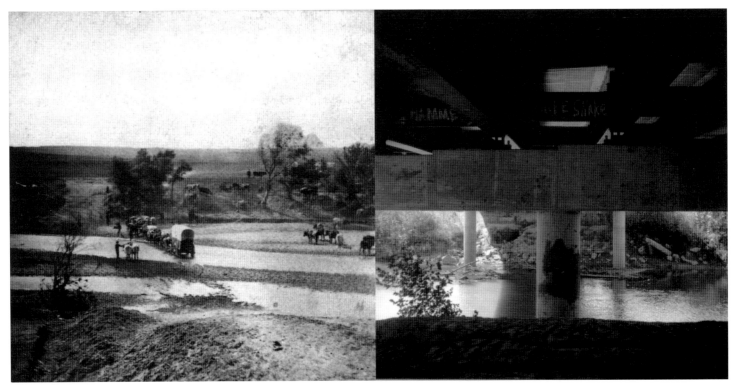

SS145. Bull Train Crossing the Smoky Hill River at Ellsworth, Kansas. 508 mi.

After Gardner took his imperial photograph of the site (see photograph 55A) and the previous stereo view, he relocated his camera in the ford and took this photograph of a loaded, south-bound Santa Fe wagon train. The open expanse of the shortgrass prairie is prominent in Gardner's view. In 1996, Charlton took his rephotograph from the same viewpoint as Gardner's, and the result is the highway bridge blocking out the view of the plains to the south, which are now agricultural fields.

Soon after Gardner took his photograph, Ellsworth would become the focal point of the Texas cattle drives. The UPED depot started serving as the westward-most jumping-off point for Santa Fe Trail caravans. Both caravans and Texas cattle herds would cross the Smoky Hill River to the south of town, where the river bedrock provided firm footing for both oxen and cattle.

William Bell used this photograph of Gardner's to create a handsome chromolithograph (see figure 3) to illustrate his book, *New Tracks in North America*. Characteristically, Bell did this without giving any attribution to Gardner.

SS147. Fort Hays, Kansas. 580 mi.

Gardner's view of Fort Hays shows a staging area for the Army located in the vast open shortgrass prairies of western Kansas. Fort Hays served an important role in the U.S. wars with American Indian peoples during the late 1860s. When Gardner took this photograph, flooding along the Smoky Hill River earlier in June had forced the Army to relocate the fort to the bluff overlooking the new town of Hays. Interestingly, Charlton's view shows a blockhouse, which was standing when Gardner took his photograph. Why Gardner chose not to include the blockhouse is open to conjecture, but perhaps he did not want to illustrate a hostile environment.

Sparse riparian tree growth is evident in Gardner's photograph, whereas in Charlton's the banks of the river are completely lined. Fort Hays is now a national register site, and as such its grounds are groomed with sod that has replaced the buffalo grass evident in Gardner's photograph. Also, Charlton's 1996 photograph shows red cedar on the grounds, which is a result of the suppression of prairie fires over the years.

EPILOGUE

What Kind of Empire?

An American empire has taken root, but it has not produced all of the fruits anticipated by its proponents nearly 150 years ago. Railroad building has had the most lasting effects on the urban contours of the state. Railroad executives determined which towns would eventually become market and cultural centers. Town boosters understood clearly that their efforts were doomed without a railroad link. Consequently, railroads had a winnowing effect on urban numbers in the state. Melvin Bruntzel has identified nine thousand town ventures in the state, whereas the 2010 federal census found only 668 incorporated towns still in existence. In other words, only a handful of town developers ever realized their dreams of building a flourishing metropolis, and those who achieved initial success did so only by securing a railroad connection.[1]

Today, as in 1867, the continuing growth and power of cities determine the economic course of Kansas. What has changed is the introduction of automobiles and trucks, which dramatically affected railroad transportation networks. By 1970, automobiles had almost completely replaced passenger trains as a means of transportation. By the same time, semitrucks were lugging a significant share of the commodity market formerly hauled by freight cars. Today the internet and cell phones have all but eliminated telegraph and landline telephones as

the most favored means of communication. Still, the urban geography established by rail systems remains in place.

Yet even a connection to a railroad link failed to guarantee success. Certain characteristics best marked which urban centers would achieve population and economic growth. According to James Shortridge, professor of geography at the University of Kansas, those cities offering higher education institutions, health services, and retail variety have flourished, as have those cities with a high quality of life and knowledge-based industries. Cities with public institutions such as county courthouses, prisons, federal labs, or federal military bases have retained solid economic foundations. The cities of Topeka, Leavenworth, Lawrence, Manhattan, and Junction City all share these characteristics. Kansas City, Missouri, and Wichita, Kansas, possess all of these traits plus economies enmeshed into larger national and international business networks. All of these factors are powered by forces transcending the effects of railroads.[2]

Nonetheless, as envisioned by early railroad promoters, railroad technology continues to drive the extractive economy of the state. Wheat, corn, soybeans, fossil fuels, and meat products are still hauled by Union Pacific freight trains traversing the state. Propelling this extractive economy are the same

urban markets, albeit exponentially stronger today, that initially advanced railroading and shaped the agricultural ecosystems of Kansas in 1867.

The American empire of a yeoman class made possible by railroad building, as fantasized by Josiah Copley and likeminded railroad promoters, is today an empire dominated by large-scale corporate farms. Less than 1 percent of the population in Kansas in 2010 made their living directly from the land as farmers. Of the 65,531 Kansas farm units recorded in the 2007 USDA census, 6 percent account for over 77 percent of the total value of agricultural products sold in the state. In western Kansas, where Gardner saw only shortgrass prairies, the empire of large-scale farming is even more pronounced. In Ellis County, where Gardner took photographs of Hays surrounded by open prairie, a mere 2 percent of the farm units accounted for 69 percent of the total value of agricultural products sold in the county in 2007. As farms become ever larger and the operations become more heavily capitalized, fewer and fewer people find economic opportunities in the rural areas of the state. In the four westernmost counties of Kansas, where Gardner took his photographs (Trego, Gove, Logan, and Wallace), only 9,900 people remained in 2010. The population in all of these counties peaked prior to World War II, and all have declined steadily since 1950. Farm units are no longer small, family-owned operations, and the Union Pacific railroad has little to no effect on whether people live there or not.

As intended by their promoters, railroads did pave the way for people to domesticate grasslands, which changed their ecosystems forever. Regardless of whether the ecosystems of the state appear as grasslands or farm fields, they will never function as they once did in Gardner's time. Consider, for example, how subsurface grassland systems respond to "restoration" through the federal Conservation Reserve Program (CRP). When a grassland system is placed into crop production, soil erosion increases, nutrient losses occur, organic matter suffers from oxidation, and the aggregate structure of the soils degrades. Employees in the Natural Resources Conservation Service implemented CRP to return croplands to native grasses, in part to restore soil fertility. When CRP lands were compared to intact grasslands, researchers found that ten years was not enough time for the soils to recover their precultivation nitrogen and carbon levels.[3] Moreover, while grasses readily take root, forbs do not, and consequently the full diversity of animal populations cannot rebound to the same levels they enjoyed under American Indian management.

Early railroad promoters' crystal balls were somewhat cloudy in predicting how railroads would shape future domestic and international markets and unleash a protestant-based cultural dominance wherever tracks were laid. William Bell foresaw railroads enabling large American cities like St. Louis to control a lucrative trade with China. However, today the tables are reversed as Shanghai and Beijing determine the flow of this trade more thoroughly than business people in St. Louis. Charles Godfrey Leland's prediction that railroads would spread protestant Christianity and destroy Mormonism also fell short of the mark. The rapid growth of the Mormon faith belies Leland's aspirations. General Hancock, on the other hand, was certainly correct in believing that railroads would spell the end of American Indian dominance in the grasslands. So thoroughly accomplished was the end of American Indian Kansas that today those nations, whose governing bodies now reside in Oklahoma, struggle with disproportionately high levels of health problems and poverty.

Just as railroads embodied cultural, social, economic, and ecological forces that transformed the grasslands, the technologies of automobiles, planes, and computers embody a set of cultural, social, and economic forces that will shape a different ecological reality in the grasslands. As these new

conditions arise, they will intermingle with the reverberations of past railroad building without fully erasing all of the ecological, social, and economic effects of trains. A hundred years from now the ecosystems and population dynamics of the state will surely differ significantly from those shown in Charlton's photographs. A set of rephotographs taken then will graphically reveal how the technologies of our age worked to reshape the ecologies, economies, and demographics of the state. Such a future rephotography will provide insights into the role humans and their cultural values and technologies play in enhancing, sustaining, or degenerating their economy, ecosystems, or life in general.

NOTES

From Alexander Gardner to John R. Charlton

1. Robert Taft, "A Photographic History of Early Kansas," *Kansas Historical Quarterly* 3 (February 1934): 3–14.

2. See William A. Bell, *New Tracks in North America: A Journal of Travel and Adventure Whilst Engaged in the Survey for a Southern Railroad to the Pacific Ocean During 1867–8* (London: Chapman and Hall, 1869).

3. Robert Taft, *Photography and the American Scene: A Social History, 1838–1889* (New York: MacMillan Co., 1938).

4. Taft, "Photographic History," 3–4.

5. Robert Taft, *Across the Years on Mount Oread, 1866–1941* (Lawrence: University Press of Kansas, 1941), 163.

6. *Sunflower Journeys,* "Changing Landscapes: The Photographs of Alexander Gardner," episode #132, March 31, 1994. http://ktwu.washburn.edu/journeys/scripts/708a.html (transcript accessed on 22 March 2006).

"The New Pioneer of Population and Settlement"

1. In 1855 this company began as the Leavenworth, Pawnee and Western Railroad Company. In 1863, John C. Fremont and Samuel Hallett obtained control of the company and changed its name to the Union Pacific Railway Company, Eastern Division. In 1868, under new ownership, the name was changed again to the Kansas Pacific Railway Company. In 1880, Jay Gould consolidated the Kansas Pacific Railway Company and the Union Pacific Railroad Company and renamed the operation the Union Pacific Railway Company.

Good introductions to the early history of this company are David G. Taylor, "Thomas Ewing, Jr., and the Origins of the Kansas Pacific Railway Company," *Kansas Historical Quarterly* 42 (Summer 1976): 155–79; Alan W. Farley, "Samuel Hallett and the Union Pacific Railway Company in Kansas," *Kansas Historical Quarterly* 25 (Spring 1959): 1–16; Richard Overton, "Thomas C. Durant and the Union Pacific, Eastern Division, 1864–1866," *Kansas Quarterly* 2 (Summer 1970): 58–65; and Charles Edgar Ames, *Pioneering the Union Pacific: A Reappraisal of the Builders of the Railroad* (New York: Appleton-Century-Crofts, 1969).

2. "Speech of Senator Yates, of Illinois," in *Senatorial Excursion Party over the Union Pacific Railway, E. D., Speeches of Senators Yates, Cattell, Chandler, Howe and Trumbull; Hon. J. aJ. Creswell, Hon. John Covode, M.C., and Hon. Wm. M. McPherson, on The Pacific Rail Road Question* (St. Louis, MO: S. Levison, Printer, 1867), 15.

3. *New York Daily Tribune,* June 4, 1863, Clipping Files, Manuscript Division, Kansas State Historical Society.

4. George T. Pierce, "The Union Pacific Railway, Eastern Division," *American Railroad Journal* (186?), Clipping Files, Manuscript Division, Kansas State Historical Society, Topeka.

5. Abraham Lincoln long had close connections with railroad companies, and he understood their operations well. See William D. Beard, "'I Have Labored to Find the Law': Abraham Lincoln for the Alton and Sangamon Railroad," *Illinois Historical Journal* 85, no. 4 (1992): 209–20; David A. Pfeiffer, "Lincoln for the Defense: Railroads, Steamboats and the Rock Island Bridge," *Railroad History* (Spring/Summer 2009): 48–55; and Brian Steenbergen, "The Illinois Central Railroad Issues in the 1858 Lincoln-Douglas Senatorial Campaign," *Lincoln Herald* 113 (Spring 2011): 30–37.

6. William G. Thomas's *The Iron Way: Railroads, the Civil War, and the Making of Modern America* (New Haven, CT: Yale University Press, 2011) highlights a central concept in this piece: that railroad companies would "control and build global networks that advanced moral progress" (11). Among earlier works that paved a way for me to understand railroad building are Charles Glaab, *Kansas City and the Railroads: Community Policy in the Growth of a Regional Metropolis* (Lawrence: University Press of Kansas, 1993); and John R. Stilgoe, *Metropolitan Corridor: Railroads and the American Scene* (New Haven, CT: Yale University Press, 1983).

7. "Speech of the Honorable B. H. Brewster," in *Senatorial Excursion Party*, 52.

8. Nelson H. Loomis, "Kansas and the Union Pacific," *Twenty-sixth Biennial Report of the Kansas State Historical Society* (Topeka, KS: State Printing Office, 1929), 99, Archives Division, Kansas State Historical Society, Topeka.

9. "Speech of the Honorable John A. J. Creswell, of Maryland," in *Senatorial Excursion Party*, 31.

10. See http://esd.ny.gov/nysdatacenter/data/population_housing/countypophistory.pdf (accessed July 15, 2013).

11. James Belich, *Replenishing the Earth: The Settler Revolution and the Rise of the Anglo-World, 1783–1939* (New York: University of Oxford Press, 2009), 9.

12. Clive Ponting, *A Green History of the World: The Environmental Collapse of Great Civilizations* (New York: St. Martin's Press, 1991), 301–9.

13. William A. Bell, *New Tracks in North America: A Journal of Travel and Adventure Whilst Engaged in the Survey for the Southern Railroad to the Pacific Ocean During 1867–8* (New York: Scribner, Welford & Co., 1870), 1.

14. Carl Abbott, *How Cities Won the West: Four Centuries of Urban Change in Western North America* (Albuquerque: University of New Mexico Press, 2008), 42.

15. Ibid., 39–40.

16. Michael Adas, *Dominance by Design: Technological Imperatives and America's Civilizing Mission* (Cambridge, MA: Harvard University Press, 2006), 79–85. The quotation is found on page 84.

17. *Report of Lieut. Col. James H. Simpson, Corps of Engineers, U.S.a., on the Union Pacific Railroad and Branches, Central Pacific Railroad of California, Northern Pacific Railroad, Wagon Roads in the Territories of Idaho, Montana, Dakota, and Nebraska, and the Washington Aqueduct. Made to Honorable James Harlan, Secretary of the Interior, November 23, 1865* (Washington, D.C.: Government Printing Office, 1865), 96–111.

18. John D. Perry, President of the Union Pacific Railway Company, Eastern Division, to Honorable O. H. Browning, Secretary of the Interior, 31 December 1868, Manuscript Division, Kansas State Historical Society, Topeka.

19. Horace Traubel, *With Walt Whitman in Camden* (New York: Mitchell Kennerley, 1914), 346.

20. Anne E. Peterson, "Alexander Gardner in Review," *History of Photography* 34 (November 2010): 357–58.

21. Josephine Cobb, "Alexander Gardner," *Image* 7 (June 1958): 124–36.

22. Ibid., 124–36.

23. See Ellen Carol DuBois, *Feminism and Suffrage: The*

Emergence of an Independent Women's Movement in America, 1848–1869 (Ithaca, NY: Cornell University Press, 1978).

24. See William Y. Chalfant, *Hancock's War: Conflict on the Southern Plains* (Norman, OK: The Arthur H. Clark Company, 2010).

25. "Josiah Copley," Armstrong County Pennsylvania Geneology Project, http://www.pa-roots.com/armstrong /beersproject/c/copleyj.html (accessed February 22, 2010).

26. Josiah Copley, *Kansas and the Country Beyond, On the Line of the Union Pacific Railway, Eastern Division, From the Missouri to the Pacific Ocean* (Philadelphia, PA: J. B. Lippincott & Co., 1867), 85.

27. Adas, *Dominance by Design*, 8, 17.

28. See Daniel Walker Howe, *What Hath God Wrought: The Transformation of America, 1815–1848* (New York: Oxford University Press, 2007); and Thomas, *The Iron Way*.

29. Bell, *New Tracks*, 9.

30. Copley, *Kansas and the Country Beyond*, 85–86.

31. Charles Godfrey Leland, *The Union Pacific Railway, Eastern Division, or, Three Thousand Miles in a Railway Car* (Philadelphia, PA: Ringwalt & Brown, 1867), 39.

32. "Speech of the Honorable G. S. Orth, M.C., of Indiana," in *Senatorial Excursion Party*, 49.

33. Kevin Kelly, *What Technology Wants* (New York: Viking, 2010), 11. A good overview of theories about technology is Richard Rhodes, ed., *Visions of Technology: A Century of Vital Debate About Machines, Systems, and the Human World* (New York: Simon & Schuster, 1999). See also W. Brian Arthur, *The Nature of Technology: What It Is and How It Evolves* (New York: Free Press, 2009); and Roe Smith and Leo Marx, eds., *Does Technology Drive History?: The Dilemma of Technological Determinism* (Cambridge, MA: The MIT Press, 1994).

34. Leland, *The Union Pacific Railway*, 13.

35. Kate Brown, "Gridded Lives: Why Kazakhstan and Montana Are Nearly the Same Place," *The American Historical Review* 106 (February 2001): 17–48.

36. Robert V. O'Neill discusses the role of human beings as keystone species in his article "Is It Time to Bury the Ecosystem Concept? (With Full Military Honors, of Course!)," *Ecology* 82 (November 12, 2001), 3281–82. The quote defining keystone species is taken from Sergio Cristancho and Joanne Vining, "Culturally Defined Keystone Species," *Human Ecology Review* 11, no. 2 (2004): 153. The one most associated with developing this concept is Robert T. Paine. See Paine, "A Conversation on Refining the Concept of Keystone Species," *Conservation Biology* 9 (1995): 962–64.

37. O'Neill, "Is It Time to Bury the Ecosystem Concept?," 3279.

38. Kelly, *What Technology Wants*, 103.

39. Ibid., 180.

40. Copley, *Kansas and the Country Beyond*, 8.

41. "Speech of Senator Yates, of Illinois," in *Senatorial Excursion Party*, 15. Italics added for emphasis.

42. Copley, *Kansas and the Country Beyond*, 8.

43. Bell, *New Tracks*, xxv.

44. Alan W. Farley, "Samuel Hallett and the Union Pacific Railway Company in Kansas," *Kansas Historical Quarterly* 25 (Spring 1959): 7.

45. Oread is the high mount that overlooks the city of Lawrence. Many of the early New England emigrants were well versed in ancient Greek mythology, and they gave the mount the name Oread, after the nymphs who the ancient Greeks associated with mountains. See "Dryades & Oreiades," Theoi Greek Mythology, http://www.theoi.com /Nymphe/Dryades.html, accessed August 19, 2013.

46. Copley, *Kansas and the Country Beyond*, 6.

47. Bell, *New Tracks*, 15. Italics added for emphasis.

48. Ibid., 16; and for a thorough discussion of the women's suffrage campaign of 1867, see DuBois, *Feminism and Suffrage*, 79–104.

49. Copley, *Kansas and the Country Beyond*, 37.

50. For information about this remarkable individual's

life, see Martha L. Sternberg, *George Miller Sternberg: A Biography* (Chicago, IL: American Medical Association, 1920); and S. C. Craig, "Medicine for the Military: George M. Sternberg on the Kansas Plains, 1866–1870," *Kansas History* 21 (Autumn 1998): 188–206.

51. George Sternberg, "The Causes of the Present Sterility of Western Kansas and the Influences by Which It Is Gradually Being Overcome," *Junction City (Kansas) Union,* 5 February 1870, 1.

52. *The Kansas Pacific Railway Company v. Joseph G. McCoy,* transcript, Manuscript Division, Kansas State Historical Society, Topeka.

53. James E. Sherow, "Water, Sun, and Cattle: The Chisholm Trail as an Ephemeral Ecosystem," in *Fluid Arguments: Five Centuries of Western Water Conflict,* ed. Char Miller (Tucson: University of Arizona Press, 2001), 141–55.

54. Copley, *Kansas and the Country Beyond,* 26.

55. "Speech of General Hancock," in *Senatorial Excursion Party,* 46.

56. Copley, *Kansas and the Country Beyond,* 20. Italics added for emphasis.

57. "Speech of Senator Yates," 13.

Imperial Photographic Pairings

1. William A. Bell, *New Tracks in North America: A Journal of Travel and Adventure Whilst Engaged in the Survey for the Southern Railroad to the Pacific Ocean During 1867–8* (New York: Scribner, Welford & Co., 1870), 1.

2. The word Kaw is a variant of the word Kansas. William Least Heat-Moon, in *PrairyErth,* gives around 140 variant spellings of the word Kansas. See *PrairyErth: (a deep map)* (Boston, MA: Houghton Mifflin Company, 1991), 122.

3. "The Kansas Pacific Railroad," *Harper's Weekly* (June 15, 1867), 373.

4. Ibid.

5. Ibid.

Stereographic Pairings

1. John Speer, *Life of Gen. James H. Lane "Liberator of Kansas"* (Garden City, KS: John Speer, Printer, 1896), 235.

Epilogue

1. Melvin Bruntzel, *Quick Reference to Kansas: Lost-Found-Missing, Towns and Places with Selected Trivia and Truths,* Chapman Center for Rural Studies, Kansas State University, http://kansasquickref.omeka.net/items/show/1.

2. James R. Shortridge, *Cities on the Plains: The Evolution of Urban Kansas* (Lawarence: University Press of Kansas, 2004), 369–80.

3. S. G. Baer, C. W. Rice, and J. M. Blair, "Assessment of Soil Quality in Fields with Short and Long Term Enrollment in the CRP," *Journal of Soil and Water Conservation* 55 (Second Quarter, 2000): 142–46.

SUGGESTED READING

There are a few works on Alexander Gardner, but as of yet no one has given him a monographic treatment. Besides John R. Charlton's publications, some of the best treatments of Gardner's work besides his Civil War photography and that outside of Kansas include Anne E. Peterson, "Alexander Gardner in Review," *History of Photography* 34 (November 2010): 356–67; Raymond J. DeMallie, "Scenes in the Indian Country: A Portfolio of Alexander Gardner's Stereographic Views of the 1868 Fort Laramie Treaty Council," *Montana The Magazine of Western History* 31 (September 1981): 42–59; and James E. Babbitt, "Surveyors Along the 35th Parallel: Alexander Gardner's Photographs of Northern Arizona, 1867–1868," *Journal of Arizona History* 22 (Fall 1981): 325–48.

There is a sizable literature on photography of the American West. A good introduction to it would include Karen and William R. Current, *Photography and the Old West* (New York: Harry N. Abrams, Inc., 1986); Alan Trachtenberg, *Reading American Photographs: Images as History, Mathew Brady to Walker Evans* (New York: Hill and Wang, 1989); Martha A. Sandweiss, *Print the Legend: Photography and the American West* (New Haven, CT: Yale University Press, 2002); Mark Klett, Kyle Bajakian, William L. Fox, Michael Marshall, Toshi Ueshina, and Byron G. Wolfe, *Third Views, Second Sights: A Rephotographic Survey of the American West* (Santa Fe: Museum of New Mexico Press, 2004); and Rebecca Senf, Stephen Pyne, Mark Klett, and Bryon Wolf, *Reconstructing the View: The Grand Canyon Photographs of Mark Klett and Byron Wolfe* (Berkeley: University of California Press, 2012). See also John R. Charlton, "'Westward, the Course of Empire Takes Its Way': Alexander Gardner's 1867 Across the Continent on the Union Pacific Railway, Eastern Division Photographic Series," *Kansas History* 20 (Summer 1997): 116–28; and Charlton, "Rephotographing Alexander Gardner's 1867 Across the Continent on the Union Pacific Railway, Eastern Division," *Transactions of the Kansas Academy of Science* 101 (October 1998): 63–81.

Good, general overviews of the grasslands and grassland ecology include Daniel Axelrod, "Rise of the Grassland Biome, Central North America," in *The Botanical Review* 51 (April–June 1985): 163–201. Axelrod argues persuasively that the grasslands encountered by the first Europeans to depict them arose as a result of conscious management practices by the people who had occupied the grasslands in the centuries before. Fire was the main tool used by precontact peoples. Geoff Cunifer's *On the Great Plains: Agriculture and Environment*

(College Station: Texas A&M Press, 2005) blends some of the newest advances in Geological Information Systems technology with agricultural census data and reaches some provocative conclusions. For some time, many scholars have observed and charted many environmental problems associated with Euro-American farming techniques. Cunifer's data and interpretations suggest that Euro-American Great Plains farmers have "maintained a stable land-use pattern that fits the environment by periodically changing the ways they farmed to fit changed circumstances" (7). O. J. Reichman's *Konza Prairie: A Tallgrass Natural History* (Lawrence: University Press of Kansas, 1987) gives a thorough introduction to the natural history and ecological complexities of the tallgrass prairies. Fred B. Samson and Fritz L. Knopf, editors of *Prairie Conservation: Preserving North America's Most Endangered Ecosystem* (Washington, D.C.: Island Press, 1996), maintain that the grasslands are one of, if not the most, misunderstood and threatened ecosystems in North America. They emphasize their concern with a collection of essays mainly by biologists and governmental officials who are currently researching grassland ecology and working on providing policies for preserving what is left of the once vast, wild grasslands. My own work, *The Grasslands of the United States: An Environmental History* (Santa Barbara, CA: ABC Clio, Inc., 2007), provides an overview of the ecological history of the grasslands, which includes the role of human beings. A rich resource for the most current research on the ecology of grasslands is the data research site, "Konza Publications" (Konza Prairie LTER, http://www.Konza.ksu.edu/Knz /pages/education/Education.aspx). An older but still highly useful bibliographic guide to the history of the grasslands is Mohan K. Mali's edited volume, *Prairie: A Multiple View* (Grand Forks: University of North Dakota Press, 1975). This limited edition annotated bibliography was the result of the Midwest Prairie Conference at the University of North Dakota in 1974. This volume contains over seven thousand entries relating to the history of, and research on, the grasslands of North America. Of course, much research has been completed since this publication, but it remains one of the best starting places for anyone seeking references on the grasslands.

A provocative and engaging rethinking of ecosystem theory and the role of humans in shaping ecosystem is provided in Robert V. O'Neill, "Is It Time to Bury the Ecosystem Concept? (With Full Military Honors, of Course!)," *Ecology* 82, no. 12 (2001): 3275–84. O'Neill takes pains to demonstrate that an understanding of any ecosystem can only occur when all elements forming it are understood, and this includes the human role in shaping them. To underscore this point, O'Neill argues that human beings should be considered the "keystone" species of any ecosystem.

The role of fire in shaping the grasslands is becoming clearer as a result of several important studies. An early proponent of humans wielding fire as an ecological management tool is Omer C. Stewart, who wrote *Forgotten Fires: Native Americans and the Transient Wilderness*, edited by Henry T. Lewis and M. Kate Anderson (Norman: University of Oklahoma Press, 2002). Initially completed in 1954, Stewart's manuscript contained a wealth of information depicting how American Indian peoples purposefully managed their environments through fire burning practices. The chapters covering the grasslands are replete with solid evidence demonstrating his contention. However, editors uniformly refused to publish Stewart's groundbreaking research, and this remained the case until Lewis and Anderson edited his original work and published it. Important works following in the wake of Stewart's study are Julie Courtwright, *Prairie Fire: A Great Plains History* (Lawrence: University Press of Kansas, 2011); and Scott Collins and Linda L. Wallace, eds., *Fire in North American Tallgrass Prairies* (Norman: University of Oklahoma Press, 1990).

There are several other interesting ways to view railroad expansion in the United States. Most recent is Richard White's economic and institutional work, *Railroaded: The Transcontinentals and the Making of Modern America* (New York: W. W. Norton &

Company, 2011). See also Craig Miner's analysis of newspaper reporting of railroad development, *A Most Magnificent Machine: America Adopts the Railroad, 1825–1862* (Lawrence: University Press of Kansas, 2010). An excellent look at the corporate structure of railroads is Gerald Berk's *Alternative Tracks: The Constitution of American Industrial Order, 1865–1917* (Baltimore, MD: Johns Hopkins University Press, 1994).

My understanding of urban dynamics in Kansas has been largely shaped by James R. Shortridge. See especially his *Cities on the Plains: The Evolution of Urban Kansas* (Lawrence: University Press of Kansas, 2004). Also highly useful in this context is Charles N. Glaab, *Kansas City and the Railroads: Community Policy in the Growth of a Regional Metropolis* (Lawrence: University Press of Kansas, 1993).

Kevin Kelly, *What Technology Wants* (New York: Viking, 2010), is a provocative read on the nature of technology and how it shapes human life. A good overview of theories about technology is Richard Rhodes, ed., *Visions of Technology: A Century of Vital Debate About Machines, Systems, and the Human World* (New York: Simon & Schuster, 1999). David E. Nye's *America as Second Creation: Technology and Narratives of New Beginnings* (Cambridge, MA: MIT Press, 2004) is an excellent historical analysis of American thinking about the role of technology in creating "civilization" out of the wild. In a similar vein of reasoning, but with an eye bent more toward ecological change, see William Cronon's *Nature's Metropolis: Chicago and the Great West* (New York: W. W. Norton and Company, 1991).

INDEX